UAL QUICKSTART GU

Photoshop Lightroom 3

NOLAN HESTER

Visual QuickStart Guide Photoshop Lightroom 3

Nolan Hester

Peachpit Press 1249 Eighth Street Berkeley, CA 94710 510/524-2178 510/524-2221 (fax)

Find us on the Web at: www.peachpit.com To report errors, please send a note to errata@peachpit.com Peachpit Press is a division of Pearson Education

Copyright © 2011 by Nolan Hester

Associate Editor: Valerie Witte Production Editor: David Van Ness Compositor: David Van Ness Proofreader: Elizabeth Kuball Indexer: FireCrystal Communications Cover design: Peachpit Press All example photographs © Nolan Hester

Notice of Rights

All rights reserved. No part of this book may be reproduced or transmitted in any form by any means, electronic, mechanical, photocopying, recording, or otherwise, without the prior written permission of the publisher. For information on getting permission for reprints and excerpts, contact permissions@peachpit.com.

Notice of Liability

The information in this book is distributed on an "As Is" basis, without warranty. While every precaution has been taken in the preparation of the book, neither the author nor Peachpit Press shall have any liability to any person or entity with respect to any loss or damage caused or alleged to be caused directly or indirectly by the instructions contained in this book or by the computer software and hardware products described in it.

Trademarks

Visual QuickStart Guide is a registered trademark of Peachpit Press, a division of Pearson Education.

All other trademarks are the property of their respective owners.

Many of the designations used by manufacturers and sellers to distinguish their products are claimed as trademarks. Where those designations appear in this book, and Peachpit Press was aware of the trademark claim, the designations appear as requested by the owner of the trademark. All other product names and services identified throughout the book are used in an editorial fashion only and for the benefit of such companies with no intention of infringement of the trademark. No such use, or the use of any trade name, is intended to convey endorsement or other affiliation with this book.

ISBN 13: 978-0-321-71310-0 ISBN 10: 0-321-71310-9

987654321

Printed and bound in the United States of America

Dedication

To Mary, my true companion of the road. In forging a life of adventure and trust, there's no better backup.

Special thanks to...

Valerie Witte, my editor, for her prodigious efforts to make this a far better book for you, the reader;

David Van Ness for his constant composure and rock-steady skills;

Emily Glossbrenner of FireCrystal for so deftly crafting an index that's a map of concepts rather than just a vocabulary list;

Nancy Davis for passing me along;

and Ceilidh, Hanz, and the rest of the road gang for making last summer and fall a journey of discovery.

Contents at a Glance

	Introduction
Chapter 1	Lightroom 3 Overview
Chapter 2	Importing Images
Chapter 3	Using Catalogs
Chapter 4	Navigating the Library
Chapter 5	Organizing and Reviewing Images
Chapter 6	Using Keywords
Chapter 7	Finding Images
Chapter 8	Creating and Using Collections
Chapter 9	Developing Images
Chapter 10	Making Local Adjustments
Chapter 11	Creating Slideshows and Web Galleries 197
Chapter 12	Making Prints
Chapter 13	Exporting Images
	Index

Table of Contents

	Introduction
Chapter 1	Lightroom 3 Overview
	Library Module3Develop Module6Slideshow Module8Print Module.9Web Module.10Controlling the Panels.11SettIng Your Work View13Putting It All Together16
Chapter 2	Importing Images
	Importing Images 19 Putting It All Together 34
Chapter 3	Using Catalogs
	Fxporting Catalogs37Importing Catalogs38Merging Catalogs41Switching Catalogs45Backing Up Catalogs46Putting It All Together48
Chapter 4	Navigating the Library
	Using the Toolbar50Setting Library Source.51Setting the Library View52Grid and Loupe View Options53Setting Thumbnail Size58Setting Sort View58Rearranging Photos59

	Moving Through Photos60Selecting Images62Rotating Images63Putting It All Together64
Chapter 5	Organizing and Reviewing Images
Chapter 6 Chapter 7	Using Keywords.91Creating Keywords.92Using Keyword Sets.100Editing Keywords.103Putting It All Together.106Finding Images.107
	Using the Library Filter
Chapter 8	Creating and Using Collections121Using Quick Collections123Using a Target Collection130Using Smart Collections134Putting It All Together136
Chapter 9	Developing Images137Making Quick Fixes.138Working in the Develop Module.143Creating Virtual Copies.144Updating the Process Version.145Using the Presets Panel.148Using the History and Snapshots Panels.150Making Basic Adjustments.152Adjusting Tone Curves.157

	Using the HSL and Color Panels
Chapter 10	Making Local Adjustments
	Using the Crop Overlay Tool
	Using the Red Eye Correction Tool
	Using the Graduated Filter
	Using the Adjustment Brush
	Putting It All Together
Chapter 11	Creating Slideshows and Web Galleries 197
	Selecting and Ordering Photos
	Using the Slideshow Module
	Choosing Slideshow Settings
	Creating Web Galleries
	Choosing Web Gallery Settings
	Previewing and Uploading a Web Gallery
	Putting It All Together
Chapter 12	Making Prints
	Setting Up to Print
	Choosing a Basic Print Template
	Customizing a Print Template
	Saving a Custom Template
	Printing Photos
	Putting It All Together
Chapter 13	Exporting Images
	Basic Exporting
	Export Setting Options
	Creating Export Presets
	Adding Export Plug-ins

Meshing Lightroom and Photoshop
Setting Up Publish Connections
Collecting Photos to Publish
Publishing a Collection
Putting It All Together,
Index

Introduction

Welcome to Adobe Photoshop Lightroom 3: Visual QuickStart Guide. Built expressly for digital photography, Lightroom runs on Windows and Mac. It doesn't require a computer faster than you can afford. And it combines many of Adobe Photoshop's amazing powers with simpler, more intuitive tools. Adjusting tone curves, always a bit mysterious in Photoshop, is easier, more straightforward, and less prone to errors.

In ways big and small, Lightroom feels like a photographic process instead of something installed on a computer. That's because Lightroom is organized around a workflow that reflects photography itself, starting with moving photos off a camera into the computer and ending with cither a print or screen image.

Lightroom does all this without ever touching the original photo. Unlike Photoshop, which writes over the pixels of your original photo with each save, Lightroom makes all its edits as software instructions, known as metadata. The edits are all stored in a database, which makes it possible to tweak the adjustments endlessly—and even apply them to another photo with a couple of clicks. That's no knock on Photoshop, which remains an essential tool for me and every other digital photographer. In fact, using Lightroom and Photoshop in tandem now seems so natural it's hard to imagine photography before Lightroom's arrival.

What's New in Lightroom 3?

You'll find lots of improvements throughout the program. Here are some of the most important changes in Adobe Photoshop Lightroom 3:

Backup when quitting: It sounds like a little thing, but it embodies the kind of smart improvement you'll find throughout the new version. Now, when you *quit* Lightroom 3, you're asked if you want to back up the catalog. If you've been doing lots of work, it's the most logical time to back up. Previously, you had to back up when you *launched* Lightroom. (For more information, see page 46.) Tethered shooting: Greatly expanded from version 2, Lightroom 3 supports a tethered connection to most current Canon and Nikon DSLR cameras. Adobe is regularly expanding that list, enabling more photographers to control shots with Lightroom and have the results imported and displayed automatically. (For more information, see page 21.)

Imports: The import process has been redone from the ground up, thank goodness. It's now much more intuitive, and it's always clear what you're importing from where. You can save frequently used settings as an import preset. You also can use Loupe view to inspect photos before moving them off the storage card. (For more information, see page 17.)

New process engine makes for greater noise reduction: A major under-the-hood reworking of Lightroom's process engine means big improvements in noise control. Luminance and color noise reduction are now as good as, or better than, all the major third-party plug-ins. Low-light, high-ISO photos now look much better. (For more information, see pages 145 and 175.)

Tone Curve: Lightroom's new ability to switch to Point Curve enables you to shape the tone curve directly. Photoshop veterans will feel right at home. (For more information, see page 157.)

Lens correction: Still a work in progress, the Develop module's lens correction feature offers the prospect of automatically correcting perspective and aberration based on the lens used. The list of supported lenses remains small, but it is growing. A downloadable manual option makes it possible for you to create a custom calibration for each of your lenses. (For more information, see page 176.) Other develop improvements: The Develop module has been smoothed and buffed from top to bottom. Collections now appear right in the Develop module, eliminating the constant switching to the Library. The Adjustment Brush can now apply "negative sharpening," which you can use to creatively blur parts of a photo. (For more information, see page 173.)

Videos: Increasingly, our cameras shoot stills and video. No, you can't edit videos in Lightroom yet, but you now can import them into the catalog. That lets you rate them, apply keywords, and use all the organizational tools that make Lightroom so handy for stills. If you have ever accidentally deleted a video off a storage card because you forgot it was there, you will love this. (For more information, see page 17.)

Slideshows: Audio and video are becoming full citizens in Lightroom slideshows. You can take your stills and export them as a video. Soundtracks can be embedded into your slideshow, and it's easy to sync the length to match the number of photos you use. (For more information, see page 207.)

Watermarks: Lightroom 3 includes a simple watermark that you can quickly add to photos used in slideshows, Web galleries, or prints. Better yet, it includes a full-fledged Watermark Editor, similar to the Identity Plate Editor, for creating custom text- or graphic-based watermarks of your own. (For more information, see page 237.)

Printing: Creating custom photo packages has become as simple as grabbing and rearranging photos on a layout. There's also a rotate-to-fit option to help you build paper-saving layouts. Maximum print resolution has been boosted to 720 pixels per inch from the previous limit of 480 ppi. (For more information, see page 217.) Publish Services: Combining aspects of the collections feature with semi-automated exports, Publish Services enables you to track and update images exported from Lightroom. You can export directly to your Flickr account to share photos over the Web. Or export to folders that you use to sync photos with a mobile phone, a screensaver program, or even Web-based storage sites such as Dropbox. (For more information, see page 244.)

Using This Book

Like all of Peachpit's Visual QuickStart Guides, this book uses lots of screenshots to guide you step by step through the entire process of importing, organizing, and adjusting your photos within Lightroom. Succinct captions explain Lightroom's major functions and options. Ideally, you should be able to quickly locate what you need by scanning the illustrations and captions. Once you find a relevant topic, dig into the text for the details. Sidebars, which run in a light-beige box, highlight the details of a particular topic, such as how previews affect your import speed or how to calibrate your monitor.

Windows and Mac: For the most part, Lightroom's features are available for both computing platforms, and within the program it's hard to even know what platform you're running. The few major differences are noted in the text. Throughout the book when keyboard-based shortcuts are shown, the Windows command is listed first, followed by the Mac command: (Ctrl-Q/Cmd-Q). By the way, you can see Lightroom's list of keyboard shortcuts within the program by pressing Ctrl-/ (forward slash) in Windows or Cmd-/ (forward slash) on the Mac.

This book's companion Web site (www.waywest.net/lightroom) has example photos from the book that you can download to work through many of the tasks step by step. The site also features tips on how to get the most from Lightroom. Feel free to write me at books@waywest net with your own tlps—or any mistakes you may find.

Welcome to Adobe Photoshop Lightroom, one of the best programs available for organizing, correcting, and displaying your digital photos. Designed specifically for photographers, Lightroom combines the power of the original Adobe Photoshop with an interface that makes it easy to tap that power. Lightroom also makes it a snap to import, sort, and track the flood of images that can so quickly overwhelm digital photographers.

In This Chapter

Library Module	3
Develop Module	6
Slideshow Module	8
Print Module	0
Web Module	10
Controlling the Panels	11
Setting Your Work View	13
Putting It All Together	16

Later chapters dive into the details. This one offers a quick tour of the Lightroom interface and the major tools included in its five modules. Those five modules— Library, Develop, Slideshow, Print, and Web—give you easy access to everything you need when working with photos. Lightroom presents the modules in that order to reflect a natural workflow—that is, the most efficient sequence of actions for working with your photos.

IGHTROOM 3

Left Panel Group Content changes with module; includes Navigator, previews, and preset choices

Main toolbar Tools change as module or view is changed

Module Picker Click to switch

among five modules

Library | Develop | Slideshow | Print | Web

Main Lightroom window

Right Panel Group Content changes with module; displays tools for current module

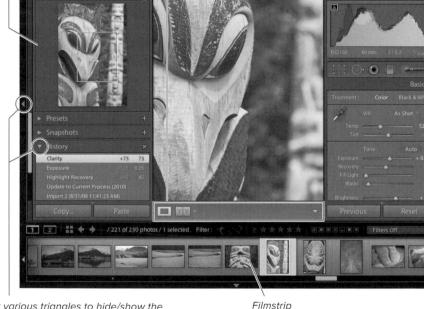

Click various triangles to hide/show the Module Picker, the Filmstrip, the two panel groups, or the panels within

Filmstrip Shows photos in the Library; click photo(s) in strip to display in main Lightroom window

A Lightroom works and looks virtually the same whether you're running Mac OS X, Windows XP, Windows Vista, or Windows 7.

Library Module

The Library module is where you import new photos; apply keywords (tags) to them; sort, rate, and label them; and mark the keepers or delete the stinkers. It has two views: Grid and Loupe **(A)**. Grid view lets you see multiple images at once; use the Thumbnails slider to vary their size. Loupe view lets you zoom in on a single photo. (For more information, see page 53.)

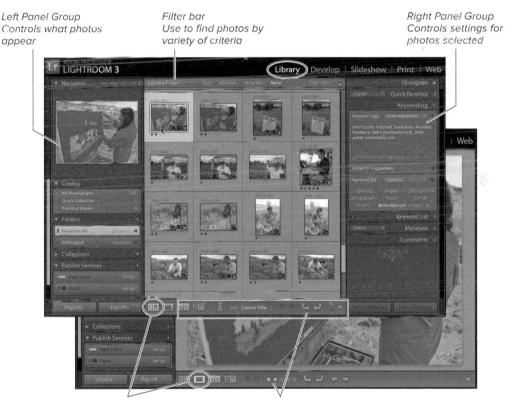

Grid/Loupe views Click to see thumbnails of multiple photos or zoom in on single photo Toolbar Choices change with module; in Library module, buttons help you compare, sort, rate, and flag photos

Whether in Grid (top) or Loupe (bottom) view, the Library module offers panels and tools for organizing your photos.

The Left Panel Group in the Library module—and all the panels within it—control what you see in the main window **B**. At the top, the Navigator helps you quickly move around within an enlarged photo displayed in the main window. The Catalog panel enables you to see all the photos in the current catalog, a smaller collection you've created, or just the most recently imported photos. The Folders panel shows you where the original master photos are stored on your computer or external hard drive. Use the Collections panel to create multiple "albums" of photos based on various criteria of your choosing. This gives you tremendous flexibility- without crowding your hard drive with duplicates of each master photo. (For more information, see pages 35 and 121.)

The Library module's Right Panel Group includes so many panels that you'll either need to use the triangles to collapse some of them or be willing to use the scrollbar to reach the lower panels. (See last Tip on page 12.) At the top, the Histogram panel displays a simple graphic that contains a tremendous amount of at-a-glance information about the selected photo. For minor fixes to a photo, you can use the Quick Develop panel, and the changes will appear immediately in the Histogram panel **(**). (For more information, see page 138.)

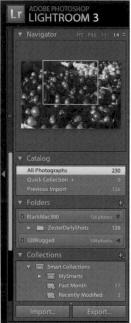

• The Left Panel Group in the Library module—and all its panels—controls what appears in the main window based on what catalog, folder, and collection you select.

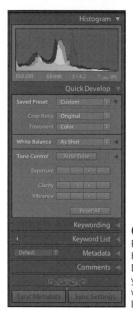

© At the top of the Right Panel Group, the Histogram and Quick Develop panels help you adjust exposures without leaving the Library module.

Key	wording
Keyword Tags Enter Keyv	rords 😫 🔻
artist Scotty Mitchell, Back2v freelance, Hell's Backbone G zester, zesterdaily.com	
	-
Keyword Set Custom	(e) v
US West zesterdaily.com	
+ Keyv	vord List 🔻
Q Filter Keywords	
▼ _PLACES	
California Northwest	

D The Library module's Keywording and Keyword List panels help you use keywords to identify and then find photos. You'll spend lots of time in the Library module's Keywording panel since it enables you to attach multiple keywords—sometimes called *tags*—to a single photo or a group of photos **①**. Not only does it suggest keywords based on your past choices, but it also helps you create sets of keywords that you can activate depending on the photos you're organizing. Outdoor Photography and Wedding Photography are two of Lightroom's built-in keyword sets. The Keyword List panel makes it much easier to find a few photos among thousands by helping you selectively filter the photos displayed within the main window.

Develop Module

The Develop module is where you make most of your adjustments to the selected photo's appearance (A). As in other modules, the Navigator sits at the top of the Left Panel Group and helps you move around within an enlarged photo. It also offers a preview of the effect of any of Lightroom's Presets as you roll your cursor over any item in the list. The Detail panel, new in version 2, gives you an up-close view while still leaving a zoomed-out view in the main window, essential for seeing the effects of sharpening and noise reduction.

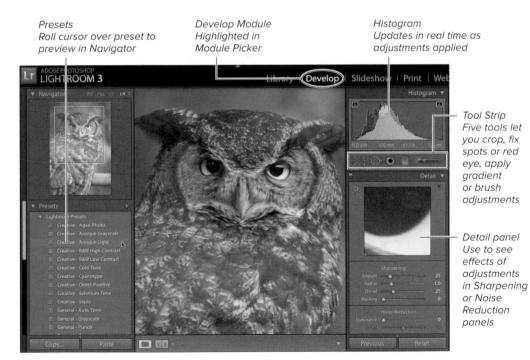

A The Develop module is where you make most adjustments to the selected photo.

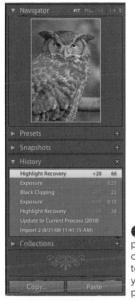

Use the History panel near the bottom of the Left Panel Group to keep track of how you've changed a photo's appearance. Near the bottom of the Left Panel Group, the History panel tracks changes to a photo—enabling you to step back to an earlier point if you change your mind about some adjustment you make ③. The Right Panel Group contains eight different development panels, giving you a wide array of tools to fine-tune your photos ④. The various sliders in the Basic panel control the bulk of Lightroom's exposure and color settings ④. (For more information, see page 152.)

). () Reset (Adobe

(The Right Panel Group contains eight different development panels to fine-tune your photos.

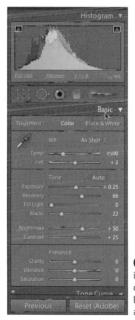

The various sliders in the Basic panel control the bulk of Lightroom's exposure and color settings.

Slideshow Module

Once you've picked a group of photos and adjusted their exposures, the Slideshow module helps you assemble them for an onscreen presentation (A). Using the included templates, you can quickly set the background, borders, and caption placement for the slides. You can also create vour own custom layouts. (For more information, see "Using the Slideshow Module" on page 199.)

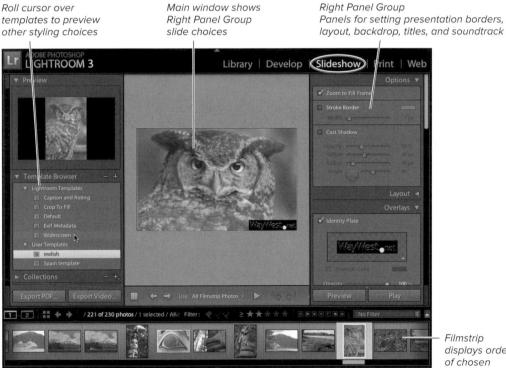

displays order slides

🕼 The Slideshow module offers complete control over the onscreen appearance, titling, and playback of your photo sequence.

Print Module

The Print module rounds up the settings you need to fine-tune photo prints: page layout, printer settings, color profiles, sharpening tailored to the final print size, and more **(A)**. Again, Lightroom gives you the choice of using layout templates or building your own. (For more information, see "Making Prints" on page 217.)

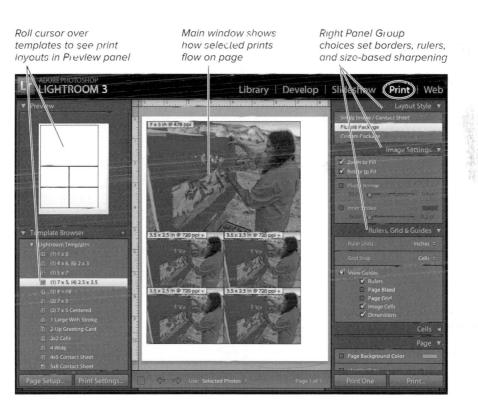

(A) The Print module lets you set how photos lay out on a page and includes controls to adjust the amount of sharpening applied to various print sizes.

Web Module

The Web module makes it incredibly simple to assemble a group of photos and prepare them for display on a Web site (A). It includes a variety of layout templates, or you can create custom ones of your own. Once you pick a layout, Lightroom can quickly generate all the thumbnails and coding needed to display the photos in HTML or in the Adobe Flash format. You can then upload the results from the module directly to your Web site. (For more information, see "Creating Web Galleries" on page 210.)

> how album and buttons appear on Web site Lit

Main window shows

Layout Style panel controls whether you use a template based on Adobe Flash, HTML, or third-party package

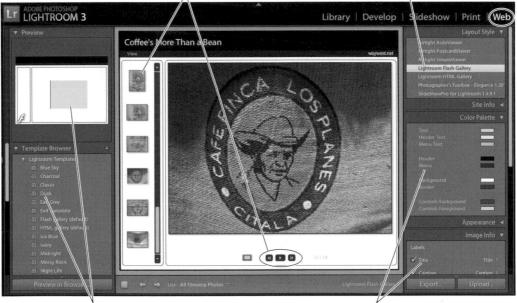

Choices depend on your Layout Style selection in the Right Panel Group

Other choices control album's appearance, colors, title or caption, and upload settings

(A) Lightroom's Web module can build photo layouts, generate the needed HTML or Flash coding, and upload it all to your Web site.

(A) These four triangles control when you see the Module Picker, the Right Panel Group, the Filmstrip, and the Left Panel Group.

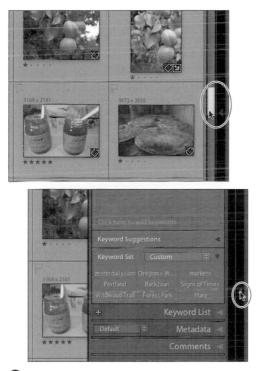

B Oops: The default action triangles make it easy to reach for a scroll bar (top) and, instead, trigger a panel to appear (bottom).

Controlling the Panels

Four areas surround Lightroom's main window: the Module Picker, the Right Panel Group, the Filmstrip, and the Left Panel Group. When and how they appear is controlled by four triangles sitting at the center of the top, right, bottom, and left boundaries (A). By default, these four areas appear and disappear whenever you roll your cursor onto or off of one of these triangles. Lightroom calls it Auto Hide & Show. (This does not happen with any of the individual panels within the panel groups, just these four.) The problem is that it's easy to accidentally trigger this behavior by, for example, trying to scroll through your main window B. Avoid the problem by changing the default action for each triangle.

To change the panel actions:

- Right-click any one of the four triangles along Lightroom's outside edge G. (Control-click on Macs with a singlebutton mouse.)
- Choose Manual from the drop-down menu and the new action is applied. This setting requires you to deliberately click the triangle to show or hide the panel.
- **3.** Repeat steps 1–2 to change the setting for the remaining three triangles.

(II) In step 2, in addition to choosing one of the top three actions, you also can choose Sync with Opposite Panel. This applies this panel's action settings to the panel on the other side of the main window (Module Picker and Filmstrip, or Left Panel Group and Right Panel Group) (D). Whether you find it useful to apply this option to either pair of panels will depend on your work style.

(III) Press Tab to simultaneously hide or show the Left Panel Group and Right Panel Group.

(IIP) To hide all panels except the one you're using, right-click in any panel's title bar and choose Solo Mode in the pop-up menu that appears. You can set this separately for the Left Panel and Right Panel groups.

To hide/show group panels:

In the Left or Right Panel Group, you can change what's revealed or collapsed by doing one of the following:

 Click a panel's title bar to expand or collapse its contents.

or

 Ctrl-click/Command-click the title bar of any panel to expand or hide the contents of *all* the panels.

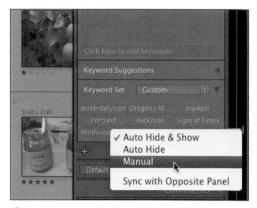

C Right-click any one of the four triangles, and choose **Manual** to change the triangle's default action.

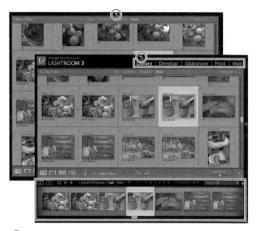

D With the top triangle set to Manual and Sync with Opposite Panel, a click hides or shows both the Module Picker and Filmstrip.

(1) In the Filmstrip, the Secondary Window button is dimmed when off (left) and white when on (right). If you want to turn it back off, click it again.

B By default, the second window opens in Loupe view.

	Secondary Window	
1 2.	Show Full Screen Show Second Monitor	ଞ୍ଜF11 企ଞ്ଜF11 Preview
	Grid Loupe – Normal / Loupe – Live	☆G ☆E
	Loupe – Locked Compare Survey	合器↩ 合C 合N

(To change the second window view, click the button and make a choice from the pop-up menu.

Setting Your Work View

Lightroom offers the ability to work with two monitors to greatly speed the job of organizing and developing images. For example, you can use the Grid view on one monitor to get an overview of your images, and use Loupe view on a second monitor to quickly inspect the details of a single image. Or, if your main monitor is more accurate color-wise, use it in Develop view and use Grid view on the secondary screen. Even if you do not have a second monitor, the Loupe view still can be used to open a second window on the *same* monitor. However, that approach Is useful only if you have a relatively large monitor.

To open a second window:

- If the Filmstrip is not visible, click the small triangle at the bottom-center of Lightroom's main window. (Or press Shift-Tab to reveal the Filmstrip, then Tab again to hide the side panels.)
- Click the Secondary Window button (A). By default, the second window opens in Loupe view (B).
- If needed, adjust the placement and size of the second view by click-dragging the window's border or the bottom-right corner. Or click the Secondary Window button above the Filmstrip and make a choice from the pop-up menu ().
- 4. To switch to a view mode other than Loupe, click Grid, Compare, or Survey in the upper-left list of views in the second window. These views work just as they do in the main window, as explained on page 52.

- 5. The second window's Loupe view offers three settings—Normal (the default), Live, and Locked ①. These settings control the relationship between what appears in the second window and what's selected in the first window:
 - Normal: With this selected, the second window shows the image selected in the first window.
 - Live: With this selected, the second window immediately shows the image that your cursor is hovering over in the first window's Grid or Filmstrip—even if another image is still selected [].
 - Locked: With this selected, the second window continues to display an image even when you select another image in the first window. To lock an image, right-click it (Controlclick on a Mac) and choose Lock to Second Monitor from the drop-down menu G.

D The second window's Loupe view offers three settings—Normal (the default), Live, and Locked—which control the relationship between what appears in the second window and what's selected in the first window.

() With the second window set to Live, rolling the cursor over a thumbnail anywhere in the first window...

• ...immediately affects what appears in the second window.

3872 x 2592	Open in Loupe Open in Survey	372
****	Lock to Second Monitor	₀₩₽
3672 × 2592	Go to Folder in Library Go to Collection	Þ
	Edit In	Þ
	Set Flag	•

() To lock an image, right-click it (Control-click on a Mac) and choose Lock to Second Monitor.

(1) In the Grid view of the main window, cllck the little 2 button to unlock what appears in the second window.

If you set the second window to full screen, the upper left list of views also includes a slideshow option. To release the lock, click Normal or Live in the second window or right-click (Control-click on a Mac) another image in the main window and choose Lock to Second Monitor from the drop-down menu again. The previous image is unlocked.

or

In the Grid view of the main window, click the Secondary Window button that appears on the locked image (1). The image is unlocked.

To close a second window:

 Down by the Filmstrip, click the Secondary Window button again. Or press Shift-F11 on your keyboard.

(IIP) You also can use the Main Window button just above the Filmstrip to quickly switch that view to full screen, and set whether the menu bar appears.

(III) If you set the second monitor to full screen, the upper-left list of views also includes a slideshow option **()**.

(IIP) In step 3, you can toggle the second window in and out of a full-screen view by pressing Alt/Option.

The Secondary Window button retains its last view, so you can just click it the next time you want it open. Or press Shift-F11.

Putting It All Together

- **1.** Open an image file in Lightroom's main window.
- 2. Change the action settings of the four triangles at the boundaries of the window. Sync the panel actions with the panel on the opposite side of the main window.
- **3.** Simultaneously hide and then show the top Module Picker and bottom Filmstrip.
- **4.** Collapse and then expand the contents of a panel.
- Switch the Right Panel Group to Solo Mode, and click in the title bar of different panels.
- 6. Open a second window in Loupe view.
- **7.** Adjust the placement and size of the second window, and lock and unlock the image.
- **8.** Change the image in the second window to Grid view.
- **9.** Set one of your monitors to Full Screen view.
- 10. Close the second window.

Importing Images

When you import images into Lightroom (A), the program automatically stores all the information about them in what it calls a catalog, which is simply a database. Keywords, development adjustments, preview settings- all the changes you make from this point forward—are stored in the catalog. Your actual images, which are still stored outside the catalog, remain untouched. Remembering that distinction between the catalog and your images is the key to understanding how Lightroom works. It's this nondestructive editing that enables you to modify and tinker with a photo without the risk of permanent damage. (For more information, see "Using Catalogs" on page 35.)

In This Chapter

Check Import Settings	18
Importing Images	19
Putting It All Together	34

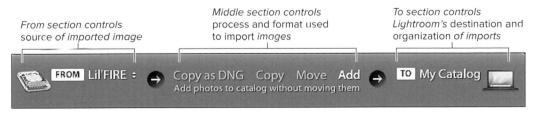

(A) Lightroom's revamped Import dialog, shown with just the top bar here, makes it much easier to understand and control what happens when importing photos.

Check Import Settings

In a welcome change from previous Lightroom versions, you no longer need to get under the hood of your PC or Mac to make it your default program for importing photos. All you have to do is install version 3. Still, you can take a quick peek at Lightroom's preferences to be sure.

To check Lightroom's import photos setting:

 Launch Lightroom, then choose Edit > Preferences (Windows) or choose Lightroom > Preferences (Mac). In the dialog, click the General tab. Look in the Import Options section to make sure the first check box—"Show import dialog when a memory card is detected"—is now selected (). None of the other settings here needs to be changed, so close the dialog. From now on, when you connect a digital camera or memory card, Lightroom opens its Import dialog automatically.

 Preferences

 General
 Presets

 External Editing
 File Handling
 Interface

 Language:
 English
 Importantial Statup

 Settings:
 Show splash screen during startup

 Import Catalog
 Import Options

 Show import dialog when a memory card is detected
 Ignore camera-generated folder names when naming folders

900			Preference	s
(Contractor of the local of the	General	Presets	External Editing	File Ha
		Settings:	Show splash scre	en durin
			Automatically ch	eck for u
Default Catalog				
When starti	ng up use thi	s catalog:	/Volumes/320Rug	iged/LR3
Import Options				
Show impor	t dialog when	a memory	card is detected	
gnore came	ra-generated	folder nar	mes when naming fo	ders

The Preferences dialog's General tab confirms that Lightroom's Import dialog will appear automatically.

To start importing: Click the Import button in the bottom left of the Library module.

B When you import from a connected camera or image card, that source is automatically selected as your image source.

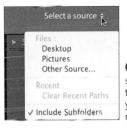

C Use the Select a source drop-down menu to choose a folder on your main hard drive or a recently opened folder.

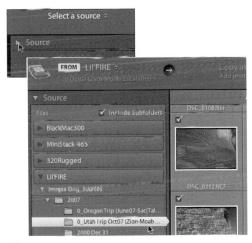

O Click Source and use the folder hierarchy to navigate to files on any connected hard drive.

Importing Images

The first time you import photos into Lightroom, it automatically creates a new catalog. On Windows machines, that catalog resides at: C:\Documents and Settings\ username\My Documents\My Pictures\ Lightroom\. On a Mac, it's created at: /User home/Pictures/Lightroom/. If you've used a previous version of Lightroom, Lightroom 3 automatically selects that earlier catalog. (For more information on creating a new catalog or combining old catalogs, see "Using Catalogs" on page 35.)

You'll also need to make a number of decisions about the import process. Once you choose your settings, however, future imports don't take much time because Lightroom can use those same settings.

To import images:

 In the Library module, click the Import button in the bottom-left corner (1).

or

From the Menu bar, choose File > Import Photos.

If you're importing directly from a connected camera or image card, that source is automatically selected in the Import dialog's From section B.

or

If you're importing photos already stored on your computer or connected hard drives, use Select a source or Source to navigate to where they're stored. Use the Select a source dropdown menu to choose a folder on your main hard drive or a recently opened folder **©**. Click Source and use the folder hierarchy to navigate to files on any connected hard drive **D**.

continues on next page

- 3. In the Import dialog's middle section, click the right-hand triangle to reveal the photos to be imported (2), uncheck any you do not want imported, and click one of the following at the top:
 - Copy as DNG (Convert to DNG in a new location and add to catalog) Pay this no mind if your camera only shoots JPEGs and does not support digital raw capture. If your camera can produce raw files, I'd recommend selecting this choice. (But first read "Raw vs. DNG" below.)
 - Copy (Copy photos to a new location and add to catalog) G: If you are importing photos from a memory card, select this option. The original photos are duplicated and moved to the hard drive where your Lightroom catalog is stored. Any metadata associated with those files (known as sidecar files) also is copied. After the import, any changes you make in Lightroom are applied to the duplicates in the new location. The originals are not

(In the Import dialog's middle section, click the right-hand triangle to reveal the photos to be imported. Then choose Copy as DNG, Copy, Move, or Add.

Copy as DNG Copy Move Add Convert to DNG in a new location and add to catalog

Copy as DNG: Creates new versions of originals and adds reference information to catalog.

Copy as DNG Copy Move Add Copy photos to a new location and add to catalog

G Copy: Copies images to new spot, adds to catalog, and leaves original images unchanged.

Raw vs. DNG

Raw camera files do not come in a single file format. Instead, various camera makers support different proprietary formats: Canon uses .CRW and .CR2, Nikon has .NEF, and so on. There's no way of knowing which of these formats will survive the test of time—and market share. That makes some photographers nervous: Will you even be able to open those files a decade from now?

Hence DNG, created by Adobe but based on open-source code, which means its workings aren't hidden behind a patent wall. It's a young format, however, and some photographers warn that there's no guarantee about its long-term survival either.

Fortunately, there is a way to keep both options open. When importing photos, in step 3 (above) choose Copy as DNG. Then in step 7 (page 24) be sure to select Make a Second Copy To and choose a *different* drive from the one holding the DNG files to store your original raw files. After you import your photos, any changes you apply in Lightroom are applied only to the DNG files. The raw files remain untouched for the future—assuming you hang on to that growing pile of hard drives.

Copy as DNG Copy Move Add Move photos to a new location and add to catalog

(I) Move: Shifts images to new spot, adds to catalog, and *deletes* images at original location.

Copy as DNG Copy Move Add Add photos to catalog without moving them

• Add: Simply adds a catalog reference to originals, which are left unchanged.

Auto Import and Tethered Shooting

Lightroom's Auto Import settings are useful mainly if you work in a studio doing what's called *tethered shooting*, where your camera is connected to your computer while you shoot. Lightroom lets you designate a folder that the program will monitor for the appearance of new shots from your tethered camera. When they appear, Lightroom automatically imports them, making it easy to inspect the shots on your computer monitor instead of on the camera's tiny LCD. To set up Lightroom's part, choose File > Auto Import > Auto Import Settings. changed, allowing them to serve as untouched backups. While Lightroom keeps all this perfectly straight, you need to remember the distinction to avoid getting confused, since you wind up with two sets of identically named images.

- Move (Move photos to a new location and add to catalog) (1): Just like the name says, under this option the original photos are moved to the hard drive where your Lightroom catalog is stored. Any metadata associated with those files (known as sidecar files) also are moved. Images and sidecar files at the original location are deleted, which is a good reason not to choose this option. If you want to make a fresh start at consolidating or reorganizing all your images, it still makes more sense to choose "Copy photos to a new location and add to catalog" instead.
- Add (Add photos to catalog without) moving them) (): The photos remain where they were originally. The Lightroom catalog will store any information you add, including development adjustments, and link to the original file. For that reason, the import is very fast. The drawback: You can work in the Develop module only when the hard drive containing the originals is connected to your computer. (Keywords, labels, metadata, and other Library module information, however, can be added without the hard drive being connected, since that information is stored in a Lightroom catalog.) If you use this choice, skip to step 6.

continues on next page

 If this is the first time you're moving or copying photos with Lightroom, use the To drop-down menu to navigate to the hard drive/folder where you want them stored ①. You can store the photos on your computer's internal drive or an external hard drive, but not on a networked drive ③. You'll have the option of refining this choice in step 12. (See "Laptop Options" on page 40.)

In future imports, if you want to move or copy photos to the same location, you can select it from the To drop-down menu **①**. TO BlackMac300 + BlackMac300 / Users / DW / Pictures TO BlackMac300 + BlackMac300 / Users / DW / Pictures Marcent : Clear Recent Paths cates

Use the To drop-down menu to navigate to the hard drive and folder where you want to store the photos you're copying or moving.

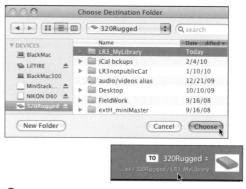

(C) Once you choose a destination, the selected hard drive appears in the To section.

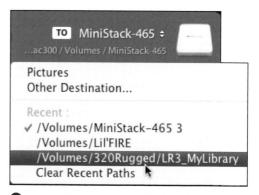

U In future imports, use the To drop-down menu to quickly pick one of your previous locations.

TO 320Rugged ÷
File Handling 🔻
Render Previews Minimal \$
Don't Import Suspected Duplicates
Make a Second Copy To : Volumes / 320Rugged

W Click File Handling to expand the panel, which controls previews, duplicates, and making a copy of your original images.

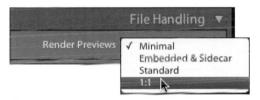

What you choose in the Render Previews dropdown menu depends on how you shoot.

Previews Affect Import Speed

You can control the quality of the previews that initially appear as Lightroom imports each photo. Rendering those previews directly affects how long it takes Lightroom to finish the import. If you simply need to confirm that Lightroom now has the photo so that you can get back to shooting, the Minimal or Embedded & Sidecar choices make sense. Otherwise, the Standard or 1:1 choices are better because they use Lightroom's color management.

- 5. Click File Handling to expand the panel, which contains the Render Previews setting . Your choice depends on how you shoot (see "Previews Affect Import Speed" below). From the drop-down menu , choose any of the following:
 - Minimal: The fastest way to display initial previews of your photos, but it uses the camera's smallest embedded preview and so does not display the colors accurately.
 - Embedded & Sidecar: Uses the camera's largest embcdded preview, which may not immediately display the colors accurately. Slightly slower than the Minimal preview, but the preview's good enough to start culling out-of-focus and cyes-shut photos. If you switch to the Develop module, however, Lightroom pauses to generate a new preview.
 - Standard: Slower than first two choices, but generates previews based on the more color-accurate raw file.
 - 1:1: Renders every pixel in the image, so you can zoom in for a one-toone view. Based on the extremely accurate ProPhoto RGB color space. Depending on your computer, this can take several minutes. It's worth the upfront wait only if color accuracy or a pixel-by-pixel check are overriding factors in your initial photo selection.

continues on next page

- 6. "Don't re-import suspected duplicates" is checked by default, so skip to the Make a Second Copy To option and click the check box. Click the file path if you want to change where Lightroom stores an immediate, one-time backup of the imported photos (top, ①). This choice is not available if you're simply adding photos to the catalog.
- 7. Navigate to where you want to store this backup, which serves as a safe-deposit box of your original images, before any changes are applied within Lightroom. Choose another hard drive for the backup to guard against the failure of your primary drive. After you select a backup hard drive and folder, the new file path appears below the Make a Second Copy To check box (bottom, ①). (Also see the first Tip on page 29.)
- 8. Click to expand the File Renaming panel, click the Rename Files check box, and make a choice using the Template drop-down menu ⁽¹⁾. This option isn't available if you're *adding* photos to the catalog. (See "Why Rename Files?" below.)

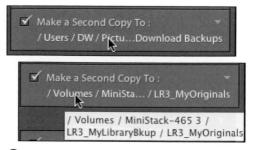

• Select Make a Second Copy To and click the file path if you want to change where Lightroom stores an immediate, one-time backup of the imported photos.

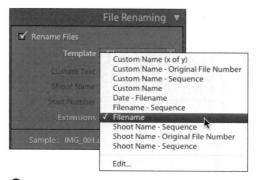

(P) In the File Renaming section, make a choice using the Template drop-down menu.

Why Rename Files?

Why bother with renaming imported image files when Lightroom's catalog enables you to search by their keywords, ratings, etc.? Because you won't always be working within Lightroom. When you export images out of Lightroom for e-mail, your blog, or Flickr, having a meaningful filename is really helpful. Certainly, the original filenames generated by your camera offer no clue about an image's content.

Lightroom's File Renaming panel lets you build your own logical, customized naming scheme to keep file chaos and anarchy at bay. Best of all, Lightroom makes renaming pretty much a set-it-and-forget-it affair based on the choices you make upfront in steps 3–5 on pages 20–23.

10. In the Apply During Import panel, use the Develop Settings drop-down menu if you want to apply a particular setting to all the imported photos **R**. Generally, it's more flexible to do this after import, using the Develop module. But it can save you time if, for example, you definitely want to make all the photos look like old-fashioned sepia-tone photos. (For more information, see "Using the Presets Panel" on page 148.)

9. Depending on your drop-down menu choice in step 8, use the Custom Text,

Shoot Name, or Start Number fields

template" on page 31.)

continues on next page

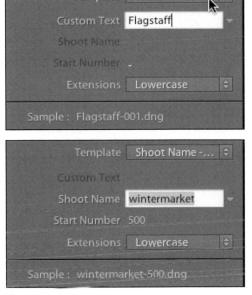

Q Use the Custom Text, Shoot Name, or Start Number fields to refine your naming scheme. The Sample line changes based on what you enter in the fields.

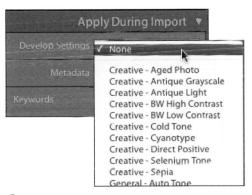

R The Develop Settings let you apply a change to all the imported photos. However, it's more flexible to do this in the Develop module after the import.

- Also in the Apply During Import panel, you can use the Metadata drop-down menu to create or apply metadata to the imported photos. Usually this is set to None, but you may want to create a copyright notice that can be applied to all your photos as you import them. To do so, choose New S. Use the New Metadata Preset dialog to create a new preset, and click Create when you're done T. Then choose your new copyright preset from the Metadata drop-down menu D.
- 12. If all the photos you're importing are, for example, of the same subject or location, use the Keywords text window to apply them. Type a keyword into the text window, and a list of similarly spelled keywords you've used before appears. Make a selection by pressing Enter (Windows) or Return (Mac). Type a comma after the keyword before entering another keyword ♥.

Apply During Import		
None		
New Edit Presets		

S Though it's usually set to None, you can use the Metadata drop-down menu to apply metadata during the import.

Nev	v Metadata Preset		
Preset Name: ©2010 Nola	ne: ©2010 Nolan Hester		
Preset: Custom			
▶ 🖂 Basic Info			
Figure 1970 Content			
V IPTC Copyright			
Copyright	Copyright 2010 Nolan Hester		
Copyright Status	Copyrighted	V	
Rights Usage Terms		V	
Copyright Info URL	http://www.waywest.net/copyright.html		
▼ Ø IPTC Creator			
Creator	Nolan Hester	V	
Creator Address	1234 Any Streeet	V	
Creator City	Anytown	V	
Creator State / Province	AnyState		
Creator Postal Code	99999	M	
▶ □ IPTC Imane			

① Use the New Metadata Preset dialog to enter information you want applied to *all* the imported photos, such as a copyright notice.

Apply During Import
Develop Settings None

Metadata 2010 Nolan Hester
Keywords
Sellwood, Portland, Oregon, spring

V Type in the Keywords text window any keywords that describe every photo in the current import.

Арі	oly During Import	V
Metadat 🗸	None ©2010 Nolan Hester	
Keywords	New Edit Presets	

Choose your new preset from the Metadata dropdown menu to apply it to every photo in the import session.

	ply During Import 🖪
+.	Destination 🔻
🔲 Into Subfolder	
BlackMac300	101 / 297 GB
	89.6 / 465 G8
320Rugged	1287 295 GB 🔻
V LR3_MyLibrary	
▼ 2010	87 🖌
02-18	87 🗸
LIFEIRE	13.2/111 GB 🖪

W If you're moving or copying images, expand the Destination panel.

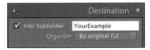

Think twice before using this option because it's easy to clutter your hard drive with lots of folders.

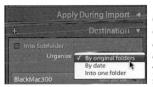

Use the Organizer dropdown menu to create a consistent yet flexible naming scheme.

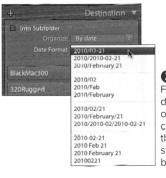

The Date Format dropdown menu offers lots of choices. I use the 2010/02-21 structure because...

...once back in the Library module, a single click in the Left Panel Group can expand or collapse a year's worth of folders.

- 13. If you're moving or copying images, expand the Destination panel. (If you're adding images to the catalog, Lightroom lists their original location.) The hard drive/folder combination you chose in step 4 appears at the bottom of the panel . Use the top section's check box or drop-down menus to further organize your imports by choosing one of the following:
 - Into Subfolder: Click the check box and use the text field to name the subfolder (2). I do not use this option, simply because it's too easy to wind up with lots of folders whose names may not make sense a year from now Instead, consider using the Organize drop-down menu choices (2).
 - By original folders: This preserves the folders and subfolders used to store the original images. Available only if your source files are already organized into folders.
 - By date: Creates and names the new folder based on the date the photos were shot. After choosing this in the Organize drop-down menu, choose a naming structure in the Date Format drop-down menu 2. I use the 2010/02-21 structure because, once back in the Library module, a single click in the Left Panel Group can expand or collapse a year's worth of folders AA. (The 2010/02/21 structure would do the same by year and month.)
 - Into one folder: As the name suggests, this moves all the photos into a single folder. This option is mainly useful if you're reorganizing a set of previously used folders.

continues on next page

14. Finally, double-check your settings and click Import **BB**. A progress bar tracks the import and preview process 🕜. Once the import finishes, an alert sounds and the card is disconnected, though not actually ejected. The Library module's Catalog panel shows the number of imported Images in the Previous Import line (1), while the Folders panel shows their location and organization (2) DD. You can continue to import other images or, once you're done, begin to review and rate them in the Grid view of the Library module (see "Organizing and Reviewing Images," page 65).

(BB) Double-check your settings, then click Import to start the process.

Copy and impor	t photos	×	
Navigator		1:4 🗢	Library Filte
Catalog			3872 x 2592
All Photographs		61	- Alter
Quick Collection		0	Decide .
Current Import		61	X
	Navigator Catalog All Photographs Quick Collection	Catalog All Photographs Quick Collection +	Navigator FIT FILL 1:1 1:4 ‡ Catalog All Photographs 61 Quick Collection + 0

CC A progress bar tracks the import process.

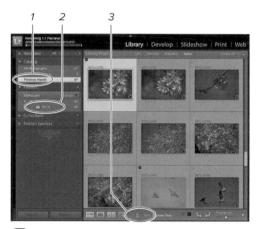

D The Previous Import entry (1) in the Catalog panel shows how many images were imported, while the Folders panel shows their location and organization (2). Reversing the sort order (z-a) (3) puts the imported photos at the top of the Grid, where you see them without scrolling.

(L) If you don't have the time to finish rendering the previews, click the X to cancel the sometimes lengthy process.

(I) Before you start a complicated import, switch the Import dialog to its compact view to double-check your settings.

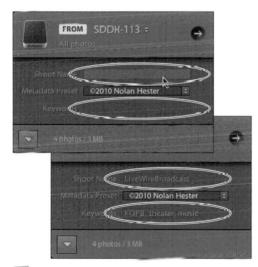

(GG) Lightroom highlights any blank fields, making it easier to fix your settings.

(IIP) You still can navigate to a folder or individual images, select them, and drag them into the Grid view of the Library module. But you're better off using Lightroom 3's new Import dialog, which offers far more control.

(IIP) In step 7, remember that these second copies are not backups of your Lightroom work. They're duplicates of your original files *before* Lightroom renames them, applies metadata, and does all the other stuff you specify in the Import dialog. I try to remind myself of this by putting them in a folder named *LR3_MyOriginals*. At this point, you have no backups/archives of your Lightroom work. (See "To set catalog backups" on page 46.)

ID In step 8, if you choose Filename, be sure your camera is set not to start numbering indlvidual *files* starting from the beginning every time you reformat the card. That was my Nikon's default, which created some shortterm chaos in Lightroom, which kept generating the same filenames.

(IP) By reversing the Grid view's sort order (z-a), imported photos appear at the top. That saves you from having to scroll down to the bottom of the window, which can be a long way down as you import more and more images (C, DD).

(III) The import and rendering processes occur separately. Click the X at the right end of the progress bar to cancel 1:1 previews if you don't have the time for Lightroom to finish **(II)**.

When you set up a complicated import, before hitting the Import button, clICK the bottom-left triangle to switch the Import dialog to its compact view **(F)**. Lightroom highlights any blank fields, making it easier to doublecheck your setup **(G)**.

To create an import preset:

- If you want to save your import settings for future use, click the Import Preset bar at the bottom of the Import dialog. Select Save Current Settings as New Preset in the drop-down menu (top, (11)).
- Name the preset in the text field, and click Create (bottom, .). Your new preset will be available in the Import Preset menu for future import sessions .

Import Preset :	✓ None	Import
	Save Current Setti	ings as New Preset 📐
	000	New Preset
	Preset Name:	MyImportPreset
		Cancel Create

To save your settings for future imports, click the Import Preset bar at the bottom of the Import dialog. Then use the New Preset dialog to name the preset.

Copy as DNG Copy Move Add Copy photos to a new location and add to catalog
File Handling Ignore Duplicates, 1:1 Previews Renaming 20100221-untitled_shoot-0001.jpg
Import Preset : MyImportPreset +

U Your new preset appears in the Import Preset menu for future import sessions.

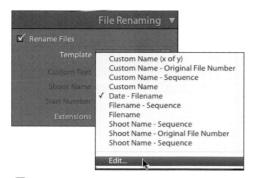

Select a template from the drop-down menu, then click the drop-down menu again and choose Edit.

Preset: Date - Filename	erelen er en er
Example: 20100218DSC8571.nef	
Date (YYYYMMDD) - Filename	

(K) The Filename Template Editor shows the preset you want to change and its current structure.

To customize a file-naming template:

- To reach the File Renaming panel, click the Import button in the Library module. To expand the panel, click its title and make sure the Rename Files check box is selected.
- First select a template from the dropdown menu, then click the drop-down menu again and choose Edit at the bottom ID.
- 3. The Filename Template Editor shows the preset you want to change—and its current structure of placeholders, or tokens, separated by hyphens **(K)**. In this example, we backspace to delete the Filename token, then click Insert to replace it with the Shoot Name token **(I)**.

continues on next page

- **4.** After typing a hyphen to separate the tokens, use the Numbering section to insert Sequence # (0001) **(M)**.
- 5. When you finish customizing the template, click the Preset drop-down menu and choose Save Current Settings as New Preset (M).
- 6. When the Rename Preset dialog appears, create a name that precisely describes the new preset, and click Create ⁽¹⁾.

	Filename Templ	ate Editor
Preset: (Date - Filename (edited)	
Example: 2	0100218-untitled_shoot-0	001.nef
	(YYMMDD) – Shoot Na ce # (0001)	ime)-
Image Name		
	Filename	1 Insert
Numbering	And the Designation of the second	
	(Import # (1)	Insert
	(Image # (1)	(Insert)

Use a hyphen to separate the first token from the next one (Sequence).

	Filename Template Editor	
Prese 🗸	′ Date – Filename (edited)	
Example	Custom Name	
	Custom Name - Original File Number	-
Date	Custom Name - Sequence	
Sede	Custom Name (x of y)	
	Date - Filename	
Image Na	Filename	
	Filename – Sequence	
	Session Name - Sequence	
	Shoot Name - Original File Number	
Numberi	Shoot Name - Sequence	
	Shoot Name - Sequence	
	Save Current Settings as New Preset	
	Update Preset "Date - Filename"	
	Conductore a looper	No.

After building out your new template, click the Preset drop-down menu and choose Save Current Settings as New Preset.

Preset:	Rename preset "date-shoe	ot-sequence"
Example: 2	0100218-untitled_shoot-	0001.nef
noo	Rename P	reset
Preset N	ame: date-shoot-see	quence-ext
		Cancel Create
Numbering		
and the state of the sec	Import # (1)	t) (Insert)
	(import # (1)	
	(Image # (1)	\$ Insert

00 Type a name that precisely describes the new preset's function and click Create.

	Filename Tei	mplate Editor	
Preset: dat	e-shoot-sequence-	ext	
Example: 2010	0218-untitled_shoo	ot-0001.nef	
Date (YYYYM Sequence #	(MDD) Shoo	t Name 📮	
Sequence	(0001)		
Image Name			
Fi	lename		Insert
Numbering			
In	nport # (1)		Insert
In	nage # (1)		Insert
S	equence # (0001)		Insert
Additional			
D	ate (YYYY)		Insert
Custom			
Sho	oot Name		Insert
Cu	stom Text		Insert
		Cance	Done
and an and the states of	and the second strength of the		

P Double-check your settings, particularly the token sequence, before clicking Done.

	File Renaming 🔻
🗹 Rename Files	
Template	date-shoot-s ≑
Custom Jaxi	
Shoot Name	sellwoodspring
Start Number	Tunner and a summary superior
Extensions	Lowercase 😂
Sample : 20100218	-sellring-0001.dng

QO After selecting your renaming preset in the Template drop-down menu, fill in the placeholdor fields to build out the naming sequence.

- Double-check your settings, particularly the token sequence, and click Done PP.
- Once you create your template, you can select it in the File Renaming panel's drop-down menu, and fill in the place-holder/token fields. In this example, we'll fill in the Shoot Name and Start Number before starting the import ⁽¹⁾/_(C). (For more information, see step 9 on page 25.)

Putting It All Together

- **1.** Open Lightroom's Preferences dialog and check the import settings.
- **2.** Use the Import button to navigate to a folder of photos. Choose to import all the photos in that folder.
- **3.** Choose to "Copy photos to a new location and add to catalog."
- **4.** Navigate to the drive where you want to store the photos.
- **5.** Set your choice of how to render previews.
- **6.** Choose another hard drive on which to create a second copy.
- 7. Choose a file-naming scheme.
- **8.** Create a copyright notice that will apply to your files as you import them.
- **9.** Apply a keyword to your photos in the Keywords text box.
- **10.** Double-check your settings and import your photos.
- **11.** Create an import preset for future imports.

Using Catalogs

Because it's essentially a database, Lightroom's catalog can speedily handle thousands of images without hogging your whole hard drive. That also enables you to do most of your editing work even when your images are stored on a disconnected hard drive or disc.

If you are upgrading from an earlier version of Lightroom, see "To import catalogs from previous versions of Lightroom" later in this chapter. If you're starting fresh with version 3, Lightroom automatically creates a new catalog the first time you import any photos, as explained in the "Importing Images" introduction on page 19. As you add photos, that catalog keeps track of where the original images are stored.

As Lightroom's ability to work quickly with large catalogs continues to improve, there's less need to switch among catalogs. Sometimes, however, you still may need to switch to earlier catalogs you created. (For more information, see "To switch to another catalog" on page 45.) The other situation where you'll switch catalogs is when using multiple computers, such as a desktop and laptop. You sometimes can

In This Chapter

Exporting Catalogs	37
Importing Catalogs	38
Merging Catalogs	41
Switching Catalogs	45
Backing Up Catalogs	46
Putting It All Together	48

sidestep this if you store your original photos and the related Lightroom catalog on an *external* drive. That way, you can move from the desktop machine to the laptop simply by connecting the external drive to one or the other. (Adobe allows you to install the Lightroom program on a desktop machine and your laptop.)

If you do not want to carry an external drive, however, you can shift Lightroom catalogs—along with any new images you create in the field—by merging your field and desktop catalogs. (For step-by-step details, see "To merge two catalogs" on page 42.) Here's the gist of the round-trip process:

- Before leaving your home or office, use Lightroom to export your photos as a catalog from your desktop machine to the laptop you'll use in the field. Then on the laptop, import that catalog into Lightroom.
- As you take new photos in the field, be sure you use Lightroom's import process to move or copy them onto the laptop.
- Back home or at the office, reverse the process: Export the catalog—along with your new photos—from the laptop. Then import it all back into the desktop machine.

One last thing: Given the vital role of catalogs in Lightroom, you need to back them up regularly (see "To set catalog backups" on page 46). You also need to protect yourself against a dead hard drive (see "Dupe Your Drives" on page 47).

A In the Library module, select the photos you want to export.

000	Export a	as Catalog	
Save As: t	ulips		
	Transfer_	Catalogs	Q search
Lil'FIRE BlackMac300 MiniStack-465 MOJAVE-100 2gbTHUMB 320Rugged 1	Name		Date Modified
► PLACES	🗹 Export ne	alog with 2 photos gative files railable previews	
New Folder		Cance	Export Catalog

(B) Name the exported catalog, choose where you want it exported, click the appropriate check boxes, and click Export Catalog.

(The export can take seconds for a few photos or several minutes for a larger catalog.

Exporting Catalogs

It is common to export a subset of photos from your desktop machine's main catalog so that you can work with them on a field laptop.

To export photos as a catalog:

- In the Library module, select the photos you want to export, using the "All Photographs" choice in the Catalog panel, a listing in the Folder panel or by manually selecting individual photos in the Filmstrip or Grid view ().
- From the Menu bar, choose File > Export as Catalog. Use the dialog to name the exported catalog and choose where you want it exported—for example, directly to a connected laptop or portable hard drive I
- **3.** Select one or both of the two export check boxes if you export the negative files (DNG). (See Tip.)
- Click Save (Windows) or Export Catalog (Mac) to close the dialog and export the catalog. A progress bar tracks the export, which can take seconds for a few photos or several minutes if you're exporting 1,000-plus photos C.

Lightroom sounds an alert when the export is finished.

In step 3, choose Export negative files if you expect to change the Develop adjustments for these images on the computer where this new catalog will be opened. If you simply want to flag, rate, label, or add keywords to the photos in the Library module, you don't need the negative (original) files, just the catalog itself. Negative files, because they are quite large, take much longer to export/import than the catalog itself, which contains only the metadata.

Importing Catalogs

There are two situations where you may need to import a catalog. The first occurs when you open an existing catalog that was created using a previous version of Lightroom. The second situation involves importing images from another catalog.

To import catalogs from previous versions of Lightroom:

- From the Menu bar, choose File > Import from Catalog.
- Navigate to the catalog you want to import—the filename ends with .*Ircat* and click Choose (A).
- If prompted to upgrade the catalog, click Start Background Upgrade

 A progress bar tracks the catalog upgrade.
- Once the upgrade is completed, the Import from Catalog dialog appears C. If you're still happy with where the original images are stored, use the File Handling drop-down menu to add or copy the photos, and choose Import. (For more about the difference between adding and moving, see step 3 of "To import images" on page 20.)
- 5. A progress bar tracks the import process ①. When the import finishes, the photos appear in Lightroom's Library module.

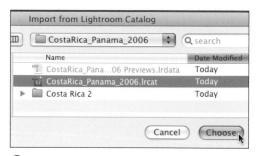

To import a Lightroom catalog, navigate to the file, which ends with *.lrcat*, and click Choose.

	Catalog Must Be Upgraded
Lr	The selected catalog file "FieldWork" must be upgraded before it can be imported with Lightroom 3.
	Lightroom will upgrade the catalog in the background and then resume the import operation after the upgrade completes
	Save Upgraded Catalog. Destination: /Volumes/320Rugged/FieldWork/FieldWork-2.ircat Change Discard Upgraded Catalog After Import.
	Cancel Start Background Upgrade

If Lightroom asks to upgrade the catalog, click Start Background Upgrade.

-	nts (180 photos) s (1 folders) 180	Preview
Costa Ric		
New Photos (1		
File Handling:	✓Add new photos to catalog without moving	
Changed Existi	Copy new photos to a new location and import	2008-August CostaRica -156,PC
Replace: Not	Don't import new photos	
Preserve	old settings as a virtual copy	(Check All) (Uncheck All)

(Use the Import from Catalog dialog to set your file-handling choices before clicking Import.

l	mport From Catalog
Lr	Import Photos from Catalog Importing Photos
	Cancel

D Finally, a progress bar tracks the import of the catalog's images into Lightroom.

Look in:	😂 tulips	~	O d	100	•
My Recent Documents	2010 tulips Pre kulips.kca				
	- L	tulips.lrcat			hoose
	File <u>n</u> ame:	tuips.ircat	(Concellant)		

(C) Navigate to the folder containing the exported Lightroom catalog and exported photos.

Import From C	atalog	X
Lr	Preparing to Im Checking for duplic	port from Catalog ate photos
		Cancel

• A progress bar appears briefly as Lightroom prepares to import the catalog.

(In the Import from Catalog dialog, set the File Handling drop-down menu.

Click Choose to change the default folder where new photos are copied.

To import another catalog:

- Before leaving home or the office, connect your laptop to your desktop computer, its external drive, or a thumb drive containing the Lightroom catalog you previously exported.
- Launch Lightroom on the laptop computer and, from the Menu bar, choose File > Import from Catalog.
- Navigate to and open the folder that contains the exported original photos and the exported Lightroom catalog. Select the catalog file, which ends with *.lrcat*, and click Choose (2). A progress bar appears briefly as Lightroom prepares to import the catalog (5).
- 4. When the Import from Catalog dlalog appears, all the folders listed in the Catalog Contents window are checked **G**. Set the File Handling drop-down menu to match the sltuation: Choose "Add new photos to catalog without moving" if you simply want to view, flag, rate, label, or add keywords to photos, all of which can be done using metadata. If you also intend to use the Develop module to apply adjustments to the originals, choose "Copy new photos to a new location and import."

If you choose the "Add" option, skip to step 6; if you choose the "Copy" option, see step 5.

5. Click Choose if you want to change the default folder for new photos copied to the laptop (1). By default, they are placed in the *My Pictures* folder, but I find it handier to create a new folder inside that one, which I name *LR3* fieldshots.

continues on next page

6. Once you finish changing the settings, click Import 1.

A progress bar tracks the import **①**. When the import finishes, the imported photos appear in the Grid view. You can now work with the imported photos as needed. To shift your work back to your desktop computer, see "Merging Catalogs" on the next page.

When you're done working with the photos on your laptop, you can export the catalog (and any changes in the photos) as explained on page 37. Then you can import the catalog back into your primary computer.

The wording of the first File Handling choice in step 4 is a little confusing. "Add new photos to catalog without moving" means Lightroom adds references in the catalog pointing back to the originals, which are not moved from one computer to the other.

Catalog Contante (3 photos)	Preview	
🗹 All Folders (1 foldere) 3	a b	4
₹ 25.0762-17 5	183 M	\$°G
New Photos (3 photos)	RESIL ATTRACT	
File Handling. Completes the time to bottom and report (ν	81.00273 surfited_process200622/100273-someter_the	on user In value _ second dece.
Copy In: U-\$10mments as \$10.56456561 * (Chrose)		
Changed biseting Photos (rone facioid)		
el Ansee versión anterprise a sistementes	Check Al Uncheck AL	_J
Show Prestew		Intert Cancel

Once you finish changing the settings, click Import.

A progress bar tracks the import.

Laptop Options

When you move or copy your originals, you'll need to decide whether to store them on an internal or external hard drive. For desktop users, the choice is academic. But photographers using laptop computers on location face some trade-offs.

While there are lots of fast, roomy external drives for desktop machines, many laptops offer only USB connections. Though manufacturer charts may say otherwise, USB 2.0 on Macs is generally too slow to be practical if you're making lots of changes to the 8- to 16-megabyte files of today's digital SLRs. If you can, use a compact external drive with an IEEE 1394 connection (also known as FireWire from Apple, i.Link from Sony). Reasonably priced 2.5" drives holding up to 500 GB are now widely available—and they weigh a lot less than that 200mm f/2.8 lens.

Put all the images on an internal drive, and Lightroom will enjoy relatively speedy read and write access. But sooner or later, the drive fills up and then you'll have to offload some of the images to an external drive.

If you can't bear traveling with an external drive for your laptop, consider creating "home" and "field" Lightroom catalogs. (For more information on how to do this, see "Merging Catalogs" on the next page.)

Some location photographers ditch the computer entirely and either carry a ton of memory cards or use a portable photo storage driver/viewer. Such viewers enable photographers to dump photos off their memory cards and use the tiny LCD screen to confirm that the photos transferred safely. Back home, they move the photos onto their computers, where they do their Lightroom work.

Merging Catalogs

Parts of the merge process are similar to what's done when exporting or importing a single catalog. But the full cycle of exportimport-reexport-reimport has a few key differences.

There are three situations in which you may need to combine, or merge, two Lightroom catalogs.

Perhaps you've exported a catalog off your desktop computer for use on your laptop, as explained on page 37. If while out in the field, you import new photos to the laptop or add metadata to that catalog, you'll need to merge those changes with your desktop's catalog when you return home. Note that in referring to desktop and laptop computers, I'm simply trying to distinguish between the *imported* and *exported* catalogs. Depending on your situation and setup, one catalog might be on the current (primary) computer and one on your other (secondary) computer.

Or maybe you have a smaller Lightroom catalog that resides on your laptop, which you want to combine with a larger master catalog on your desktop computer. By merging the two on your desktop, you can regain space on the laptop's hard drive (after, of course, making sure the master catalog now includes the laptop's shots).

Finally, you can use this same method to consolidate several catalogs scattered across multiple hard drives into a single larger catalog on your primary hard drive.

In all these situations, you begin by exporting the catalog from one computer so that it can then be imported into another catalog on a different computer.

To merge two catalogs:

- To move photos off the computer you are using, in Lightroom choose File > Export as Catalog.
- Use the dialog to name the exported catalog and choose where you want it exported (A). At the bottorn, be sure to select all three export check boxes, and then click Save. A progress bar tracks the export (B).
- **3.** When Lightroom sounds an alert after the export is finished, quit Lightroom and connect the laptop or memory card containing the exported catalog to your desktop computer.
- On your desktop computer, use Lightroom to choose File > Import from Catalog.
- 5. Navigate to the catalog exported from the laptop—the file name ends with .*lrcat*—and click Choose **(C**. A progress bar tracks the import.

xport as Cata	log		Contraction of	191054	and a second	12200	0.000	? >
Save in:	D Transfer_C	atalogs	~	0	1	0		
My Recent Documents	tulips							
My Documents								
Ø	File name:	tulipsv2			6	~	ſ	Save N
My Network	Save as type:	Supported Files			6	•	ĺ	Cancel
		Exporting a catalog with 10 ph						

(A) Name the exported catalog and choose where you want it exported.

B A progress bar tracks the export.

0.10	Import from Lightroom Catal	og
< > (1) (1) (1) (1) (1) (1) (1) (1) (1) (1)	tulipsv2	a search
DEVICES BlackMac Disk LUFIRE BlackMa300 MiniStack MiniStack MOJAVE-100 208THUMB 320Rugged PLACES	Name	Date Modified Today, 6:13 PM Today, 6:13 PM Today, 6:13 PM

C Navigate to the catalog exported from the laptop and click Choose.

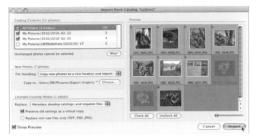

O Click Show Preview to see thumbnail images of the laptop computer's catalog and set how they'll be handled.

(3) Lightroom dims thumbhails that are identical in both catalogs.

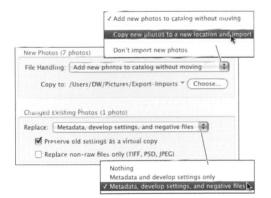

Use the File Handling and Replace drop-down menus to control the import of new and changed photos.

6. Click Show Preview to see an expanded version of the Import from Catalog dialog with thumbnail images of the laptop computer's catalog
Ontents check boxes to choose which images should be imported.

Lightroom compares those choices against its existing catalog and displays thumbnails based on the results (). Images identical to those already in the desktop catalog are dimmed. Undimmed images with an exclamation point tell you that the laptop and desktop versions do not match. In our example, that's because development adjustments were made to the laptop version. New images, which do not exist in the desktop catalog, also are undimmed but lack the exclamation point.

- Use the File Handling drop-down menu in the New Photos section to control whether new photos are moved to the desktop computer (). Choose one of the following:
 - Add new photos to catalog without moving: Leaves the new photo originals on the other computer and just imports their metadata into the current computer's catalog.
 - Copy new photos to a new location and import: Copies new photos onto your desktop computer and imports their metadata into the current computer's catalog. Click the Choose button in the New Photos section to set where new photos are stored on your desktop computer. Once this is finished, you can delete the originals on the other computer if you need to free up hard drive space.

continues on next page

- Don't import new photos: A less likely choice to use. Perhaps you're still tweaking the photos on the laptop and not ready to add them to the desktop computer. But you risk sowing more confusion for yourself whenever your catalogs don't match.
- 8. Use the Replace drop-down menu in the Changed Existing Photos section to control how Lightroom deals with different versions of photos found in the laptop and desktop catalogs. Choose one of the following:
 - ► Nothing: Imports only *new* photos from the other computer.
 - Metadata and develop settings only: Leaves the original photos (negative files) on the other computer. Useful for tracking originals that you deliberately store on offline hard drives. Below the drop-down menu, click "Preserve old settings as a virtual copy" to store the old and new settings in the desktop catalog.
 - Metadata, develop settings, and negative files: Use when you want to pull all the metadata and original photos (negative files) together. Below the drop-down menu, click "Preserve old settings as a virtual copy" to store the old and new settings in the desktop catalog. If you want to leave original raw files untouched, you also can click "Replace non-raw files only (TIFF, PSD, JPEG)."
- After double-checking your settings, click Import. The imported catalog's photos are added to your current computer's catalog G.

G The imported catalog's photos appear in your current catalog. Depending on your choices in step 8, virtual copies appear with turned corners next to the changed version.

(IIP) Lightroom cannot directly merge catalogs created with previous versions of the program. Instead, you must first upgrade the catalog to version 3. (See "To import catalogs from previous versions of Lightroom" on page 38.)

(III) In step 1, it's possible to use the Library module's Grid or Filmstrip to select only *some* of the laptop's photos for exporting. But you risk undermining the whole purpose of combining catalogs, which is to consolidate your photos into a single catalog rather than splinter them across different catalogs on different machines. Over the long run, I've found it less confusing to always export *all* the photos as a single catalog.

Switching Catalogs

By default Lightroom uses your most recent catalog as its default startup. That makes sense if you do most of your work in the same catalog. Many photographers, however, prefer to create smaller catalogs organized by subject or client. For those photographers, Lightroom makes it easy to switch from catalog to catalog as needed.

To switch to another catalog:

- From the Menu bar, choose File > Open Catalog (Ctrl-O/Cmd-O).
- 2. Use the dialog to navigate to the catalog you want to use and choose Open.
- **3.** Click Relaunch when asked by Lightroom. Lightroom closes the current catalog, restarts, and opens the catalog selected in step 2.

IP If you want to switch to a catalog you have used before, choose File > Open Recent and select it in the drop-down menu. If prompted, click Relaunch. Lightroom quits and restarts using the selected catalog.

Backing Up Catalogs

Since Lightroom catalogs contain only metadata, they back up very quickly usually in a few seconds. For that reason, I set the backup frequency for once a day. In a welcome change, backups now are made when you *quit* Lightroom instead of when you *start* it, making the process less of a hassle.

To set catalog backups:

- From the Menu bar, choose Edit > Catalog Settings (Windows) or Lightroom > Catalog Settings (Mac).
- Select the General tab and, in the Backup section, use the pop-up menu to choose "Every time Lightroom exits" O. Close the dialog. From now on, when quitting time comes, Lightroom backs up all the changes made in your just-finished work session.
- By default, Lightroom stores the backup on Windows machines at C:\Documents and Settings\username\My Documents\ My Pictures\Lightroom\Backups\. On a Mac, it's created in /User home/Pictures/ Lightroom/Backups/. To change it, click Choose ⁽³⁾.

) (Catalog Settings
	General File Handling Metadata
Information	
Location:	/Users/DW/Pictures/newLR3_catalogHere/newLR3_catalo
File Name:	newLR3_catalog.lrcat
Created:	2/18/10
Last Backup:	
Last Optimized:	
Size:	4.43 MB
and the second second	Never
Backup	Once a month, when exiting Lightrööm
Back up catalog 🗸	Once a week, when exiting Lightroom
	Once a day, when exiting Lightroom
	Every time Lightroom exits
	When Lightroom next exits

(A) In the Backup section, use the pop-up menu to choose "Every time Lightroom exits."

Back Up Catalog
atalog "newLR3_catalog" indicate it should be backed up each time it is closed This only backs up the catalog file, not the photos referenced by it.
/Users/DW/Pictures/newLR3ere/newLR3_catalog/Backups (Choose)
Skip this time Backup

B Click Choose to navigate to a backup hard drive that does not contain the catalog itself.

C Click Backup to start the process. When it's done, Lightroom quits.

Dupe Your Drives

As if all this talk of backups weren't enough, you also need to create a system for cloning the hard drives where your images are stored. No doubt you've heard the saying that it's not a matter of *if* your hard drive will die but *when*. Before your eyes glaze over, consider this:

In 20-plus years of computing, I had never had a hard drive die until this past winter. No little clicks or warning signs. One moment it was working; the next it wasn't. Fortunately, I'd cloned the drive that morning, something I do every day, so I was back in business in less than an hour,

On the Mac side, I swear by SuperDuper! (www.shirt-pocket.com/SuperDuper), which enables me to create a bootable clone of my main drive. Another favorite is Carbon Copy Cloner (www.bombich.com). There's no equivalent for Windows machines, so consider one of several services that enable you to store your Lightroorn catalogs and images on the Internet: Microsoft's Live Mesh (www.mesh.com), Dropbox (www.dropbox.com), or Backblaze (www.backblaze.com).

- Navigate to a different hard drive, create a folder dedicated for backup catalogs, and click Choose. When the Back Up Catalog dialog reappears, the Backup Folder file path reflects the changed location ^(C).
- 5. Click Backup to close the dialog and start the optimization process. Depending on the size of the catalog, it can take anywhere from a few seconds to several minutes. When it's done, Lightroom quits.

If you are traveling with a laptop and want to create backup catalogs somewhere other than your main drive, take along a small external drive or burn CDs/DVDs. You can pack both separately from your laptop. It's a bit of hassle, but if your laptop dies or is stolen, at least you'll still have your photos.

Putting It All Together

- In the Library module, select photos to export and click Export. Name the catalog and choose a drive as the export destination.
- Choose not to export the negative files and export the catalog.
- **3.** If you have photos in another catalog, connect your computer to the drive containing your previous catalog.
- **4.** Launch Lightroom on your computer and, from the Menu bar, choose Import from Catalog.
- **5.** Navigate to the file that contains that catalog. Select that catalog file and click Choose.
- In the Import from Catalog dialog, choose "Add new photos to catalog without moving." Click Import.
- Use Lightroom to export a catalog you want to merge with another catalog. When the export is done, quit Lightroom.
- Connect the secondary laptop or memory card containing the exported catalog to your main computer.
- Launch Lightroom on the main computer, choose File > Import from Catalog, and navigate to the exported catalog.
- **10.** Click Show Preview and select which images should be imported.
- In the File Handling menu, choose "Add new photos to catalog without moving."
- **12.** In the Replace drop-down menu, choose "Metadata and develop settings only."
- **13.** Double-check your settings and click Import.

The Library module is where you'll do most of your organizing and selecting of images. This chapter focuses on how to get around the Library efficiently. The following chapter, "Organizing and Reviewing Images," dives into picking, labeling, and otherwise identifyIng images you want to use for slides, prints, or the Web.

In This Chapter

Using the Toolbar	50
Setting Library Source	51
Setting the Library View	52
Grid and Loupe View Options	53
Setting Thumbnail Size	58
Setting Sort View	58
Rearranging Photos	59
Moving Through Photos	60
Selecting Images	62
Rotating Images	63
Putting It All Together	64

Using the Toolbar

Lightroom's toolbar, visible by default, runs across the bottom of the Library module's main window. If you're working on a laptop display, you may want to hide it sometimes to see more thumbnail images.

To turn off/on toolbar:

 From the Menu bar, choose View > Hide Toolbar. If the toolbar is hidden, choose View > Show Toolbar ().

or

 Press the T on your keyboard. If the toolbar is visible, it disappears; if it's hidden, it reappears.

To set toolbar choices:

 Make sure the toolbar is visible and click the triangle at the right end of the toolbar. Use the pop-up menu to show or hide a particular set of tools ⁽¹⁾. Repeat for each of the ten choices you want to show or hide.

While the toolbar can display up to 11 sets of items, to see them all you'd need a really wide monitor or you'd need to collapse the side panel workgroups. It's more practical to turn on just those you use regularly. My own working sets for the Library module: View Modes, Sorting, Flagging, and Thumbnail Size **G**.

The toolbar settings can be set differently for each module. So you could turn on the Slideshow set for the Slideshow module only.

To show or hide the toolbar, choose View > Show Toolbar/Hide Toolbar. Or press the T on your keyboard to toggle it on or off.

(B) Use the toolbar's pop-up menu to show or hide a particular tool set.

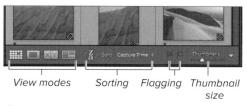

G It's more practical to turn on just the toolbar items you use regularly.

The Catalog panel gives you four choices: All Photographs, Quick Collection, Previous Import, or Previous Export as Catalog.

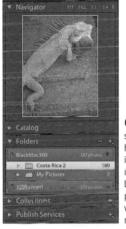

 The Folders panel shows all connected hard drives containing images you've already imported into the Library. Navigate to the particular folder you want displayed in the main window.

G The Collections in the first subfolder, Smart Collections, are generated automatically. Any collections you create manually are also listed.

Setting Library Source

What appears in the Library module's main window and the Filmstrip is controlled by which catalog, folder, or collection you select in the Left Panel Group. You can change the contents instantly by selecting another source among these three.

To set the Library module's photo source:

If the Left Panel Group is hidden, press Tab. In the panel group, do any of the following:

- Click the triangle on the left side of the Catalog panel to see a list of four catalogs: All Photographs, Quick Collection, Previous Import, or Previous Export as Catalog (a). Select one of the four, and the images in the main window and/or Filmstrip change to reflect your choice. (See "Creating and Using Collections" on page 121 for more information.)
- Click the triangle on the left side of the Folders panel to see a list of all connected hard drives containing images you've already imported into Lightroom's Library ⁽¹⁾. Use the triangles to navigate to a particular folder of photos to display them in the main window. The images in the main window and/or Filmstrip change to reflect your choice.
- Click the triangle on the left side of the Collections panel to see a list of all of Lightroom's collections. The collections listed in the first subfolder, Smart Collections, are generated automatically. Collections you've created manually are also listed. Make a selection and the images in the main window and/or Filmstrip change to reflect your choice C. (See "Creating and Using Collections" on page 121.)

Setting the Library View

The Library module offers four basic views, each of which can be tweaked with plenty of options. The Grid view works well for getting an overview of your images. The Loupe view helps you take a closer look at a single image. Use Compare view to spot the differences between a pair of images, while the Survey view lets you inspect several images at once. (For more information on using the Compare and Survey views to winnow images, see page 52.)

To switch to Grid view:

 If the toolbar is visible, click the button on the far left.

or

- Press the G on your keyboard. or
- From the Menu bar, choose View > Grid.

To switch to Loupe view:

 If the toolbar is visible, click the button on the far left.

or

Press the E on your keyboard (think E for Expanded).

or

 From the Menu bar, choose View > Loupe.

To switch to Compare view:

 If the toolbar is visible, click the button on the far left.

or

- Press the C on your keyboard.
 or
- From the Menu bar, choose View > Compare.

To switch to Survey view:

If the toolbar is visible, click the solution on the far left.

or

- Press the N on your keyboard. or
- From the Menu bar, choose View > Survey.

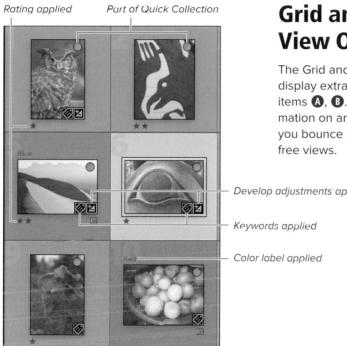

Grid and Loupe View Options

The Grid and Loupe views enable you to display extra information for 31 different items (A), (B). It's easy to toggle this information on and off as you need it, letting you bounce between detailed and clutter-

Develop adjustments applied

A Just some of the Grid view's extra information options.

Click to add/remove flag

Click to rotate left/right

B To minimize visual clutter, another Grid view option enables you to display clickable buttons, such as rotate left/right, only when you roll over the image.

To set Grid view options:

1. In the Library module, from the Menu bar choose View > View Options.

or

Press Ctrl-J/Cmd-J.

ΰľ

Right-click (Control-click on singlebutton Macs) any image and choose View Options in the pop-up menu **G**.

 When the Library View Options dialog appears, click the Grid View tab D. Select the Show Grid Extras check box and then set the remaining check boxes and drop-down menus. (For more information, see the "Grid View Options" sidebar on the next page.)

(IIP) You can control what information appears in the Filmstrip by right-clicking (Control-clicking on single-button Macs) a thumbnail. Choose View Options and make a choice in the pop-up menu **(B**).

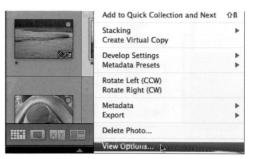

(To set Grid view options, right-click (Controlclick on single-button Macs) any image and choose View Options.

90	Library View	Options	
	Grid View Lo	oupe View	1
Show Grid Extras:	Compact Cells		÷
Options			
Show clickable its Tint grid cells wit Show image info		anly	
Cell Icons			
Pags	E	Unsaved Metadata	
Thumbnail Badge	s 🗹	Quick Collection Markers	
Compact Cell Extras			
Index Number	Top Label:	Cropped Dimensions	\$
Rotation	Bottom Label:	Rating	Ð
Expanded Cell Extra	s		
Show Header with	h Labels:	Use De	faults
File Name		Caption	-
Label		File Extension	-
Show Rating Fool	ter		
🗹 include C	olor Label		
	otation Buttons		

() In the Grid View tab of the Library View Options dialog, select the Show Grid Extras check box and then set the remaining check boxes and drop-down menus.

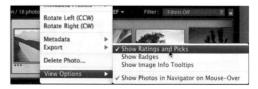

 To control what information appears in the Filmstrip, right-click (Control-click on single-button Macs) a thumbnail. Choose View Options and make a choice in the pop-up menu.

Grid View Options

Show Grid Extras is turned on by default; deselect it if you want to hide the extra information. Use the drop-down menu to choose Compact Cells or Expanded Cells. Then set the remaining check boxes and drop-down menus D:

Options: Select which of the three options you want to appear. If you deselect "Show clickable items on mouse over only," the rotate and flag buttons appear on all the thumbnails. "Show image info tooltips" helps you learn Lightroom's many interface items.

Cell Icons: See (A) to understand how the first three icons are used. The last, Unsaved Metadata, alerts you when edits have been made to an image but have not been saved back to the *original* image.

Compact Cell Extras: The Index Number is not applied to the actual photo; its display simply gives you a relative sense of where you are in a large group of photos. The Rotation buttons make it easy to correct a photo without traveling down to the toolbar. Use the Top Label and Bottom Label drop-down menus to choose from 31 information items that can be displayed **()**. I prefer to apply such labels in the Loupe view to keep the thumbnails less cluttered.

Expanded Cell Extras: These choices allow each thumbnail to display up to six extra items of information. The drop-down menus offer the same 31 choices found in the Compact Cell Extras drop-down menus. All that extra information, however, means that you cannot squeeze as many thumbnails into Lightroom's main window **G**, **H**. However, you can always press the J key to cycle from compact to expanded cells.

	File Base Name File Extension
	Copy Name
	Folder
	Common Attributes
	Rating
1	Label
	Rating and Label
	Capture Date/Time
	Cropped Dimensions
	Megapixels
	Caption
	Copyright
	Title
	Location
	Creator
	Common Photo Settings
	Exposure and ISO
	Exposure
	Lens Setting
	ISO Speed Rating
	Focal Length
	Exposure Time
	F-Stop
	Exposure Bias
	Exposure Program
	Metering Mode
	Camera
	Camera Model
	Camera Serial Number

The Grid view dropdown menus offer 31 different information items you can display.

G The Compact Cell view option shows only minimal information extras—but lets you squeeze more thumbnails into a given view.

(b) The Expanded Cell view option offers lots of information extras, at the cost of showing fewer thumbnails in a given view.

To set Loupe view options:

- 1. In the Library module, from the Menu bar choose View > View Options.
- When the Library View Options dialog appears, click the Loupe View tab ①.
 Select the Show Info Overlay check box and then set the remaining check boxes and drop-down menus. (For more information, see the "Loupe View Options" sidebar on the next page.)

Show Info Ove	erlay: Info 1		
	anay: Ento 1		
Loupe Info 1			
	File Name	~	Lize Defaults
	Capture Date/Time	~	
	Cropped Dimensions	~	
	Show briefly when photo d	langes	
Loupe Into 2			
coope and a	File Name Exposure and ISO	>	Use Defaults
Lucyc and a		> > >	Use Defaults
coope and a	Exposure and ISO	v v v hanges	Use Defaults
General	Exposure and ISO Lens Setting	v v hanges	Use Defaults
coope and a		×	Use Defaults

() In the Loupe View tab, select the Show Info Overlay check box and then set the remaining check boxes and drop-down menus.

Loupe View Options

You can cycle through the Loupe view options—show Info 1, show Info 2, hide all extra information—by pressing the I key.

Show Info Overlay is turned on by default; deselect it if you want to hide the extra information. Use the drop-down menu to choose Info 1 or Info 2. Then set the remaining check boxes and drop-down menus **①**:

Loupe Info 1: Each of the three drop-down menus offers the same 31 information choices as in the Grid view options (). I find it useful to display exposure information in this group ().

Loupe Info 2: As with Loupe Info 1, the drop-down menus offer 31 information choices (1). I find it useful to display caption/name information in this group (1).

General: Depending on the speed of your machine and the size of the preview being generated, Lightroom sometimes takes several seconds to display the Loupe view. If you click the check box here, Lightroom handily tells you that it's working on the preview instead of just showing a blank window **(**).

	000	Library View Optio	ns	
3/21/08 8:30:03 AM	CONTRACTOR OF	Grid View Loupe View		
^{1/} ₃₂₀ sec at <i>f</i> / 11, ISO 200	Show Info Overla	y: (Info 1		
and the second se		Capture Date/Time	Use Defaults	
		Exposure and ISO		
		None	- ID)	
	and present the state of	Show briefly when photo changes		
and the second s	Loope Info 2	www.co.co.co.co.co.co.co.co.co.co.co.co.co.	were an an and and a second	
	10 August and a second	Caption	Use Defauits	
In man		litle	- (a)	
The second	Sector and the sector of the	None		
		Show briefly when photo	changes	
	General			
	Show message	when loading or randering p	hotos	

K Here the Info 1 choice displays exposure-related information.

	D Library View Options
Kelso Dunes at dawn	Grid View Image View
Wildflower Ramble	M Show Info Overlay: Info 2
	Capture Date/Time
and the second	Exposure and ISO
	None
	Show briefly when photo changes
	Loupe Info 2
	Caption Use Defaults
and the second sec	Title
	None
	Show briefly when photo changes
	General
	Show message when loading or rendering photos

Here the Info 2 choice displays caption/name information.

Each of the Loupe view's three drop-down menus offers the same 31 information choices as in the Grid view options.

Setting Thumbnail Size

Depending on what you're doing, you can fine-tune the size of the thumbnails to suit the task. For example, to quickly find all your obvious duds—lens cap on, flash failed to fire, and so on—you might zoom out to look over as many Irriages as possible. To get a better sense of your best shots, you'd want to zoom in enough to actually see some details of the images.

To set thumbnail size:

 If the toolbar is visible, drag the Thumbnails slider to change the size of the images.

or

 Press the – (minus) or + (plus) key to zoom out or zoom in on the thumbnails. (On the Mac, press Ctrl with the – [minus] or + [plus] key.)

Setting Sort View

Lightroom offers 12 ways to sort your view of images in the Library module. Since it's easy to switch from one to another, you can pick the sort view that works best for a particular task. When you first review a batch of newly imported images, for example, sorting by reverse order of capture time puts the most recent images at the top where you can see them immediately.

To set sorting:

 Click the Sort pop-up menu to pick the type of sort applied to the main window A. Click the a-z button just left of the Sort menu to set the sort order (descending or ascending).

Click the Sort pop-up menu to pick the type of sort applied to the main window.

Orag a photo to another spot in the Grid. The thin vertical line between the existing images becomes bold black, marking the selected photo's destination.

B Release the cursor and the selected photo moves to its new spot in the Grid.

(A stack of mini-thumbnails signals that you are moving more than one image.

Rearranging Photos

If you are working within a collection, you can easily rearrange photos in the Grid view if that makes it easier to compare or organize them. The shuffling doesn't change the photos, just your view of them. (For more information on collections, see 121.)

To rearrange photos:

- 1. Click to select a photo you want to move. Its surrounding frame lightens.
- Click again in the center of the photo and drag it to another spot in the grid. The thin vertical line between the existing images becomes a bolder black, marking the selected photo's destination. A mini-thumbnail of the selected image also appears (A).
- 3. Release the cursor and the selected photo moves to its new spot in the Grid ^(B).

(IP) You also can select multiple images and drag them to a new place in the grid. A stack of mini-thumbnails signals that you've selected more than one image **(G)**. The selected images do not need to be next to each other, though they will be once moved **(D)**.

D The selected images, which may not have been next to each other before the move, are grouped together afterward.

Moving Through Photos

Lightroom offers several ways to move among the images in the Library's main window: forward or back one image at a time, from screen to screen, or to the top or bottom of the window.

To move from photo to photo:

In any view (Grid, Loupe, Compare, or Survey), do one of the following:

- Press the keyboard's left/right arrow keys to move back or forward one photo at a time.
- If Navigate is turned on in the toolbar drop-down menu, use the previous or next buttons to move to another image ().

(IIP) In the Grid view, you also can press the up/down arrow keys to move to the image above or below the current image.

When working in the Loupe view, you can keep a sense of your place in the image sequence by turning on the Filmstrip (Shift-Tab, then Tab again to hide the side panels) ③.

If the Navigate buttons are turned on in the toolbar, you can use them to move to another image.

() When working in the Loupe view, the Filmstrip helps you keep a sense of where you are in the overall image sequence.

To move from screen to screen:

 In the Grid or Loupe view, press the Page Up/Page Down keys. The Library's main window changes to display a new screen of images (in Grid) or a new single image (in Loupe).

or

Scroll through the Filmstrip to find another image, click its thumbnail, and the Library's main window displays that selection.

To move to top or bottom of the Grid:

 In the Grid view only, you can jump to the top of the thumbnails by pressing the Home key. Or move to the very bottom of the thumbnails by pressing the End key.

Selecting Images

Lightroom offers several ways to select one image, a group of adjacent images, or multiple images not next to each other. Once selected, you can apply the same action to all those images.

To select an image:

 In the Grid view, roll the cursor over an image you want to select, and click. The image is selected, as indicated by its surrounding frame becoming lighter than the other images ().

To select multiple images:

- 1. Click the first image you want to select in the Grid view.
- Press and hold Ctrl (Windows) or Cmd (Mac) while clicking each of the other images you want to select. The surrounding frame of each selected image lightens ^(B).

or

If all the images you want are in a row, press Shift and click the last image in the group. The surrounding frames lighten for all the images between the first and last clicked images **()**.

(IP) When you select multiple images, the surrounding frame for the one selected *first* is brighter than the rest **()**.

(IIP) To select all the images in the Grid, press Ctrl-A/Cmd-A. The surrounding frames for all the images lighten, indicating that they are selected.

(IP) To deselect an image in the Grid, press the / key. If multiple images are selected, they are deselected one at a time as you continue pressing the / key.

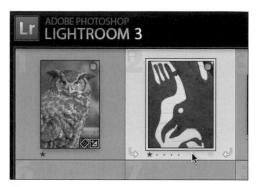

A The frame of a selected image is lighter than those of the other images.

To select multiple images, press and hold Ctrl (Windows) or Cmd (Mac) while clicking the other images you want.

() If all the images you want are in a row, just press Shift and click the last image in the group to select them all.

(A) To rotate an image, click one of the two arrows at the bottom corners.

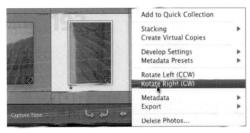

 You also can rotate selected Images by rightclicking them (Control-clicking on single-button Macs) and choosing Rotate Left or Rotate Right.

(If the two rotate arrows are turned on in your toolbar, click the one you need.

Rotating Images

Most digital cameras now do this automatically, but manually rotating images may still be necessary, especially with scanned images. While rotating images arguably belongs in the "Developing Images" chapter, you're more likely to notice unrotated images at this stage, so I've put it here.

To rotate an image:

Select the image(s) you want to rotate in the same direction and do any of the following:

- Roll the cursor over any of the selected images and click one of the two arrows at the bottom corners to rotate the image clockwise or counterclockwise. The images rotate in the selected direction ().
- Right-click (Control-click on singlebutton Macs) any of the selected images and choose Rotate Left or Rotate Right from the drop down menu (). The images rotate in the selected direction.
- If the two rotate arrows are turned on in your toolbar, click the one you need **(**. The images rotate in the selected direction.

IP It the rotate arrows are not visible in the Grid view, you can turn them on using the Grid view options. (See "To set Grid view options" on page 54.)

(IIP) To deselect an image you've selected in the Grid view, press the / key. If multiple images are selected, they are deselected one at a time as you continue pressing the / key.

Putting It All Together

- 1. Turn on the toolbar and use the pop-up menu to show or hide a particular set of tools.
- 2. Set a Library source and switch its view to each of the four options: Grid, Loupe, Compare, and Survey.
- **3.** Change the view options for each of those four views.
- **4.** Change the thumbnail size using the slider, and then change it using the keyboard.
- Change the Library view sorting order, and then reverse that order using the a-z button.
- **6.** Rearrange the photo order using the click-and-drag method.
- In any Library view, use the keyboard to move forward and backward one photo at a time.
- In any view, use the keyboard to move through the photos screen by screen. Try the same thing using the Filmstrip.
- **9.** In the Library's Grid view, use the keyboard to jump to the top and bottom of the thumbnails.
- 10. In the Grid view, select several photos sitting next to each other. Again in Grid view, select several photos scattered throughout the grid of thumbnails.
- **11.** Select and rotate an image using the toolbar, and then using the drop-down menu.

Organizing and Reviewing Images

You'll do most of your organizing and reviewing of images in the Library module. Along with the catalog database discussed in Chapter 3, the Library module is what gives Lightroom an edge over its more well-known cousin, Photoshop. Both give you vast photographic powers, but Lightroom's Library module offers the most efficient way to pick, label, rate, and otherwise identify individual photos amid the incoming digital flood.

It's tempting to jump ahcad to the Develop module and immediately start fixing and tweaking the exposures of your photos. After all, it can be a bit of a slog combing through your images, comparing one against another, and making the judgments about which ones to keep and which to reject. But the time spent offers a hidden bonus: Deleting poor images (explained on page 88) will leave you with far fewer—and much better—images once you finally turn to adjusting their exposures.

In This Chapter

Dimming the Lights	66
Stacking Photos	68
Flagging Photos	73
Using Ratings and Labels	77
Using the Compare and Survey VIews	83
Removing or Deleting Photos	88
Putting It All Together	90

Dimming the Lights

Lightroom's "lights out" feature lets you dim or hide every part of the program's interface except the photos. This can be very helpful when you need to concentrate on your photos—and their sometimes subtle differences.

To dim or turn off the lights:

- Select the photos on which you want to concentrate (A). In any module:
 - In the Menu bar, choose Window > Lights Out and Lights Dim or Lights Off.

or

- Press the L on your keyboard once (to dim) or twice (to turn lights off).
- Depending on your choice, the surrounding Lightroom interface dims by 80 percent ^(B) or darkens completely ^(C).

To jump directly from lights on to lights dimmed without having to cycle through all three settings, press Shift-Ctrl-L/Shift-Cmd-L. Repeat to jump directly back to lights on.

Select the photos you want to focus on once the lights are dimmed.

(B) By default, the lights dimmed choice darkens the Lightroom interface by 80 percent. You can adjust the amount of dimming.

C The lights-out choice hides every bit of Lightroom except the selected photos.

			Pre	ference	es			
	General	Presets	External	Editing	File Han	dling	Interface)
Pane	is							
	End Marks:	Flourish	(default)		Font Size:	Small	l (default)	\$
Light	ts Out							
S	creen Color:	Black (de	fault)	•	Dim Level:	80% ((default)	4

(D) Use the Dim Level drop-down menu to adjust the dimming effect by 50 to 90 percent. Screen Color choices range from pure black to pure white.

To cycle through the lights settings:

 In any module, press the L on your keyboard up to three times to go from lights on to lights dimmed to lights off, and back to lights on.

To change the lights setting:

- In any module, press Ctrl-, /Cmd-, (comma) and click the Interface tab in the Preferences dialog.
- In the Lights Out panel, use the Dim Level drop-down menu to set the dimming effect between 50 and 90 percent (the default is 80 percent) **●**.
- In the same panel, the Screen Color drop-down menu lets you choose among several colors other than black (including white, simulating photos on a blank page), if you find that default not to your liking.
- **4.** To apply the settings and close the dialog, click OK.

Stacking Photos

Lightroom's stacking feature lets you gather a bunch of similar images and "stack" them, much as you might bunch up slides on an old light table to concentrate on the remaining photos. You can even automatically stack photos, which is particularly useful for tidying up contiguous, same-subject photos, such as bursts of motor-drive shots, panorama sequences, or bracketed high dynamic range (HDR) exposures.

To stack/unstack photos:

- 1. In the Filmstrip or Grid view, select the photos you want to stack (A).
- Right-click (Control-click on singlebutton Macs) one of the selected images and, in the pop-up menu, choose Stacking > Group into Stack ^(B). The selected photos are rearranged as one photo with a small number showing how many photos the stack contains ^(C).
- To unstack a group of photos, right-click (Control-click on single-button Macs) the number atop the stack and choose Unstack in the pop-up menu D. The stack disappears, replaced by all the photos previously in the stack.

(IIP) Don't confuse unstacking a stack with expanding it. Unstacking dismantles the stack, while expanding simply reveals all the photos contained in the stack.

(III) You cannot create a stack while working within a collection, only by selecting All Photographs in the Catalog panel or by selecting a hard drive or folder in the Folders panel. If you try to stack images while working inside a collection, the Stacking option does not appear when you right-click (Control-click on single-button Macs) the images.

A Select the photos you want to stack.

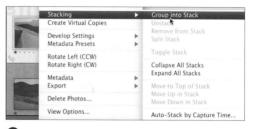

B Right-click (Control-click on single-button Macs) the selected images and choose Stacking > Group into Stack.

O To unstack a group, right-click (Control-click on single-button Macs) the number atop the stack and choose Unstack.

() To expand a stack, click the bar on either side of the top photo.

() To collapse a stack, click the bar on the left side of the first photo.

(In the Grid view, click on the photo you want to add to the stack.

(I) Drag and drop the photo on the stack and a thick, black border appears.

When photos are stacked, any changes made to the selected stack are applied only to the top photo. Expand the stack before applying ratings, flags, labels, or development adjustments.

To expand/collapse a stack:

- In the Grid view, a stack is marked not only by a small number in the upper-left corner but also by vertical bars down each side of the top photo ⁽¹⁾. Press the S on your keyboard or click the bar on either side of the photo. The stack expands, with each photo in the stack showing a slightly darker background than other photos in the grid.
- After you're done looking at the individual photos, press the S on your keyboard or click the vertical bar to the left of the stack's first image or to the right of the stack's last photo to collapse the stack ①. The stack collapses down to a single photo.

To add a photo to a stack:

In the Grid view, click on the photo you want to add to the stack G. Drag and drop it on the stack and a thick, black border appears (1). Release the cursor and the photo is added to the stack, reflected by the updated small number in the stack's upper-left corner (1).

() Release the cursor and the photo is added to the stack, updating the small number in the stack's upper-left corner.

To remove a photo from a stack:

 In the Grid view, expand the stack and find the photo you no longer want included in the stack. Right-click (Control-click on single-button Macs) the small number in the photo's upper left and, in the pop-up menu, choose Remove from Stack ①. The photo is no longer included in the stack of related images.

(IIP) Don't confuse Remove from Stack with Unstack. The former plucks a single photo from the stack; the latter dismantles the entire stack.

To change a stack's top photo:

 By default, a collapsed stack displays the first photo in the sequence. To use another photo in the stack, expand the stack, right-click (Control-click on singlebutton Macs) the small number in the photo's upper left, and in the pop-up menu, choose Move to Top of Stack (). That photo becomes the stack's cover photo.

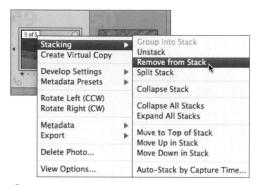

• Right-click (Control-click on single-button Macs) the upper-left number of the photo and choose Remove from Stack.

3 of	Stacking Create Virtual Copy	Þ	Group into Stack Unstack Remove from Stack
	Develop Settings		Split Stack
S	Metadata Presets	•	Collapse Stack
	Rotate Left (CCW) Rotate Right (CW)		Collapse All Stacks Expand All Stacks
	Metadata Export	* *	Move to Top of Stack Move Up in Stack
	Delete Photo		Move Down in Stack
	View Options		Auto-Stack by Capture Time

Kight-click (Control-click on single-button Macs) the upper-left number of the photo and choose Move to Top of Stack.

• Select the photos you want to auto-stack. If you want, you can select entire folders using the Folders panel.

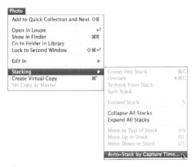

Choose Photo > Stacking > Auto-Stack by Capture Time.

	Company of Company of Company
Time Batween Etaelis:	0.20.00
More Stacks	Fewer Stacks
18 stacks, 6 unstacked	(Cancel) Stack

Set the Time Between Stacks slider anywhere between 0 seconds and 1 hour. Adjust the time based on the stack count in the lower left and click Stack.

To auto-stack photos by capture time:

- Select the photos you want to stack. You can stack an entire folder, a single photo session, or the results of a photo search ①.
- From the Menu bar, choose Photo > Stacking > Auto-Stack by Capture Time .
- Set the Time Between Stacks slider anywhere between 0 seconds (the far right) and 1 hour (the far left) . The number of stacks (and unstacked photos) based on the setting appears in the lower left of the dialog. Adjust if necessary, and click Stack.
- 4. In the Grid view, all the photos remain expanded (unstacked), but their borders have changed to indicate whether they belong to a stack ①. Light-bordered photos are *not* part of any stack; dark-bordered ones are part of a stack. The beginning of each stack shows a small number for how many photos belong to that stack. Roll the cursor over any dark-bordered photo and you'll see a number for its position in the stack sequence ①.

continues on next page

• The photos remain unstacked, but those with dark borders now belong to a stack.

P Roll the cursor over any dark-bordered photo to see its position number within the stack.

5. To collapse a particular stack, double-click the small number of the first photo in the stack (**Q**). The stack collapses. To re-expand it, double-click the first photo again (**R**).

or

To collapse all the stacks, right-click (Control-click on single-button Macs) the small number in the upper left of any photo and choose Collapse All Stacks in the pop-up menu **S**. All the selected photos collapse into their respective stacks **①**. To re-expand all the stacks, right-click (Control-click on single-button Macs) the upper left of any stacked photo and choose Expand All Stacks in the pop-up menu.

(IIP) How long an interval you choose when defining your stacks depends on the subject. For a sports event, you might pick an interval of a few seconds. For landscapes, it might be an hour, the maximum amount.

(IIP) Step 5's Collapse All Stacks command offers a quick way to clean up your Grid view, and then you can expand a single stack for review.

(IIP) All the stacking commands also can be found by choosing Photo > Stacking and making a choice in the drop-down menu.

() To collapse a particular stack, double-click the small number of the first photo in the stack.

(B To re-expand a stack, double-click the first photo again.

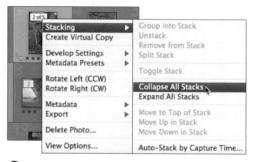

() To collapse all the stacks, right-click (Controlclick on single-button Macs) the number in the upper left of any photo and choose Collapse All Stacks.

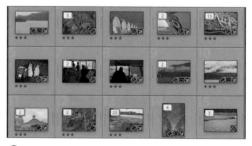

() With all stacks collapsed, the numbers tell how many photos each stack contains.

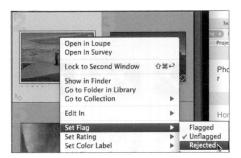

To mark rejects, right-click (Control-click on single-button Macs) a photo and choose Set Flag > Rejected.

(b) In the Grid view, you can click the upper-left corner of a selected image and choose Rejected.

(In the Compare view, click the black flag at the bottom left of the photo you want to mark as rejected.

D In the Grid view, if the flagging option is active, you can click the black flag in the toolbar.

Flagging Photos

Flagging your photos as soon as you import them lets you quickly mark poor-quality photos as rejects (a black flag) and nicer ones as picks (a white flag). Whether you start by marking your rejects or your picks is up to you. I find the process goes faster marking the rejects first. I hold off deleting photos until after a complete review.

To mark rejects:

- In the Filmstrip or any of the four view modes (Grid, Loupe, Survey, or Compare), select one or more photos you want to mark as rejected. Then, depending on your view and toolbar settings, do one of the following:
 - Right-click (Control-click on singlebutton Macs) a photo and in the pop-up menu, choose Set Flag > Rejected ().
 - Press the X on your keyboard.
 - If you're in the Grid view, click the upper-left corner of one of the selected images and choose Rejected in the pop-up menu (B).
 - If you're in the Compare view, click the black flag at the bottom left of the photo you want to mark as rejected **G**.
 - In the Grid view, if the flagging option is active, click the black flag In the toolbar **D**.
- The rejected photo(s) are marked with a black flag and, in the Filmstrip and Grid view, dimmed compared to unrejected photos.

(IIP) If you're looking for a quick way to mark rejects, use the Painter tool or the keyboard's X key in tandem with the forward arrow key. (For more on the Painter tool, see page 75.)

To mark picks:

- In the Filmstrip or any of the four view modes (Grid, Loupe, Survey, or Compare), select one or more photos you want to mark as flagged. Then, depending on your view and toolbar settings, do one of the following:
 - Right-click (Control-click on singlebutton Macs) and in the pop-up menu, choose Set Flag > Flagged.
 - Press the P on your keyboard.
 - If you're in the Grid view, click the upper-left corner of one of the selected images and select Flagged in the pop-up menu.
 - If you're in the Compare view, click the white flag at the bottom left of the photo ①.
 - In the Grid view, if the flagging option is active, you can click the white flag in the toolbar.
- 2. The white flag appears by the picked photo(s) **G**.

(IIP) A quick way to mark picks is to use the Painter tool, or alternate between pressing the keyboard's P key and forward arrow key. (For more information on using the Painter tool, see the next page.)

(IP) Any time after marking your picks, you can quickly gather them up by choosing Edit > Select Flagged Photos from the Menu bar. It's then easy to create a Quick Collection or custom collection. (For more information, see "Creating and Using Collections" on page 000.)

In the Compare view, click the white flag at the bottom left of the photo you want to mark as picked.

(6) White flags mark your picks; black flags mark your rejects, which also are dimmed.

(1) To mark photos using the Painter tool, click the triangle at the far right of the toolbar and choose Painter.

() Click the spray can in the toolbar to activate the Painter tool.

O Click the Paint pop-up menu that appears and choose Flag.

(Use the second Paint pop-up menu to choose whether you want to mark photos as Flagged, Unflagged, or Rejected.

To mark photos using the Painter tool:

- Turn on the toolbar (View > Show Toolbar or press the T on your keyboard).
- Click the triangle at the far right of the toolbar and choose Painter in the popup menu ().
- **3.** Click the Painter tool (the spray can) in the toolbar **1**.
- Click the Paint pop-up menu that appears and choose Flag ①. Click the second Paint pop-up menu that now appears and make a choice based on whether you want to mark photos as Flagged, Unflagged, or Rejected ③.

continues on next page

- In the main window, find a photo you want to mark, position your cursor (now a little spray can) over it (left, ①). Click once. The photo dims, the cursor changes from a spray can to an eraser, and a flag appears in the photo's upper left (right, ①).
- 6. To mark another photo, repeat steps 4 and 5. Or, to quickly mark multiple photos, click once and drag the cursor over those photos . .

(III) To unmark a photo, make sure the Painter tool is selected in the toolbar. Move the cursor over the photo, press Alt/Option, and it becomes an eraser. Click once to unmark a single photo or click and hold, and then drag to unmark multiple photos. A Remove Flag note confirms your action, and the dimming effect disappears **()**.

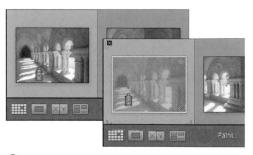

Position the spray can over a photo and click once (left). The photo dims, the cursor changes to an eraser, and a flag appears in the photo's upper left (right).

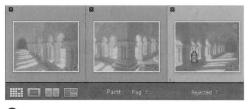

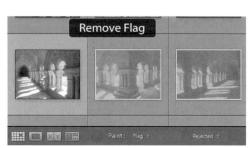

To unmark a photo, move the cursor over the photo, and press Alt/Option. When it becomes an eraser, click once. A note confirms your action, and the photo is no longer dimmed.

To mark several photos, click and drag the cursor over them.

Using Ratings and Labels

There is no right or wrong way to use Lightroom's ratings and color labels. Some photographers use ratings a lot, others hardly at all. Some love the color labels. while others can't stand them. When reviewing photos, I'm quite conservative in awarding four or five stars to photos. That leaves me some leeway later for marking truly standout photos. It's much easier to upgrade a few lhree-star photos to five stars than to go back and revise downward all your overrated photos. I use the color labels to designate temporary categories for photos, such as applying purple to images that still need a lot of development work. As I tweak photos, I shift the color labels upward until I finally apply red to photos ready to post on the Web or print. That's one approach. Other photographers use collections (explained in the next chapter) to track their workflow. It may take some experimenting to discover how you best like to work.

To turn on ratings or labels in the Grid view, see "Grid and Loupe View Options" on page 53. To use ratings or labels to find particular photos, see "Using the Library Filter" on page 108.

To apply ratings:

- In the Filmstrip or any of the four view modes (Grid, Loupe, Survey, or Compare), select one or more photos to which you want to apply the same rating. Then, depending on your view and toolbar settings, do one of the following:
 - Press the 1 through 5 keys.
 - Right-click (Control-click on singlebutton Macs) and in the pop-up menu, choose Set Rating and the number of stars you want applied (A).
 - If the ratings option in the Library module's toolbar is active, click the appropriate star in the toolbar ^(B).
 - If you're in the Grid or Compare view, click one of the five dots below any selected image. (The first dot corresponds to one star, the second to two stars, and so on.)
 - Select the spray can button in the toolbar, set the rating and apply to one or more photos. (For more information on using the Painter tool, see "To mark photos using the Painter tool" on page 75.)
- 2. The corresponding star rating is applied.

ID In any view mode, to remove ratings from the selected photos, press the 0 (zero) key. Or press any star twice to toggle off all the stars.

If you're in the Survey view, the rating is not applied to all the selected photos. Instead, it's applied only to the photo you click directly. This allows you to apply different ratings within the selected photos **G**.

To apply ratings, you can right-click (Controlclick on single-button Macs) a photo, then choose Set Rating and the number of stars you want applied.

(B) If the toolbar's ratings option is active, select the photo(s) and click the appropriate star.

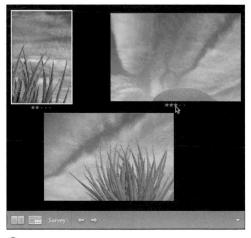

(In the Survey view, ratings are applied only to the photo you click directly.

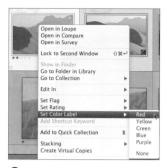

D To apply color labels, rightclick (Control-click on singlebutton Macs) a photo and choose Set Color Label and the label you want used.

() In the Grid or Compare view, If the small gray square appears at the bottom right of the selected image, you can click it and select a label.

If the toolbar's label option is active, select the photo(s) and click the appropriate color.

To apply color labels:

- In the Filmstrip or any of the four view modes (Grid, Loupe, Survey, or Compare), select one or more photos to which you want to apply the same label. Then, depending on your view and toolbar settings, do one of the following:
 - Press the 6 through 9 keys, which correspond with the red through blue labels. (Oddly, there is no key for the fifth label, purple.)
 - Right-click (Control-click on singlebutton Macs) and choose Set Color Label and the label you want applied in the pop-up menu D.
 - If you're in the Grid or Compare view, click the gray square at the bottomright corner of one of the selected images and select a label in the pop-up menu (). The gray square appears only if you've set the Grid view options to include Rating and Label. (For more information, see "To set Grid view options" on page 54.)
 - If the label option for the toolbar is active, click the appropriate label in the toolbar ⁽⁶⁾.
 - Select the spray can button in the toolbar, set the color label, and apply the label to one or more photos. (For more information on using the Painter tool, see "To mark photos using the Painter tool" on page 75.)
- 2. The color label is applied.

To use the Review Status label set:

Besides the Default label set, Lightroom includes a second label set that you can use to mark a photo's review status. To switch, choose Metadata > Color Label Set > Review Status G. This label set now is available whenever you right-click (Control-click on single-button Macs) a photo and choose Set Color Label 1. To switch back to the default set, which just uses the names of colors, choose Metadata > Color Label Set > Lightroom Default.

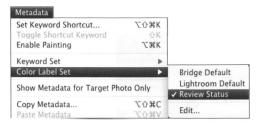

(G Choose Metadata > Color Label Set > Review Status to switch to Lightroom's second built-in label set.

	Open in Loupe Open in Survey		
	Lock to Second Window 🏵	₩↔	
Les	Show in Finder Go to Folder in Library Go to Collection	•	
Mojave Sprin		•	
	Set Flag Set Rating	* *	
2	Set Color Label Add Shortcut Keyword	•	To Delete Color Correction Needed
	Add to Quick Collection	В	Good to Use Retouching Needed
S ★ · MojaveSprin	. Stacking Create Virtual Copy	Þ	To Print None

(1) After switching, a new set of label choices appears when you right-click (Control-click on single-button Macs) a photo and choose Set Color Label.

Set Keyword Shortcut Toggle Shortcut Keyword	て合第K 公K	
Enable Painting	∕Z₩K	
Keyword Set	•	
Color Label Set		Bridge Default
Show Metadata for Target Ph	oto Only	Lightroom Default ✓ Review Status
Copy Metadata	℃☆೫C	
Paste Metadata	V#OT	Edit 📐

To create a new label set, choose Metadata > Color Label Set > Edit.

Red		6	
Yellow		Edit Color Label	Set
Green	Preset: Lightroo	m Default (edited	- Train adamstration
Purple	Print Ready		6
fyou wish t	Web-Slide Re	ady	7
ame names	ОК		8
	Minor Fixes N	leeded	9
State of the state of the	Major Fixes N	leeded	

Choose Default in the Preset drop-down menu and type new text for each label.

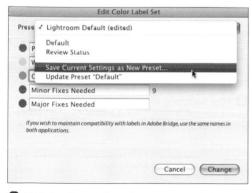

(Click the Preset drop-down menu and choose Save Current Settings as New Preset.

To create a new label set:

- While in the Library module, from the Menu bar choose Metadata > Color Label Set > Edit 1.
- In the Editor Color Label Set dialog, choose Default in the Preset drop-down menu (top, 1).
- Type in the new text you want to use instead of the existing label text. Repeat for each label you want to change (bottom, ①).
- Do not click the Change button. Instead, click the Preset drop-down menu at the top and choose Save Current Settings as New Preset ().

continues on next page

- **3.** To adjust your view of the photos, do one of the following:
 - Click the toolbar's button to switch it to the unlocked position. Click to select the first photo you want to adjust, and use the Zoom slider to adjust your view . If necessary, click the other photo and use the Zoom slider to adjust that view as well.
 - If you want to zoom in on both photos by the same amount, click the toolbar's button to switch it to the *locked* position. Use the Zoom slider to adjust the amount D.
 - If you start with the toolbar's button unlocked, but when zooming in on one photo realize you want to zoom in by the same amount in the other photo, click the Sync button . The view of the other photo zooms to the same magnification as the active photo .

(6) With the toolbar's Link Focus button *unlocked*, you can adjust the Zoom slider independently for each photo.

(D) With the toolbar's Link Focus button *locked*, any adjustments with the Zoom slider apply to both photos.

• The view of the other photo now zooms to the same magnification as the active photo.

If, when zooming in on one photo, you realize you want to enlarge the other photo by the same amount, click the Sync button.

Make Candidate

Select Select Close previous Compare next photo photo view

G Use the Compare view's toolbar buttons when reviewing Select and Candidate photos.

H The right (Candidate) photo is sharper, so it's flagged as a pick and then made the Select photo using the Compare view toolbar.

- 4. With the view now set, you can make judgments more easily about which photos should be Selects and Candidates. Use the Compare view's tools to switch or compare them G.
- 5. As you review photos, you also can apply the flags, ratings, and labels to further distinguish photos from each other. In the example, the right (Candidate) photo is sharper, so it's flagged as a pick and then made the Select photo using the Compare view toolbar (B).
- 6. Once you finish comparing photos, click the toolbar's Done button. The Compare view switches to the Loupe view.

TIP When moving around in a zoomed view, opening the Navigator panel helps you see where you are in the active photo ().

It can be helpful to turn on the photo info options when comparing photos (Ctrl-I/Cmd-I) (For more information, see Grid and Loupe View Options on page 53.)

The Compare view also is useful when working with virtual coples to which different develop settings have been applied. (For more Information, see page 144.)

Using Compare View with the Filmstrip

When comparing similar photos not shot in a continuous sequence, the Compare view is easier to use with the Filmstrip visible **①**. You can, for example, choose a Select photo and a Candidate photo in the Filmstrip and mark either as Flagged or Rejected. Rejected photos appear dimmed in the Filmstrip. Press your keyboard's forward and back arrows to quickly compare the Select photo against another Candidate photo **①**.

When comparing similar photos not shot in a continuous sequence, the Compare view is easier to use with the Filmstrip.

The Filmstrip makes it easy to quickly compare the Select photo against another Candidate photo (right).

(In the Filmstrip, select several photos you want to review and click the toolbar's Survey view button.

 All the selected photos are grouped in the main window. Click any photo and a large X appears in the bottom right.

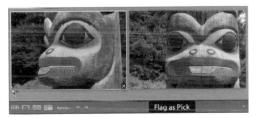

When you get down to your final two choices, click the small white flag in the lower left of the favorile to mark it as your top pick.

To use the Survey view:

- 1. In the Filmstrip or Grid view, select several photos you want to review.
- Press the N on your keyboard or click the Survey view button in the toolbar
 All the selected photos appear in the main Lightroom window.
- Click to select any photo in the main window, and a large X appears in the bottom right ①.
- 4. To remove a photo from the Survey view, click the X. The photo is removed only from the Survey view, but it remains part of your catalog and is not deleted.
- As you work in Survey view, you also can right-click (Control-click on singlebutton Macs) any photo and use the pop-up menu to apply flags, ratings, or labels.
- 6. Continue removing photos by clicking the lower-right X until you get down to your final two choices. Click your favorite, and click the small white flag in the lower left to mark it as your top pick
 M. You can create a new Survey view collection by selecting other photos in the Filmstrip, or switch to another view.

The Survey and Compare views really come into their own when you have a second monitor to use. (For more information, see "To open a second window" on page 13.)

Removing or Deleting Photos

Lightroom gives you two choices when you're ready to weed out those photos you've marked as bad or second-rate. You can remove a photo from the current Lightroom catalog or delete it from your hard drive. Removing photos does not erase the image but simply tells Lightroom to ignore it. In effect, the pointer from the catalog back to the actual image is severed, which does not free up much space on your hard drive. In contrast, deleting a photo moves it to your Recycle Bin/Trash. Once you empty the Recycle Bin/Trash, the photo will be erased and you regain that 5 MB to 10 MB of space on the hard drive. Whether you remove or delete depends on your ruthlessness as an editor—and whether you truly want a photo gone for good. By the way, removing or deleting those photos before you start major keywording saves you a lot of work. (Keywording is covered in the next chapter.)

To remove or delete photos:

- 1. Select the photo(s) you want to remove or delete (A).
- 2. Press the Backspace/Delete key.
- **3.** In the dialog that appears, do one of the following:
 - If you only want to remove the photo(s) from the Lightroom catalog, choose Remove B.

or

 If you want to remove the photo(s) from the Lightroom catalog and delete it from your hard drive, choose Delete from Disk C.

A Select the photo you want to remove or delete. In this case, the left photo is flagged as a reject.

Lr	Delete the selected master photo from disk, or just remove it from Lightroom?
	Delete moves the file to Finder's Trash and removes it from Lightroom.
	Delete from Disk Cancel Remove

(b) If you only want to remove the photo from the Lightroom catalog, click Remove.

Lr	Delete the selected master photo from disk, or just remove it from Lightroom?
	Delete moves the file to Finder's Trash and removes it from Lightroom. One virtual copy will also be removed.
	Delete from Disk. Cancel Remove

G If you want to remove the photo from the Lightroom catalog *and* delete it from your hard drive, click Delete from Disk.

(D) In either case, the photo no longer appears in Lightroom's main window or Filmstrip.

(3) If you choose to *delete* the photo, it's moved to the Recycle Bin/Trash, along with the catalog's accompanying XMP file.

4. With either choice, the photo no longer appears in the Filmstrip or the main Lightroom window ①. If you chose to delete the photo, it's moved to the Recycle Bin/Trash, along with the catalog's accompanying XMP (metadata) file ①.

(IIP) You can *remove* a photo from the catalog without bothering with the Delete from Disk/Remove dialog **(3)**. In step 2, press Alt-Backspace/Option-Delete, and the photo is removed immediately.

Use Ctrl-Z/Cmd-Z to undo your action if you *remove* a photo by accident.

There Is no undo command if you accidentally *delete* a photo. However, until you empty your Recycle Bin/Trash, you can open it and move the photo back to your desktop. Then you can reimport the photo into Lightroom.

(IIP) You also can use the Library Filter to quickly find all photos marked as rejects or assigned low ratings. (For more information, see "Using the Library Filter" on page 108.)

Putting It All Together

- 1. Select a few photos in the Library's Grid view and dim the lights. After inspecting them, turn the lights back on.
- 2. In the Filmstrip or Grid view, select several photos and group them Into a stack.
- **3.** Use the keyboard to collapse and expand that stack several times.
- **4.** In the Grid view, add another photo to the stack, and then remove it.
- In the Filmstrip or any of the four view modes, manually mark some photos as rejects and others as picks. Use the Painter tool to do the same to other photos.
- **6.** Apply various ratings and labels to some photos using the keyboard and the Painter tool.
- 7. Create a new label set and make it your default set. Then switch back to the original default set of labels.
- In the Filmstrip or Grid view, select two photos and use the Compare view's Zoom slider to see how they differ.
- **9.** In the Filmstrip or Grid view, select several photos and use the Survey view to see how they differ. Use the X button to cull out the weakest photos.
- **10.** Select the culled photos and press the Backspace/Delete key. Use the dialog to decide if you want to remove them from Lightroom or delete them from your hard disk.

Using Keywords

Keywords act as tags for your photos. Because they are tucked into the metadata of each photo, they stay out of the way until you need them to help you find a particular photo. When you first start adding images to Lightroom, the keyword feature may seem more bother than it's worth. Once your catalog grows to several hundred (or thousand) images, however, keywords become essential for pulling that one photo from the digital haystack. If you hope to sell any of your images, remember: Stock image agencies depend on keywords when seeking photos. So keywords may be a bit of a bother, but they can be worth the time-and the money.

Your first chance to apply keywords comes when you import photos into Lightroom, as explained in step 12 on page 26. The rest of the time, you'll use the keyword tools found in the Library module's Keywording and Keyword List panels.

In This Chapter

Creating Keywords	92
Using Keyword Sets	100
Editing Keywords	103
Putting It All Together	106

Creating Keywords

Lightroom gives you two ways to create keywords. The first, using the Keywording panel, is quick and simple. The second, using the Keyword List panel, is a tad more involved but offers options to create nested keywords and keyword synonyms. An example of nested, also called grouped, keywords might be: Places > US West > Southwest > Utah > Capitol Reef N.P. Add the keywords Capitol Reef N.P. to any photo and it's automatically also tagged with the Utah, Southwest, US West, and Places tags (A). This is probably the single most effective way to manage what otherwise can become a sprawling list of keywords. The Keyword List panel's synonyms feature helps you anticipate other words that might be used in searching your photos later on. By entering "amphibian" as a synonym for frog, for example, you reduce the risk of not finding a relevant photo simply because you used another word in the search. (For more information on searching for photos, see "Using the Library Filter," on page 108.)

As you create keywords over time, Lightroom can track those words and offer suggestions of similarly spelled keywords. This auto-completion feature not only saves you time but also helps keep your keyword spellings consistent. (For more information, see page 98.) Lightroom also makes it easy to apply existing keywords by simply dragging and dropping them onto photos.

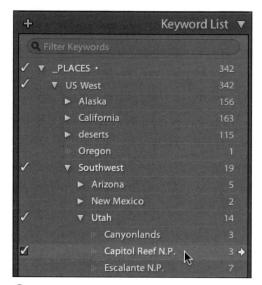

With nested keywords, adding a "child" keyword to a photo automatically applies its "parent" terms as well.

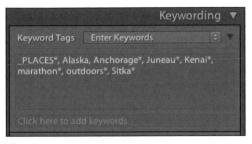

(B) In the Right Panel Group, the Keywording panel offers a simple way to add keywords.

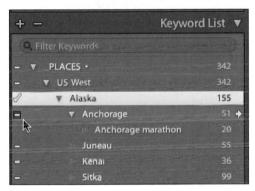

G Sitting just below the Keywording panel, the Keyword List panel includes options to create nested (parent-child) keywords.

Start General, Then Get Specific

Keywording moves along faster if you start by adding keywords that apply to the most photos. For example, add keywords to all your photos from Alaska first, then keyword only the shots from the town of Sitka, and finally keyword those from the Sitka National Historical Park. This broad-to-narrow application of keywords is more efficient—and jogs your memory in creating related keywords.

To see a photo's existing keywords:

- In the Library module, select the photo(s) you want to check for keywords and:
 - Expand the Keywording panel and look in the Keyword Tags text box.
 If you've selected multiple photos, keywords applied to only some of the photos have an asterisk B.

or

 Expand the Keyword List panel. Keywords applied to every selected photo are checked; keywords applied to only some of the selected photos have a dash C.

(III) In the Keyword List panel, If you click the arrow at the far right of any line, the Library Filter feature displays only the photo(s) to which that keyword is applied. (For more information on the Library Filter, see page 108.)

To create simple keywords:

- In the Library module, select the photo(s) to which you want to add the same keyword.
- Expand the Keywording panel and click in the "Click here to add keywords" text box 0.
- Type in the first keyword you want to add, then enter a comma and a space, and type the next keyword ¹/₂.
- When you're done entering keywords, press Enter/Return. The new keywords are added to the list of keywords applied to the selected photo(s) ().

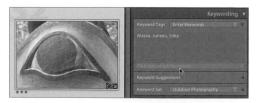

D To add simple keywords, expand the Keyword-Ing panel and click in the "Click here to add keywords" text box.

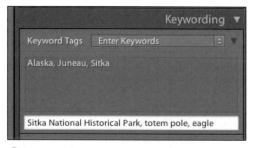

• Separate the keywords you enter with commas.

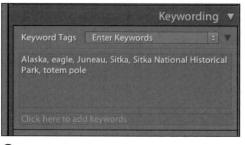

When you're done entering keywords, press Enter/Return. The new keywords are added to the selected photos.

(G To add keywords and associated synonyms, click the + button in the upper left of the Keyword List panel.

	Create Keyword Tag
Keyword Name:	frog
Synonyms:	amphibian
	Keyword Tag Options
	Include on Export
	Export Containing Keywords
	🗹 Export Synonyms
	Creation Options
	Add to selected photos
	(Cancal) (Create

Henter keywords in the Keyword Name text box, separated by commas. Use the Synonyms text box to add search terms that might be used instead of the keywords.

(1) The new keyword is added to the Keyword List panel.

To create keywords with synonyms:

- In the Library module, select the photo(s) to which you want to add the same keyword.
- Click the + button in the upper-left corner of the Keyword List panel G. The Create Keyword Tag dialog appears.
- In the Keyword Name text box, type the keyword you want to add ①. Type any synonyms that you expect you or others might use later to search for photos like this one. Enter a comma and space after each synonym.
- Choose which of the Keyword Tag Options you want applied. (For more information, see the "Keyword Tag Options" sidebar on page 98.)
- 5. Click Create and the keyword appears in your Keyword List ①. You also can find the photo by searching for the synonym ①. (For more information on finding photos, see 107.)

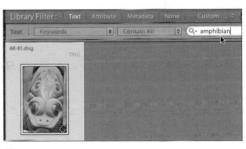

• You can search for any added synonyms using the Library Filter.

To create nested keywords:

- In the Library module, select the photo(s) to which you want to add the same keyword.
- Click to select the keyword within which you want to nest another keyword. Click the + button in the upper-left corner of the Keyword List panel (). The Create Keyword Tag dialog appears.
- 3. In the Keyword Tag text box, type in the keywords you want to add, separating each with a comma **1**.

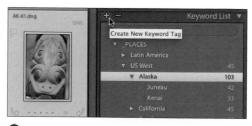

(To add nested keywords, click the + button in the upper left of the Keyword List panel.

	Create Keyword Tag
Keyword Name:	Sitka
Synonyms:	
	Keyword Tag Options
	Include on Export
	Export Containing Keywords
	K Export Synonyms
	Creation Options
	Put inside "Alaska"
	Add to selected photos

• Enter keywords in the Keyword Name text box, separated by commas. Use the Synonyms text box to add search terms that might be used instead of the keywords. Then choose the appropriate Keyword Tag Options.

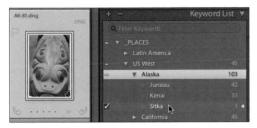

0 The new keyword is added to the Keyword List panel.

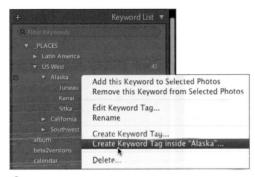

(1) In the Keyword List panel, right-click (Controlclick on single-button Macs) what will become the "parent" keyword and choose the Create Keyword Tag inside item.

- 4. Choose which of the Keyword Tag Options you want applied. (For more information, see the "Keyword Tag Options" sidebar.) In the Creation Options section, be sure to click the "Put inside..." check box.
- Click Create and the keyword appears in your Keyword List, nested under the term selected in step 2 .

(IIP) You also can nest keywords by rightclicking (Control-clicking on single-button Macs) any keyword in the Keyword List panel and choosing "Create Keyword Tag inside" in the pop-up menu **(1)**.

(III) You also can download commercial sets of nested keywords from the Web. Just search for the term "controlled vocabulary."

To set the catalog to suggest existing keywords:

- From the Menu bar, choose Edit > Catalog Settings (Windows) or Lightroom > Catalog Settings (Mac). The Catalog Settings dialog appears.
- Click the Metadata tab and select "Offer suggestions from recently entered values" O. Make sure the other two boxes, which control how metadata is saved, also are selected. Click OK to close the dialog.

Now when you begin to type a keyword, Lightroom suggests similarly spelled keywords, which helps you remember keywords you've already created ①. To select a suggested keyword, choose it in the pop-up menu and press Enter/Return twice.

30	Catalog Settings
	General File Handling Metadata
Editing	
Offer sug	estions from recently entered values (Clear All Suggestion Lists)
Include D	evelop settings in metadata inside JPEG, TIFF, and PSD files
Automatic	ally write changes into XMP

• Click the Metadata tab and select "Offer suggestions from recently entered values." With this on, Lightroom auto-completes keywords as you type them.

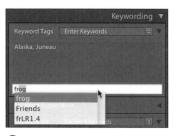

When you begin to type a keyword, Lightroom suggests similarly spelled existing keywords.

Keyword Tag Options

Include on Export: Checked by default, this option sends the keyword tag along with any photos you later export. Whether you leave it checked may depend on who will be using the exported photos: yourself on another computer or a client who you may—or may not—want to see the keywords.

Export Containing Keywords: This option sends the keywords and any *containing* keywords along with the exported photos (e.g., "US West" as well as "Alaska"). As with the previous option, whether you leave this option checked depends on the needs of the person receiving the exported photos.

Export Synonyms: This option includes your synonyms, along with the keywords, with any exported photos.

Put inside "___": This option appears only if you select an existing keyword in the Keyword List before clicking the + button. You can use this option to "nest" your new keyword in a more inclusive keyword, such as "Alaska" in the example **(I**). (For more information on nested keywords, see "To rearrange keyword groups" on page 105.)

Add to selected photos: Checked by default, which usually makes sense since you selected the photo(s) in step 1. Sometimes, however, you may remember another keyword that you'll want to apply later to some other shots. By unchecking the option, you can create keywords without applying them to the current photos.

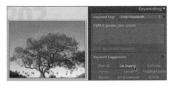

Q Select the photo(s) to which you want to add a keyword. Click a keyword in the list of Keyword Suggestions.

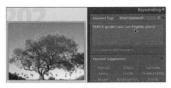

(B) The keyword is added to the photo's list of keywords in the Keywording panel.

Select and drag the photo(s) to your target keyword, and a stack of thumbnails appears above the keyword. Release your cursor and the keyword is added to the photo(s).

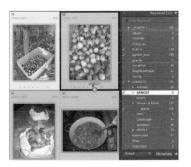

Drag the keyword onto the selected photo(s). The keyword appears over the photo nearest the cursor, along with a green plus sign. Release your cursor and the keyword is added to the photo(s).

To quickly apply existing keywords:

 Select the photo(s) to which you want to add a keyword. Expand the Keyword Suggestions list in the Keywording panel, and click the keyword you want to add **①**. The keyword is added to the photo's list of keywords **R**.

or

- Expand the Keyword List panel so that you can see the keyword you want to add. Select the photo(s) to which you want to add the keyword and drag them onto the keyword. A stack of thumbnails appears over the highlighted keyword **S**. Release your cursor and the keyword is added to the photo(s).
- Expand the Keyword List panel so that you can see the keyword you want to add. Select your photo(s). Drag the keyword onto the selected photo(s). The keyword appears over the target photo, along with a green plus sign 1. Release your cursor and the keyword is added to the photo(s).

(IIP) In the third method above, it's much easier to see the keyword above the photos if the Grid view is set to Expanded Cells instead of Compact Cells. (For more information on the Expanded Cells option, see "Grid and Loupe View Options" on page 53.)

Using Keyword Sets

Keyword sets are great for pulling together a set of words that you often apply in the same work session. If you often shoot photos of your family—and who doesn't you might create a keyword set containing their names. That way, you can access the names with a single click, which can be handy when you're working through a group of family picnic photos. While each keyword set can contain no more than nine words, there's no limit on how many sets you can create.

Lightroom gives you a head start on creating keyword sets by always tracking your most recently used keywords. When, for example, you finish working with photos with similar locations or subjects, the keywords you assigned can then be quickly turned into a permanent keyword set. Lightroom also includes three keyword sets built around three of the most common photo subjects: Outdoor Photography, Portrait Photography, and Wedding Photography.

To convert recent keywords into a set:

- After a session of creating or adding keywords for photos with similar subjects, expand the Keywording panel. Use the Keyword Set pop-up menu to choose Recent Keywords (). Don't worry if the list of recent keywords contains some unrelated keywords; you can edit them in a moment.
- Use the Keyword Set pop-up menu to choose Save Current Settings as New Preset B.
- In the New Preset dialog, name your new set (called a preset) and click Create O. The new keyword set is selected in the Keyword Set pop-up menu.

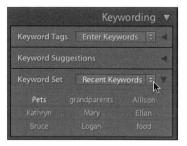

A Use the Keyword Set pop-up menu to choose Recent Keywords.

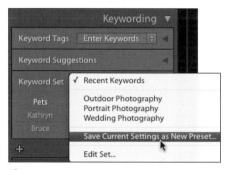

B Use the Keyword Set pop-up menu to choose Save Current Settings as New Preset.

00	New Preset
Preset Name:	Untitled Preset
000	New Preset
Preset Na	me: Family & Friends
	Cancel Create

O Name your new keyword set (here called a preset) and click Create.

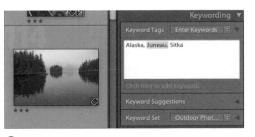

• To remove a keyword from a photo, select it in the Keywording panel and press Backspace/ Delete.

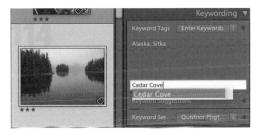

If you're in the main Keywording text box, press Tab to jump to the "Click here to add keywords" text box. You can then add other keywords.

Editing Keywords

It's easy at any point to remove, delete, or edit a keyword. Lightroom automatically updates every instance of the keyword. That means your keywords can evolve or grow more specific as your collection of photos grows. It makes it a drag-and-drop affair to reorder your nested keywords, no matter how elaborate the system becomes.

To remove a keyword from a photo:

- 1. Select the photo(s) from which you want to remove a keyword.
- In the Keywording panel's list of applied keywords, select the keyword(s) you want to remove along with the comma (). (See Tips.)
- **3.** Press Backspace/Delete to remove the keyword(s). Repeat the steps if you need to delete more keywords from the selected photo(s).

In step 2, you can double-click a keyword to select it and its comma.

III) In step 3, if you press Tab after pressing Backspace/Delete, the cursor moves to the "Click here to add keywords" text box, which makes fast work of adding other keywords ().

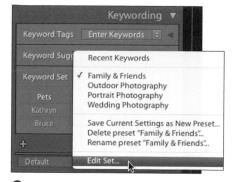

D Use the Keyword Set pop-up menu to choose Edit Set.

cyve	ords				
ets	ts gra		andparents	Allison	
Kathryn Ma		Mary		Ellen	
Bruce		Log	gan	food	
-		(Cancel	Change	
	Kathryn		Mary	Ellen	
			Logan	Warren	

• Select any keyword you don't want as part of this keyword set (top). Delete or replace it with a new keyword and click Change (bottom).

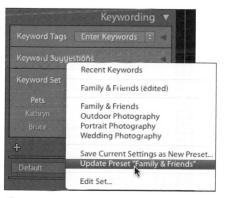

When the new keyword set reappears, it will not reflect your edits, so use the Keyword Set pop-up menu to choose Update Preset.

- 5. In the Edit Keyword Set dialog, select any keywords you don't want as part of this keyword set. Delete them or replace them by typing in new keywords (3). It's OK to add keywords you've never used before. Click Change to apply the edits and close the dialog.
- 6. When the new keyword set reappears, it will not reflect your edits, so use the Keyword Set pop-up menu to choose Update Preset ⁽¹⁾. The keyword set updates to reflect the changes ⁽³⁾. Now this set is available in the pop-up menu when you are working in this catalog. You also can export the keyword set for use in another catalog.

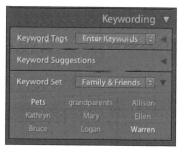

G The keyword set updates to reflect the changes.

To select and use a keyword set:

- Expand the Keywording panel, click the Keyword Set pop-up menu, and choose a keyword set of your own or one of Lightroom's three built-in keyword sets: Outdoor Photography, Portrait Photography, or Wedding Photography ⁽¹⁾.
- Once that set's keywords appear, you can click any one of the nine words to apply it to a selected photo ①.

(IIP) You can edit and add to Lightroom's built-in keyword sets. See steps 5 and 6 in the previous section "To convert recent keywords into a set."

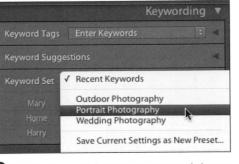

Click the Keyword Set pop-up menu and choose one of Lightroom's three built-in keyword sets.

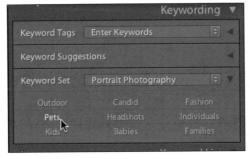

Once a set's keywords appear, you can click any one of the nine words to apply it to a selected photo.

To delete a keyword from the catalog:

- In the Keyword List panel, right-click (Control-click on single-button Macs) the keyword you want to remove from the Lightroom catalog and choose Delete in the pop up menu O.
- When the alert dialog asks if you're sure about the action, click Delete ①. The keyword is deleted from the current Lightroom catalog, as well as from any photos within the catalog. (The photo itself is not deleted.)

If you want to remove keywords that you've never applied to any photos in the catalog, make sure you're in the Library module. Then in the Menu bar, choose Metadata > Purge Unused Keywords. Those words are removed immediately and cannot be retrieved.

To edit keywords:

- In the Library mode, right-click (Controlclick on single-button Macs) a keyword in the Keyword List panel and choose Edit Keyword Tag in the pop-up menu ().
- In the Edit Keyword Tag dialog, type in a new name, add synonyms, or change the selected options (). Click Edit to close the dialog and apply the change.

If you only need to change the name, right-click (Control-click on single-button Macs) the keyword in the Keyword List panel and choose Rename in the pop-up menu.

O To delete a keyword from the entire catalog, right-click (Control-click on single-button Macs) in the Keyword List panel on the keyword you want to remove and choose Delete.

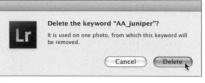

• The alert dialog warns you that the keyword will be deleted from the current Lightroom catalog, as well as from any photos within the catalog. If you're sure about the action, click Delete.

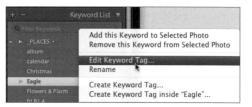

() To edit a keyword, right-click (Control-click on single-button Macs) it in the Keyword List panel and choose Edit Keyword Tag.

	Edit Keyword Tag
Keyword Tag:	eagle
Synonyms:	raptor, bird, bald eagle
	Keyword Tag Options
	M Include on Export
	S Export Containing Keywords
	S Export Synonyms

() In the Edit Keyword Tag dialog, you can enter a new name, add synonyms, or change the options.

+ -	Keyword List 🔻
Q Filter Keywords	
▼ Alaska	155
▼ Anchorage	51
Anchorage marathon	20
Sitka	99
album	2
Amboy Crater	23
Anza-Borrego	3
Arizona	3
Atwater	13
calendar	8
California Amboy Crater	131 🗘
Canyonlands	3

G In the Keyword List panel, drag the keyword to where you want it to appear within the hierarchy.

÷		Keyword List	
Q F			
¥			5
	▼ Anchorage		1
	Anchorage marathon		
			20000000 - CA
-	album		2
	Anza-Borrego		3
			3
	Atwater)
1. 	ralendar		3
	California		
h.	Amboy Crater		3
1	Canyonlands		3

(1) The keyword moves to its new position within the keyword group.

To rearrange keyword groups:

- **1.** In the Library module, expand the Keyword List panel.
- Click the keyword you want to rearrange within a keyword group, and drag it to where you want it to appear within the keyword groupings G.
- Release the cursor and the keyword moves to its new position within the keyword group .

Putting It All Together

- 1. In the Library module, select several photos. Create and apply a keyword to them.
- Use those same photos to create a keyword tag nested inside the previously applied keyword.
- **3.** Edit the catalog so that it automatically suggests the use of your recently created keyword.
- **4.** Use the Keyword List to quickly apply existing keywords to other photos.
- Convert your recent keywords into a keyword set and save it as a new preset.
- 6. Select your new keyword preset, edit the keywords, and set the preset to update automatically.
- Use the Keyword Set pop-up menu to switch to one of Lightroom's built-in keyword sets.
- **8.** Select a photo and remove one or more of the keywords applied to it.
- **9.** Use the Keyword List panel to delete a keyword from the catalog.
- Edit a keyword to change its name or add several synonyms for that keyword.

Finding Images

As the number of images you import into Lightroom inevItably becomes overwhelming, you'll need ways to fetch exactly the photos you need without a lot of work. The Library Filter toolbar provides a powerful way to quickly sift through your images.

In This Chapter

Using the Library Filter	108
Putting It All Together	120

Using the Library Filter

The Library Filter pulls together a variety of ways to search your photos. Using its three main search buttons—Text, Attribute, and Metadata—you can quickly cast a wide net to find all of a particular type of photo or drill down to a single specific image. The Library Filter toolbar also includes a Custom Filter pop-up menu with six predefined searches, plus the ability to tailor your own.

In version 3, Lightroom's Library Filter includes a lock at the far right. If the button is locked, your search filter terms become "sticky"—that is, they remain active even when you change your image source. That makes it easier to switch from one hard drive to another while trying to find a particular photo—without losing your search criteria. It also works when you're searching through different collections, as explained in the next chapter.

To show/hide the Library Filter toolbar:

 In the Library module, choose View > Show Filter Bar (A).

or

In the Library module, press the \ (back slash) on your keyboard.

or

 In the Develop module, press the - (hyphen) on your keyboard.

The Library Filter toolbar appears at the top of the main window, ready for use (1). Repeat the above action, and the toolbar disappears.

(A) To show or hide the Library Filter toolbar, choose View > Show Filter Bar/Hide Filter Bar. Or press the \ key to toggle it on or off.

Use lock to save search terms when switching image source

Filter lets you search by:	Т	urns off filter to show all	
Library Filter : Text	Attribute	Metadata None	Filters Off 🗧 🔒
	Rating, Color	File Type, Camera data,	Six predefined or custom schemes

The Library Filter's four search buttons—Text, Attribute, Metadata, and Custom Filter—let you find photos several ways. None turns off the filter to show all available photos.

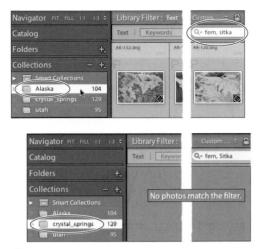

(6) When the Library filter is locked, your search criteria are applied even when you switch your image source in the Folders or Collections panels.

To turn on/off the Library Filter lock:

 Click the Library Filter's far-right Lock button to switch between locked and unlocked. When it's locked, any search criteria you choose, such as text, attribute, or metadata, are applied even as you switch your image source using the Folders or Collections panels . If the button is unlocked, your search criteria disappear as soon as you switch to another source.

or

 To start a new search, click the button again to unlock it, then choose your image source and enter new criteria.

To search for photos by text:

- Use the Catalog D, Folders B, or Collections B panel to select a photo source for your search.
- In the Library Filter toolbar, click the Text button to reveal the Text toolbar G.
- 3. By default, the Text toolbar is set for Any Searchable Field and Contains All. That's perfect for a quick broad search, so type your search terms directly into the query field, and the photo results appear in Lightroom's main window (1).
- 4. If you want to start a new text search, click the X to clear the previous search term ①.

(III) Even if a hard drive is not connected at the moment, you can still search for information about its photos since the Lightroom catalog stores all the information.

(II) If you need to refine the search, use the Text toolbar's first pop-up menu to specify which fields to search and the second pop-up menu to narrow or expand what you're seeking (). Then type your search terms into the query field.

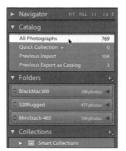

Choose All Photographs in the Catalog panel to search every photo in the current catalog, which covers every hard drive listed in the Folders panel.

() To search a specific

hard drive or folder.

make a choice in the

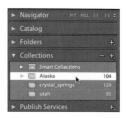

To search a collection, make a choice in the expanded Collections panel.

G In the Library Filter toolbar, click the Text button to display the Text toolbar below it.

(b) Type your search terms in the query field, and the photo results appear in Lightroom's main window.

Text Attribute	Metadata None	Custom Filter 🗧
Contain	• Q- Panorama	R
Text Attribute	e Metadata None	Custom Filter 🗘
Contain	÷ Q+)

Click the X to clear the previous search so that you can start a new search.

Library Filter : Text At	tribute Metadata None
Text Any Searchable Field	Contains All
✓ Any Searchable Field Filename Copy Name Title Caption Keywords	Contains ✓ Contains All Contains Words Doesn't Contain Starts With Ends With
Searchable Metadata Searchable IPTC Searchable EXIF	
Any Searchable Plug-in Field	

Use the Text toolbar's first and second pop-up menus to refine your search. Then type your search terms into the query field.

(IIP) You do not need to press Enter/Return to trigger the search; the words alone do the trick.

(IIP) Press Ctrl-F/Cmd-F to jump straight to the Text entry window from anywhere in the Library module.

(IIP) The Library Filter can search through stacked photos, displaying photos in results possibly hidden in a collapsed stack.

(IIP) Don't let this throw you off: Search results do not disappear until you enter new search terms. That means that when you initially start a new text search, the main window displays photos from the previous text search. In fact, Lightroom does the same thing for your previous Attribute and Metadata searches as well.

Searching Without Getting Lost

It's possible to hide the Library Filter toolbar but leave the search filters on. That combination makes it hard to tell at a glance if you're seeing all of your photos or only the search results () To avoid such confusion, keep the toolbar visible whenever you're searching photos (press \). The toolbar eats up some screen real estate, but it's always clear what's going on (), ().

Confusion: With the Library Filter toolbar hidden, it's hard to tell if you're seeing all your photos or just the search results.

() No confusion. With the toolbar showing, it's clear that these are photos found in a search.

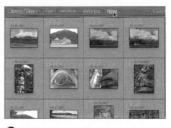

With None selected in the toolbar, again it's clear that you're seeing all your photos.

To search for photos by attribute:

- 1. Use the Catalog, Folders, or Collections panel to select a photo source for your search.
- In the Library Filter toolbar, click the Attribute button to reveal the Attribute toolbar (1).
- **3.** Click the Flag, Rating, or Color labels applied to the photos you're searching for, and the results appear in Lightroom's main window **O**.

(IIP) You also can use the Filmstrip's Filter buttons to find photos in the strip based on their flag, rating, or color label **(P)**. However, I find the Library Filter toolbar more flexible and less confusing.

Three buttons at the Attribute toolbar's far right enable you to search for photos by Kind. Besides searching for virtual copies or master photos, you also can find any videos imported into Lightroom **①**. While you cannot edit a video in the Develop module, you can double-click a thumbnail to launch it in your default video program. (For more information on virtual and master photos, see page 144.)

To search for photos by attribute, click the Attribute button in the Library Filter toolbar.

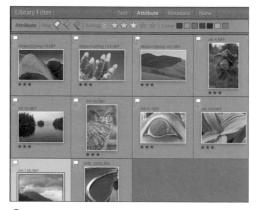

O Choose the Flag, Rating, or Color labels, and the results appear in Lightroom's main window.

? You also can use the Filmstrip's buttons to find photos based on their flag, rating, or color label.

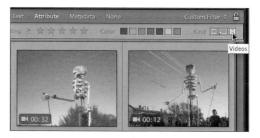

Q Three buttons at the Attribute toolbar's far right enable you to search virtual copies, master photos, or videos.

Library Filte				ute Metadata		
Date	3	Camera		Lens		1
All (432 Dates	6487	All (20 Cameras)	6487	All (9 Lenses)	6487	
▶ 1994	7	C150,D390	1	1.1-6.5 mm	1	
▶ 1998	1	C300Z,D550Z	14	4.6-17.3 mm	134	
▶ 2002	146	C740UZ	7	5.4-10.8 mm	5564	
▶ 2003	2316	C3040Z	2	5.4-16.2 mm	9	

() To search for photos by metadata, click the Metadata button in the Library Filter toolbar.

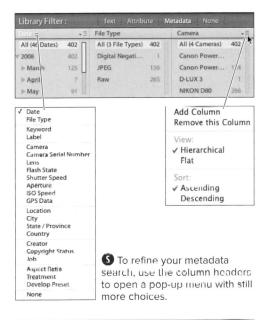

• As you drill down in your search, Lightroom's main window displays the ever-narrowing photo results.

To search for photos by metadata:

- 1. Use the Catalog, Folders, or Collections panel to select a photo source for your search.
- In the Library Filter toolbar, click the Metadata button to reveal the Metadata toolbar (). By default, the Metadata toolbar displays four columns set to Date, Camera, Lens, and Label.
- To refine your metadata search, click any of the column headers to trigger a popup menu offering an amazing 23 choices
 Change the setting in any or all of the columns. You also can add, remove, or re-sort any column by clicking the small icon in the upper right of any column and making a choice in the pop-up menu.
- To fine-tune your search even further, you can scroll down the columns listing multiple sub-categories to make more choices. Lightroom's main window displays the ever-narrowing photo results 1.

Using the Metadata button, you can combine all three search approaches—Text, Attribute, and Metadata. After clicking the Metadata button, also click the Text and Attribute buttons if you want to order up a supercombo search **①**.

U You can combine all three search approaches—Text, Attribute, and Metadata—for multiple-criteria searches.

Adding and Syncing Metadata

After getting comfortable using the Library Filter to search Lightroom's metadata, you may want to add information for photos directly in the Metadata panel. If you like, you also can then sync all or just some of that metadata to other photos. It saves you from constantly rekeying the same information.

- 1. Select the photo(s) to which you want to add the same metadata.
- Use the left-hand pop-up menu, if the Metadata panel is not showing the metadata field(s) you need ♥.
- **3.** Enter your information in the appropriate metadata fields for the selected photo(s), pressing Enter/Return when you're done with each field. The metadata is added to the selected photos in the Grid **W**.

continues on next page

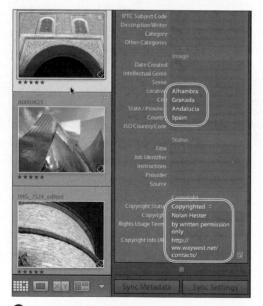

W Location and copyright metadata is added for the photo selected in the Grid.

Use the left-hand pop-up menu, if the Metadata panel is not showing the metadata field(s) you need.

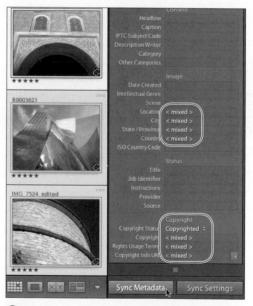

Select additional photos to which you want to apply some of the top photo's metadata. Fields labeled <mixed> do not all contain the same location and copyright information.

Adding and Syncing Metadata (continued)

- 4. With these source photo(s) still selected, now also select target photos to which you want to apply some of the metadata entered in step 3. Some of the metadata fields are labeled <mixed> because they do not all contain the same information X.
- 5. Click Sync Metadata, and the Synchronize Metadata dialog lets you check which fields you want to apply to all the photos **①**. Fields with metadata you do not want applied to all the photos should remain unchecked. Click Synchronize. A task bar tracks the synchronization, which may take a moment, depending on how many photos you selected.
- 6. Select any of the photos you targeted for syncing in step 4. Only the fields you checked in step 5 are updated with metadata from the source photo(s) 2.

Nolan Hester	
Copyrighted	
by written permission only	M
http://ww.waywest.net/contacts/	V
Alhambra	
Granada	
Andalucia	
Spain	0
hambra, Alsace et Burgundy, Building- chitecture, fullsize, iPhotoLib, iginal, Spain	
	Copyrighted Uy written permission only http://ww.waywest.net/contacts/ Althambra Cranada Andalucia Spain bambra, Alsace et Burgundy, Building- chitecture, fullsize, iPhotoLib,

Check the fields you want to apply to all the photos (for example, copyright-related). Leave unchecked fields that you do not want to synchronize (location- and keywords-related).

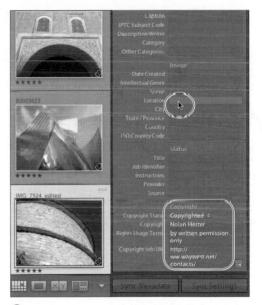

After syncing, the targeted photo (bottom) includes the source photo's copyright but not its location metadata.

To switch between search results and all photos:

 Click None in the Library Filter toolbar to turn off the search and see all your photos.

or

 Press Ctrl-L/Cmd-L to turn off the Library Filter and see all your photos. When the switch takes place, a Library Filters Off note also briefly appears in the main window.

To use the custom filters:

- In the Library Filter toolbar, click the Custom Filter pop-up menu (AA). Choose one of the following:
 - Default Columns: Switches the Library Filter to the Metadata toolbar with the columns set to the metadata fields Date, Camera, Lens, and Label.
 - Filters Off: Switches to immediately show you *all* the photos in the selected catalog, folder, or collection. It works just like the Library Filter's None button.
 - Flagged: Switches the Library Filter to the Attribute toolbar and shows you only photos flagged as Picks.
 - Location Columns: Switches the Library Filter to the Metadata toolbar with the columns set to the metadata fields Country, State/Province, City, and Location.
 - Rated: Switches the Library Filter to the Attribute toolbar and shows you only photos with a rating of at least one star.
 - Unrated: The opposite of the previous option, this one shows you photos without any rating.

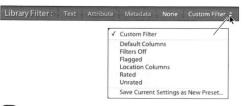

AA Click the Custom Filter pop-up menu to choose among six predefined schemes.

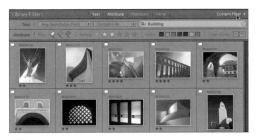

BB To save a custom filter setting as a preset, click the Custom Filter button.

1	Custom Filter			
	Default Columns			
	Filters Off			
	Flagged			
	Location Columns			
	Rated			
	Unrated			
	Save Current Settings as New Preset			
	Update Preset "Rated"			

CC In the pop-up menu, choose Save Current Settings as New Preset.

Preset Name:	Untitled Preset
	Cancel Create
a sur a sur	New Preset
Preset Na	me: x_Buildings-2starPicks

DD Name your custom filter and click Create.

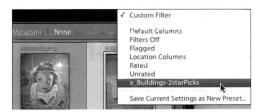

(E) The Preset is added to the Custom Filter list. Activate it by selecting it in the pop-up menu.

- Save Current Settings as New Preset: As explained below, this choice lets you save a particular search setting as a custom filter.
- 2. After making a choice in the pop-up menu, you can fine-tune the filter settings further to find the exact photos you need. If desired, you can save those settings as a custom filter (see next page).

To save custom filter settings as presets:

- After creating a particular set of filters with the Text, Attribute, or Metadata choice, you can save the settings for use later. With your settings visible in the Library Filter, cllck the Custom Filter button (BB).
- 2. In the pop-up menu, choose Save Current Sellings as New Preset **CC**.
- 3. Type in a name for your custom filter, which Lightroom calls a preset, and click Create ID.

The preset is added to the Custom Filter list and can be activated at any time by selecting it in the Custom Filter pop-up menu **(E)**.

(IIP) By default, the Custom Filter lists all the filters alphabetically, mixing your filters in with the default filters. You can group your filters by adding letters or dashes at the beginning. I add x_{-} to mine so the default filters stay at the top of the pop-up menu, where they're easier to spot.

To delete a Custom Filter preset:

- In the Library Filter toolbar, click the Custom Filter pop-up menu and choose the preset you wish to delete. The preset is selected as the current custom filter.
- Click the Custom Filter pop-up menu again, and choose "Delete preset 'name of your preset'" (1). When the alert dialog appears, click Delete. The preset is removed from the pop-up menu.

To rename a Custom Filter preset:

- In the Library Filter toolbar, click the Custom Filter pop-up menu to choose a preset. The preset is selected as the current custom filter.
- Click the Custom Filter pop-up menu again, and choose "Rename preset 'name of your preset." When the rename dialog appears, type in a new name and click Rename. The name of the preset is updated in the pop-up menu.

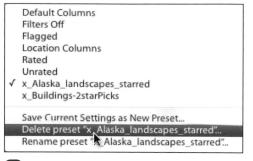

(I) To delete a Custom Filter preset, click the Custom Filter pop-up menu and choose "Delete preset."

Even More Metadata Finds

Lightroom offers so many ways to find your photos that it could take another book to explain them all. Here, however, are two especially handy ones using metadata:

- When working in the Keyword List panel, roll your cursor over the number at the right end of a keyword and press the arrow that appears GG. Lightroom activates the Library Filter's Meta-data toolbar and displays every photo using the keyword GH.
- When working in the Metadata panel, click the arrow to the right of the Capture Time field, and Lightroom fetches every photo taken that day ID. Not every arrow in the Metadata panel works this way, so mind your clicks.

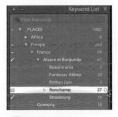

GG In the Keyword List panel, roll your cursor over the number at the right end of a keyword and press the arrow that appears...

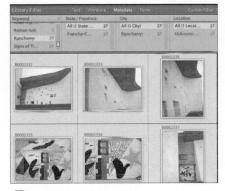

(III) ...and Lightroom displays every photo using the keyword.

(I) In the Metadata panel, click the arrow to the right of the Capture Time field, and Lightroom fetches every photo taken that day.

Putting It All Together

- 1. Turn on the Library Filter toolbar.
- **2.** To get a feel for how the Library Filter lock works, turn it on and off as you change your image source.
- **3.** Use the Library Filter toolbar to search for photos by text.
- Use the Library Filter toolbar to search for photos by flag, rating, or color label.
- **5.** Use the Library Filter toolbar to search for photos by metadata, such as date, camera, or lens used.
- 6. Add metadata to a photo, such as a location, and then sync that metadata to other photos shot at the same location.
- 7. In the Library Filter toolbar, use the popup menu to create a custom filter.
- **8.** Save that custom filter as a search preset.
- **9.** Create another search preset and then delete it.
- **10.** Select a search preset that you've created and give it a new name.

Creating and Using Collections

Collections are great for creating groups of photos you expect to view regularly. Using the Library Filter, you can quickly turn anything you find into a permanent collection. A collection might include photos of the same event, place, or keywords. Collections take up little hard drive space because instead of duplicating a file, they use multiple pointers to the original photo, similar to shortcuts on Windows machines or aliases on Macs. That means collections can contain photos from different folders, enabling you to see only the photos you want to for a particular task.

In This Chapter

Using Quick Collections	123
Using a Target Collection	130
Using Smart Collections	134
Putting It All Together	136

Collections can be tied to Lightroom's various modules. For example, you can set up—and preserve—a Slideshow collection with exactly the layout and overlays you want **(A)**. With Lightroom 3, you now can see your collections within the Develop module—eliminating the need to shuttle back to the Library module.

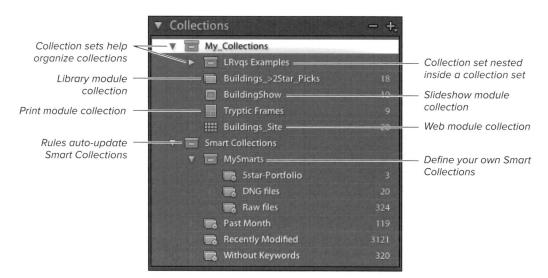

A You can create collections tied to Lightroom's various modules.

When you add a photo to a Quick Collection, a note appears briefly, confirming your action.

B The Quick Collection lists how many photos it contains as you add photos.

Using Quick Collections

When you're manually gathering photos, you can build your collections using a temporary Quick Collection or a Target Collection. The great thing about both is how easy they make it for you to quickly mark photos for collections. Using the B and forward arrow keys, you can rip through the Grid view or Filmstrip, marking photos as you go. A Quick Collection is often the easiest way to start marking photos for what will later become a regular collection.

To add to a Quick Collection one photo at a time:

- Using the Grid view or Filmstrip, click on a photo you want to add to a Quick Collection.
- 2. Press the B on your keyboard.

or

Right-click (Control-click on singlebutton Macs) and choose Add to Quick Collection in the drop-down menu.

 An Add to Quick Collection note appears briefly (A), and the image is added to your Quick Collection (B).

You can have only a single Quick Collection at any one time. But the Quick Collection persists until you deliberately empty it, so you can build it over the course of several computer sessions if necessary.

continues on next page

In the Grid view or Filmstrip, you can rapidly add images to the Quick Collection by selecting the first image, pressing the B on your keyboard, pressing the forward arrow to move to the next image, pressing the B again if you want to add that one, or pressing the forward arrow again to move to the next image. Your hands never leave the keyboard, so you can efficiently sift through many images.

IF Badges are set to show in the Grid view (View > Grid View Style > Show Badges), you can add images to a Quick Collection by rolling the cursor over an image until a small circle appears in the upper-right corner **G**. Click the circle and an Add to Quick Collection note appears briefly **D**. The small, white circle turns gray, indicating that the image is now part of the Quick Collection **B**.

• Add images to a Quick Collection by rolling the cursor over an image until a small circle appears in the upper-right corner.

O Click the circle and an Add to Quick Collection note appears briefly.

The small, white circle turns gray, indicating that the image is now part of the Quick Collection.

() To add multiple images to a Quick Collection, select them and choose Add to Quick Collection in the pop-up menu.

(You also can click and drag the selected Images to the Quick Collection listing in the Catalog panel.

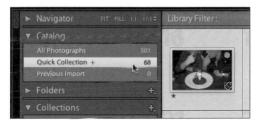

(1) The Quick Collection's photo count updates as you add more photos.

To add multiple images to a Quick Collection:

- Using the Grid view or Filmstrip, select the photos you want to add to a Quick Collection.
- Right-click (Control-click on singlebutton Macs) and choose Add to Quick Collection in the pop-up menu ().

or

Click and drag the selected images to the Quick Collection listing in the Catalog panel **G**.

or

From the Menu bar, choose Photo > Add to Quick Collection.

3. The selected photos are added to the Quick Collection, updating the number of photos listed in the Quick Collection listing in the Catalog panel ().

IP If you're using the Filmstrip and working in the Slideshow, Print, or Web modules, step 2's last option would be Edit > Λdd to Quick Collection.

To remove image(s) from a Quick Collection:

- 1. Using the Grid view or Filmstrip, select the photos you want to remove from the Quick Collection.
- Right-click (Control-click on singlebutton Macs) and choose Remove from Quick Collection in the pop-up menu 1. The images are removed from the Quick Collection, as reflected in the image count in the Catalog panel.

or

Roll the cursor over the gray circle in the upper-right corner of a single image **①**. Click the circle and a Remove from Quick Collection note appears briefly **③**. The small gray circle disappears, indicating that the image is no longer part of the Quick Collection **①**.

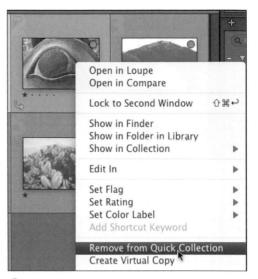

() To remove images from a Quick Collection, select them, and choose Remove from Quick Collection in the pop-up menu.

• You also can remove photos from the Quick Collection by rolling the cursor over the gray circle in a photo's upper-right corner.

Click the circle and a Remove from Quick Collection note appears briefly.

() The small, gray circle disappears, indicating that the image is no longer part of the Quick Collection.

Catalog	
	501
Quick Collection +	Save Quick Collection、 工業E
Previous Import	Clear Quick Collection 企業E
	Set as Target Collection NO#E

To save a Quick Collection as a regular collection, right-click (Control-click on singlebutton Macs) the Quick Collection listing and choose Save Quick Collection.

	Save Quick Collection
Collection Name:	AlaskaSelect
	Clear Quick Collection After Saving
	Cancel Save

Name your collection in the Collection Name text box, leave the check box selected, and click Save.

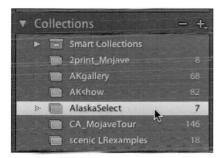

► Navigator	Fill -Fi - 111¢	
▼ Catalog		1
All Photographs	501	
Quick Collection +	Save Quick Collection	_₩B
	Clear Quick Collection	€ #B
	Set as Target Collection	て 企業B

To empty a Quick Collection, right-click (Control click on single-button Macs) the Quick Collection listing and choose Clear Quick Collection.

To save a Quick Collection as a regular collection:

- In the Catalog panel, right-click (Control-click on single-button Macs) the Quick Collection and in the pop-up menu choose Save Quick Collection .
- Type a name for your collection in the Collection Name text box, leave the check box selected, and click Save (1).
 When the Save Quick Collection dialog closes, the new collection appears in the Collections panel (1). The Quick Collection is empty once again.

ID In step 2, if you do not select Clear Quick Collection After Saving, you will not be able to create a new Quick Collection until you manually clear the collection (see below).

To empty a Quick Collection:

 In the Catalog panel, right-click (Controlclick on single-button Macs) the Quick Collection listing and choose Clear Quick Collection In the pop-up menu (). The Quick Collection empties, and the count resets to 0 (). You now can create a new Quick Collection if desired.

Q The Quick Collection empties, and the count resets to 0.

To create a collection:

- Switch to the module on which the collection should be based, such as Slideshow. Select the photos that you want to make into a collection (R).
- In the Collections panel, click the + (plus) pop-up menu and choose Create Collection S.

or

Use the keyboard shortcut: (Ctrl-N/ Cmd-N)

 In the Create Collection dialog, type in a descriptive name ①. Make sure "Include selected photos" is selected and click Create.

Lightroom's main window displays the new collection, and it's added to the Collections panel list **①**. If you used a filter to gather the collection, notice that None is now highlighted, confirming that you no longer need to run the filter to see these photos.

(IIP) In gathering photos for a collection, you can use the Library Filter including, as in (**(**), a custom filter. Just be sure to choose All (Ctrl-A/Cmd-A) before proceeding to step 2.

(IP) When your Catalog > All Photographs setting shows a large number of photos, it may be faster to select a single folder and gather photos there for a collection. Once added to the collection, it's easy to switch to another folder and repeat the process.

(IIP) All your collections remain visible in the Collections panel, no matter what module you use to create a collection. Double-click a collection in the panel and Lightroom switches to the module where it was created.

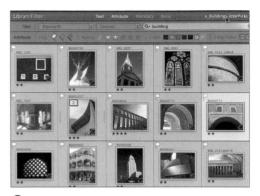

() To create a collection, start by selecting photos. In this case, the collection contains the results of the custom filter created on page 117.

S Then click the + (plus) pop-up menu and choose Create Collection.

lame:	Collection	
Set:	None	•
	Create Collection	
Nam	e: Buildings_>2Star_Picks	
Se	et: None	

Give the collection a descriptive name, choose "Include selected photos," and click Create.

U The main window displays the new collection, and it's added to the Collections panel list.

V To delete a collection, right-click (Control-click on single-button Macs) it in the Collections panel and choose Delete.

► Navigator FIT F	TLL 1:1 1:3 \$
▼ Catalog	
All Photographs	8301
Quick Collection +	4
Previous Import	1673
► Folders	÷.,
▼ Collections	÷.
LR2vqs Examples Smart Collections Duildingp >225tar	

To add to a collection, drag and drop the selected photos to the collection listing.

To delete a collection:

 In the Collections panel, right-click (Control-click on single-button Macs) a collection you no longer need and choose Delete **()**. The collection is removed from the Collections panel list.

To add to a collection:

Make sure the Collections panel is visible, select photos you want to add to the collection, and drag and drop them to the collection listing **(1)**. The number of photos listed for the collection changes to reflect the additions.

(III) You also can add to a collection by marking it as a so-called Target Collection (see next page).

Using a Target Collection

Lightroom's Target Collection feature works almost identically to a Quick Collection. Unlike a Quick Collection, however, which requires you to transfer to a collection and then clear its contents, a Target Collection can be tied to *any* collection with an easy on/off action. The more collections you have, the more you will find yourself using the Target Collection feature to add to them.

To set a Target Collection:

- Right-click (Control-click on singlebutton Macs) a collection listed in the Collections panel and choose Set as Target Collection in the pop-up menu (A).
- 2. In Lightroom's main window, select the photo(s) you want to add to the Target Collection and then take one of the same actions that are available when adding to a Quick Collection:

Press the B on your keyboard.

or

Right-click (Control-click on singlebutton Macs) and choose Add to Target Collection in the pop-up menu.

or

Roll your cursor over an image until a small circle appears in the upper-right corner **1**. Click the circle and an Add Photo to Target Collection note appears briefly. The small, white circle turns gray, indicating that the image is now part of the Quick Collection.

3. The photo(s) are added to the Target Collection.

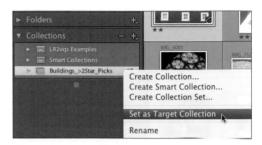

(A) To set a Target Collection, right-click (Controlclick on single-button Macs) a collection in the Collections panel and choose Set as Target Collection.

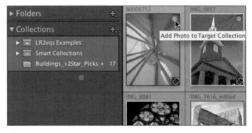

Roll the cursor over an image until a small circle appears in the upper-right corner. Click the circle and a confirming Add Photo to Target Collection note appears briefly.

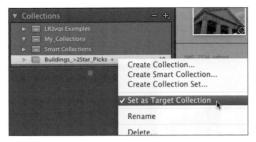

(To turn off the Target Collection, right-click (Control-click on single-button Macs) it in the Collections panel and choose the already checked Set as Target Collection.

	LR2vqs Examples	
V		
r E	Smart Collections	
10- (Buildings_>2Star_Picks	11

D The + mark disappears, signaling that the Target Collection has been turned off.

(IIP) In the Collections panel, the Target Collection is marked with a + (plus) at the end of the collection's name **(B)**.

(IIP) You can target only one collection at a time. But you can quickly set another collection as the target.

(IIP) As with a Quick Collection, using the Grid view or Filmstrip, you can rapidly add images to the Target Collection by selecting the first image, pressing the B on your keyboard, pressing the forward arrow to move to the next image, pressing the B again if you want to add that one, or pressing the forward arrow again to move to the next image.

To turn off a Target Collection:

 Find the Target Collection in the Collections panel; it's marked with a + (plus). Right-click (Control-click on single-button Macs) the Target Collection and choose the already checked Set as Target Collection in the popup menu **(**. The + mark disappears, signaling that the Target Collection has been turned off **(**).

To create a collection set:

- As you create more collections, it helps to group them into sets. In the Collections panel, click the + (plus) and choose Create Collection Set in the pop-up menu .
- In the Create Collection Set dialog, type in a descriptive name. Change the Set pop-up menu to None and click Create .

The new collection set, with an icon like a little shoe box, is added to the Collections panel list **G**.

Collections	Create Collection
	Create Smart Collection
Smart Collections	Create Collection Set
Buildings_>2Star_Picks +	Sort by Name
	✓ Sort by Kind

() To create a collection set, click the + (plus) in the Collections panel and choose Create Collection Set.

e: Coll	ection Set
t: Sm	art Collections
	Create Collection Set
Name:	My_Collections

Give the set a descriptive name, change the Set pop-up menu to None, and click Create.

▼ Colle	ections	- +
Þ	LR2vqs Examples	
VE	My_Collections	
> E	Smart Collections	
	Buildings_>2Star_Picks +	18

G The new collection set, marked with a shoe box icon, is added to the Collections panel list.

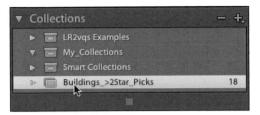

 $\ensuremath{\textcircled{}}$ To make a collection part of a set, select it and...

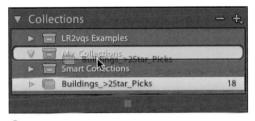

...drag and drop the collection onto a collection set.

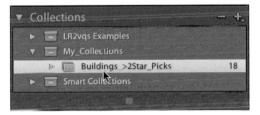

• The selected collection becomes part of the collection set, indicated by an indented listing.

To make a collection part of a set:

- Click a collection in the Collections panel (1), and drag and drop it onto a collection set (1).
- Release the cursor and the selected collection becomes part of the collection set ①.

(IIP) You can create collection sets within collection sets.

Using Smart Collections

Smart Collections generate collections of photos based on rules you create. As you import new photos into Lightroom, Smart Collections use those rules to update their contents. To get you started, Lightroom includes some pre-built Smart Collections (A).

To create a Smart Collection:

- In the Collections panel, click the + (plus) and choose Create Smart Collection in the pop-up menu (B).
- In the Create Smart Collection dialog, type in a descriptive name. Use the Set pop-up menu to choose None or an existing collection set.
- **3.** Use the Match pop-up menu to set whether "all" or "any" of the rules you are to create must be met (see Tip).
- Much as you did in setting the Library Filter metadata searches, use the first drop-down menu—you have 34 choices!—to begin creating your first rule **(C)**. Use the second drop-down menu to expand or narrow the first choice's search.
- 5. To add another rule, click the + (plus) again. (Or, click the (minus) to remove a rule.) When you're done adding rules, click Create **①**. The Smart Collection is added to the Collections panel list **①**.

(III) In step 3, setting Match to "all" narrows your search, while choosing "any" expands the search.

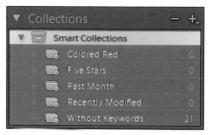

A Lightroom includes some pre-built Smart Collections.

Collections –	4
The second	Create Collection
	Create Smart Collection
	Create Collection Set

(B) To create a Smart Collection, click the + (plus) in the Collections panel, and choose Create Smart Collection.

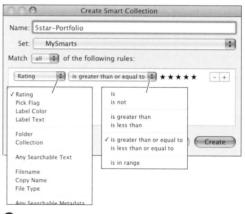

G After naming your Smart Collection, set the Match menu, and use the left-hand drop-down menu to begin creating your first rule. Use the second drop-down menu to expand or narrow the first choice's search.

Name:	5star-Por	tfolio			
Set:	MySma	arts			\$
Match 🕞	all 🗘 o	f the following	rules:		
Rating	0	is greater than (or equal to 🕄	****	- +
Pick Fla	ag 🗘	is	÷	flagged	- +
			G	Cancel (reate

D When you're done adding rules, click Create.

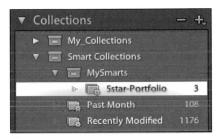

• The Smart Collection is added to the Collections panel.

Collections My_Cullections My_Smart Collections T MySmarts	- +.
Sstar-Portfolio Past Month Recently Modified Without Keywords	Create Collection Create Smart Collection Create Collection Set
	Edit Smart Collection 🔈
	Delete
	Export this Collection as a Catalog
	Export Smart Collection Settings

To edit or rename a Smart Collection, rightclick (Control-click on single-button Macs) a Smart Collection and make a choice in the pop-up menu.

To edit or rename a Smart Collection:

- Right-click (Control-click on singlebutton Macs) any Smart Collection listed in the Collections panel, and choose Edit Smart Collection or Rename .
- Use the Edit Smart Collection dialog to change the collection's rules or its name. When you're done, click Save to close the dialog and apply the edits.

In step 1, you can choose to export a Smart Collection as a catalog, which you could store on another hard drive for safekeeping (). You also can export/import the settings you created for a Smart Collection, which handily enables you to use those settings in another catalog.

Putting It All Together

- Add photos to a Quick Collection one photo at a time, and then by adding multiple photos at once.
- 2. Remove some photos from the Quick Collection.
- **3.** Save the Quick Collection as a regular collection.
- **4.** Empty the Quick Collection so that it's ready for other photos.
- **5.** Create a collection and add some photos to it.
- **6.** Set a Target Collection, add some photos to it, and then turn off the Target Collection.
- 7. Create a collection set and add an existing collection to that set.
- **8.** Create a Smart Collection, name it, and create a set of rules for it.
- 9. Change the name of a Smart Collection.

Developing Images

Developing images—adjusting their exposure, getting the colors just right, tweaking all the details—lies at the heart of photography. Lightroom has so many tools for doing just that, it can overwhelm even darkroom veterans. But the real joy of Lightroom, as you'll discover in this chapter, is how all the tools offer immēdlate *visual* feedback. You make an adjustment and you can see what's right or wrong about it. So don't let all the sliders, expanding panels, and myriad choices faze you. Lightroom actually makes the whole process fun.

In This Chapter

Making Quick Flxes	138
Working in the Develop Module	143
Creating Virtual Copies	144
Updating the Process Version	145
Using the Presets Panel	148
Using the History and Snapshots Panels	150
Making Basic Adjustments	152
Adjusting Tone Curves	157
Using the HSL and Color Panels	162
Creating Black-and-White Photos	166
Using the Detail Panel	172
Using the Lens Corrections Panel	176
Using the Effects Panel	180
Putting It All Together	182

Making Quick Fixes

With the right photo, the Quick Develop panel can work brilliantly (A), (B). Other times it can make a so-so photo worse. Even when Quick Develop gets it wrong, it's easy to change your mind if the results

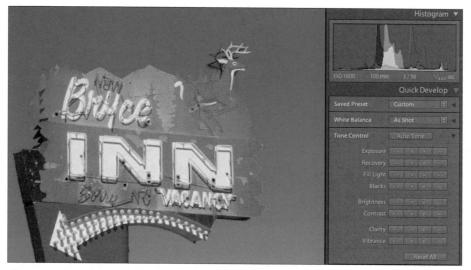

A Sometimes, with the correct photo...

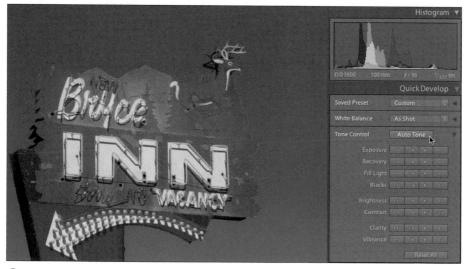

B ...a couple of clicks in the Quick Develop panel can work brilliantly.

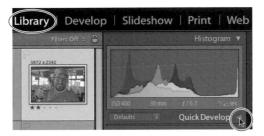

(If the Library module's Quick Develop panel is collapsed, click the right-side triangle to expand it.

Calibrating Your Monitor

If you don't calibrate your monitor, you simply will not be able to produce reliable results-no matter how precisely you apply Lightroom's development adjustments. Software-only packages, such as the Mac's built-in Display Calibrator Assistant, fall short because they depend on our subjective sense of color. which varies from person to person. Hardware-software combinations. which include a device that attaches to the screen to read its light output, cost \$100-\$300. Datacolor, Panlone, and X-Rite produce some of the most popular combinations. What you save in bad color prints quickly makes up for the cost. (For more information, enter "monitor calibrate hardware" in your favorite Web search engine.)

aren't pleasing. So it's often worth giving Quick Develop a try. If the Quick Develop panel doesn't deliver what you need, Lightroom also has the full Develop module.

The Quick Develop panel gives you fast access to most of the major tools found in the Develop module. Reflecting its stripped-down appearance, however, the Quick Develop panel does not offer the precise controls found in the Develop module. As you gain experience with the Develop module's effects, you actually may use the Quick Develop panel more often and with greater confidence. For that reason, this section offers a quick run-through of the Quick Develop controls, leaving the details to later sections highlighting the Develop module (scc page 143).

While initially it seems odd that Adobe put the Quick Develop panel in the Library module instead of the Develop module, the reason is that the Library module is where you review your shots. In sifting the good from the bad, sometimes a few clicks in the Quick Develop panel help you decide if a photo is worth more work later in the Develop module.

To apply Quick Develop adjustments:

- In the Library module, make sure the Histogram panel is expanded, since it helps you gauge the effects of any adjustments. If the Quick Develop panel is collapsed, click the right-side triangle to expand it O. Depending on whether the Quick Develop panel has been opened before, you may need to click each subpanel's right-side triangle to see all of the panel's options.
- 2. In the Grid view, select one or more photos you want to adjust.

continues on next page

- Each section of the Quick Develop panel uses a combination of drop-down menus or arrow buttons to make adjustments to the photo(s), which are applied immediately ①. The single arrow buttons boost or reduce an adjustment by 5 points out of 100. The double arrows apply 20 points of adjustment. You can adjust any of the following settings:
 - Saved Preset: Use the drop-down menu to choose one of Lightroom's built-in develop adjustments, such as Creative-Sepia for an old-style appearance. If you have created any develop presets of your own, they also appear in the drop-down menu. (For more information, see "Using the Presets Panel" on page 148.)
 - **2 Crop Ratio:** Use the drop-down menu to apply one of the common print proportions to the photo(s). (For more information, see "Using the Crop Overlay Tool" on page 184.)
 - **3 Treatment:** The drop-down menu lets you quickly convert a photo from color to black and white. (For a more complicated method that offers richerlooking results, see "Creating Blackand-White Photos" on page 166.)
 - White Balance, Temperature, Tint: Use the White Balance drop-down menu to apply a preset combination of temperature and tint to a photo. You also can use the individual Temperature and Tint buttons to create a custom white balance. (For more information on this and the remaining controls in this section, see "To apply basic adjustments" on page 152.)
 - **5** Tone Control, Exposure, Recovery, Fill Light, Blacks: Click the Tone Control button to apply an automatic

combination of Exposure, Recovery, Fill Light, and Blacks. Or use the arrow buttons to individually apply any of the four controls. Unlike the rest of the Quick Develop buttons, the four controls use "stops" instead of 5- and 20-point steps. (See second Tip.)

- **Brightness, Contrast:** Even in small increments, the brightness and contrast controls are blunt instruments that affect the entire photo's appearance. Use the panel's Tone Control and Clarity sections instead, or switch to the Develop module for more precise results.
- Clarity, Vibrance: Clarity controls contrast in a photo's middle tones.
 Vibrance boosts or reduces color saturation in everything except skin tones.
- If you are not happy with any adjustments, see "To undo Quick Develop adjustments" on page 142. As with all Lightroom adjustments, you don't need to perform a Save command since all the adjustments are captured as metadata as you work.

(IP) When using the single and double arrows to make adjustments, you can apply an in-between value—for example +15—by clicking a combination such as a double arrow (+20) and an opposing single arrow (-5).

If you're unfamiliar with the photographic term *stop* used in the Tone Control section, here's the gist: An *increase* of one stop *doubles* a setting's effect; a one-stop *decrease* reduces the effect by *half*. Also called *f-stops*, they are a measure of how much light passes through a lens opening. The smaller the number, the *larger* the opening. For example, a lens set at f/8 lets in *twice* as much light as one set at f/11. Moving in the other direction, a lens at f/16 lets in *half* as much light as one at f/11.

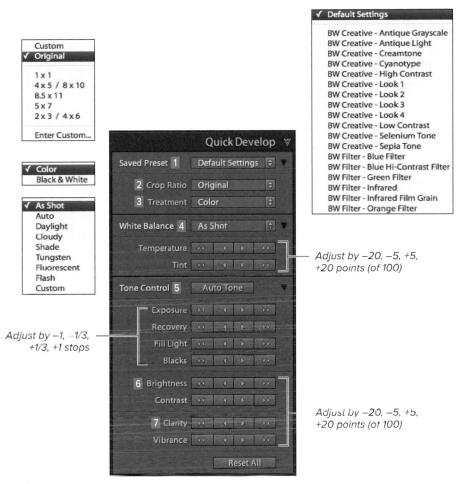

D The Quick Develop panel offers quick access to major image adjustments.

To undo Quick Develop adjustments:

 If you made *no* adjustments to the photo before starting the Quick Develop adjustments, click Reset All. The photo returns to how it looked before you began the Quick Develop work.

or

- If you want to undo only the adjustments you have made with a single tool, such as Tint or Brightness, click the tool's name next to the buttons. The photo returns to how it looked before you began using that particular tool.
- If you made lots of other adjustments to the photo *before* starting your Quick Develop work (crop, exposure, etc.), use the Develop module's History panel. (See "To use the History panel" on page 150.)

Working in the Develop Module

With the exception of the Library module's Quick Develop panel, most of your image adjustments are applied in the Develop module (A). The Left Panel Group contains the Presets, Snapshots, and History panels. The Right Panel Group contains eight separate panels, of which the Histogram, Basic, Tone Curve, and Detail panels are the ones you'll use most often. All these panels apply what are known as global adjustments; that is, they affect the entire photo. Just below the Histogram panel runs the Tool Strip. With the exception of the Cropping tool, the Tool Strip applies local adjustments. These adjustments affect only selected parts of the photo, which you select using masks and brushes. For coverage of the Tool Strip, see Chapter 10 on page 183.

Presets Roll cursor over preset to preview in Navigator

Develop module Highlighted in Module Picket Histogram Updates in real time as adjustments applied

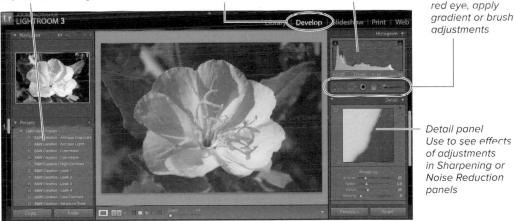

A Most of your image adjustments are applied in the Develop module.

Tool Strip

Five tools let you

crop, fix spots or

Creating Virtual Copies

As with the Library module's Quick Develop panel, you don't need to save your Develop module work since every adjustment is stored as metadata. But Lightroom includes a handy way of making *virtual* copies of your photo. These virtual copies make it easy to compare a photo with one set of adjustments against another version that uses a different set of adjustments. As with everything in Lightroom, these virtual copies are metadata, so they don't hog space on your hard drive.

To make a virtual copy of a photo:

- 1. In the Filmstrip or Grid view, select a photo (or several photos) of which you want to make a virtual copy.
- Right-click (Control-click on singlebutton Macs) the photo(s) and choose Create Virtual Copy/Create Virtual Copies in the drop-down menu (). A copy of the selected photo appears next to the original (master) photo and is marked by a turned-over left corner ().

(A) To make a virtual copy of a photo, right-click (Control-click on single-button Macs) the photo(s) and choose Create Virtual Copy/Create Virtual Copies in the drop-down menu.

 A copy of the selected photo appears next to the original photo and is marked by a turned-up corner.

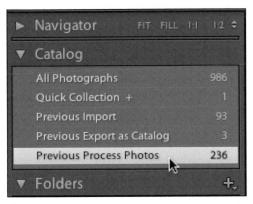

Click the Previous Process Photos entry in the Catalog panel to display those photos in the Grid or Loupe views.

Updating the Process Version

Lightroom 3 includes a new development process for detail and effects adjustments. This process (named 2010 for the year of its release) is not applied automatically to photos you may have originally edited using earlier versions of Lightroom, which used the 2003 process. You can, however, update these previously edited photos, enabling you to take advantage of Lightroom 3's huge improvements in handling sharpening, noise, and post-crop vignetting.

To find pre-2010 process photos:

- 1. In the Library module's Grid view, select a photo source in the Left Panel Group.
- 2. From the menu bar, choose Library > Find Previous Process Photos. The Grid view displays all your pre-2010 process photos.
- 3. Expand the Catalog panel and click the Previous Process Photos entry to see the photos in the Grid or Loupe views. You can update them one by one immediately or return to them as you have time (A).

To update the process version:

- Using the Library module's Grid or Loupe view, select the photo you want to adjust.
- Switch to the Develop module and click the exclamation point button at the photo's bollom-right corner B.
- 3. Choose Review Changes via Before/ After C (see Tip). Click Update.
- 4. When the Before/After view appears, click on a darker part of the photo to check the relative noise of each version. If you're satisfied with the results, return to the Loupe view. If you're not happy with the results, see "To revert to the original process version" on page 147.

(III) As you get a better sense of how Lightroom 3's 2010 process handles images originally edited in Lightroom 2, you might skip choosing Review Changes via Before/After. If your Filmstrip contains only similar images from the same shooting session, you might even click Update All Filmstrip Photos.

B To update the process version, click the exclamation point button below the photo.

	Update Process Version
Lr	New processing technology is available for this image. Slight to moderate visual changes in noise reduction and sharpening adjustments may occur as part of the update. You may elect to preserve the original settings by selecting Cancel.
	Review Changes via Before/After
	Update All Filmstrip Photos Cancel Update

C Choose Review Changes via Before/After before clicking Update.

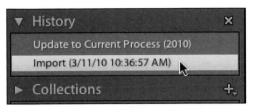

D To revert to the 2003 process version, click the entry below the process update entry in the History panel.

To revert to the original process version:

- Open the History panel in the Left Panel Group. Update to Current Process (2010) appears at the top.
- Click whatever entry appears right below the process update entry ①. The photo reverts to the 2003 process.

Using the Presets Panel

Lightroom's built-in Develop presets include many of the adjustments you are most likely to need. Preview them in the Presets panel to see what's possible before you even touch the Develop module's Right Panel Group. They also provide handy starting points for creating your own just-so development settings, which you can then save in the User Presets section of the Presets panel.

To preview and apply a Develop preset:

- Using the Library module's Grid or Loupe view, select the photo you want to adjust.
- Switch to the Develop module and open the Navigator and Presets panels in the Left Panel Group.
- Roll your cursor over the list of presets, and the Navigator offers a preview of each effect (). When you find a preset you like, click it in the list and the effect is applied to the photo.

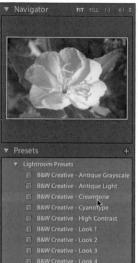

Roll your cursor over the list of presets, and the Navigator offers a preview of each preset's effect.

B When you have a setting you might want to apply later to another photo, click the + (plus) in the Presets panel.

New Devel	op Preset
Preset Name: vignette(-100,24	midpt)
Folder: User Presets Auto Settings	ţ.
Auto Tone	
Settings	
White Balance	Treatment (Color)
Basic Tone Exposure Highlight Recovery Fill Light Black Lipping	Color Saturation Vibrance Color Adjustments
Contrast	Split Toning
Tone Curve	 Vignettes Lons Vignetting Post-Crop Vignetting
Clarity	Ciaduated Filters
Sharpening Noise Reduction Luminance	Process Version Calibration
Color	Chromatic Abervation
🗌 Grain	Lens Profile Lorrections
Check All Check None	Cancel Create

(Name the new preset, clear all the settings by clicking Check None, and then select only the effects you want made part of the preset.

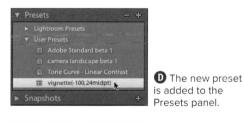

To delete a Develop preset, select the preset in the panel and click the – (minus).

To create a Develop preset:

- 1. In the Develop module, apply any effects you want to a photo.
- When you have a combination of settings that you might want to apply later to another photo, click the + (plus) in the Presets panel ().
- When the New Develop Preset dialog appears, name the new preset, leave the folder set to User Presets, click Check None, and select only the effects you want made part of the preset G. Click Create to close the dialog, and the new preset is added to the User Presets section of the Presets panel D.

In step 3, give your preset a name that precisely describes its effect. "Nice vignette" will not mean much three months from now, while "vlgnette(-100,24midpt)" remains obvious.

(IIP) Watch as you work for any series of develop adjustments for which you can create a preset. Collectively they can become tremendous timesavers in your workflow.

To delete a Develop preset:

 Select the preset in the panel you want to delete and click the – (minus). The preset is removed from the list ⁽¹⁾.

Using the History and Snapshots Panels

The History and Snapshots panels work like time machines by enabling you to get back to a particular spot in your sequence of applying develop adjustments. The History panel records in sequence every adjustment you make and enables you to rewind the process step-by-step. While found within the Develop module, the panel can also be used to reverse course when a Quick Develop adjustment goes awry.

As you apply a long series of development adjustments, it can be handy to take "snapshots" when you like the results so far. If you want to retrace your steps, you can jump right back to one of those snapshots.

To use the History panel:

- To roll back a photo's adjustment in either the Develop module or the Library module's Quick Develop panel, open the Develop module's Navigator and History panels.
- 2. The most recent adjustments to the photo are listed at the top of the History panel. Roll your cursor over the list, watching how the photo's appearance changes in the Navigator panel **(A)**.
- **3.** When you find a setting you like, click it in the list and those adjustments are restored to the photo. You can then resume your work in the Develop module's Right Panel Group or switch back to the Library module's Quick Develop panel.

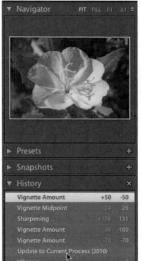

Roll your cursor over the History list to see how the photo's appearance changes in the Navigator panel.

B Click the + (plus) to create a new snapshot.

Snapshot Name:	Untitled Snapshot
000	New Snapshot
Snapshot Nar	ne: vignette -70, 50
	Cancel

(Name the listing and click Create to add it to the Snapshots list.

• The newly created snapshot is added and highlighted in the Snapshots panel.

 Name your Snapshots based on the actual numbers in the right-hand adjustment panel. The History entry here doesn't match because it uses numbers *relative* to the previous setting.

To use the Snapshots panel:

- To preserve a set of development adjustments, whether currently or previously applied to a photo, roll your cursor over the list of applied adjustments in the History panel. When you find the one you like, click it. The photo changes to reflect those adjustments.
- Go to the Snapshots panel (also in the Develop module's Left Panel Group) and click the + (plus) B.
- Type a descriptive name for the setting in the New Snapshot dialog and click Create (). It's added to the Snapshots panel list, as well as the History panel ().
- **4.** To return the photo to this snapshot's settings at any time, click its name in the Snapshots panel.

In step 3, name your snapshot based on the numbers appearing in the relevant adjustment panel in the Right Panel Group. Don't simply repeat the name or numbers generated in the adjacent History panel **3**. The reason is that the History name is *relative*: It tells you how much that setting has changed from its *previous* setting. It offers you no clues, for example, about a vignette setting's actual midpoint or amount.

Making Basic Adjustments

You'll make the majority of your development adjustments in the Basic panel, which controls three key aspects of any photo: its color balance, its tone, and its presence. If you have already used the Library module's Quick Develop panel, you've gotten a taste of what the three do. However, you'll find that the Develop module gives you much finer control over their settings. In most cases, Lightroom's panels and the tools within them are arranged with the first-to-use adjustments at the top and the last-to-use at the bottom. You can use them in any order you like, but top to bottom generally yields the most consistent results. Remember as well that you can further adjust a photo using the Tone Curve panel (page 158).

To apply basic adjustments:

- 1. Make sure the Histogram panel 1 is expanded to help you gauge the effects of any adjustments. If the Basic panel is collapsed, click the right-side triangle to expand it **A**.
- 2. Open the Filmstrip and select a photo you want to adjust. In Lightroom's main window, click the YIY button in the lower left to set which Before and After view you want to use **B**. Lightroom's main window presents a before and after version of the photo, which helps gauge the effect of the adjustments **G**.
- **3.** Use any of the Basic panel's **2** controls, whose adjustments are applied immediately as you move the sliders:
 - 3 Treatment: To convert a photo from color to black-and-white, click the Black & White button. (For a more complicated method that offers richer-

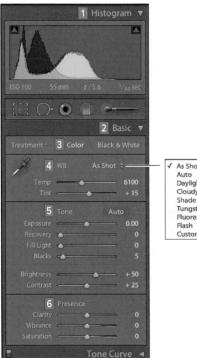

✓ As Shot Daylight Cloudy Tungsten Fluorescent Custom

🚯 Make sure the Histogram panel 🚺 is expanded to help you gauge the effects of any adjustments made in the Basic panel.

B Click the YIY button to set which Before and After view you want to use.

C The Before and After versions of the photo help you gauge the effect of adjustments.

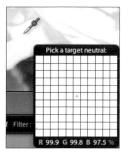

D Click the White Balance panel's eyedropper and use it to find a color-neutral white or gray in the photo.

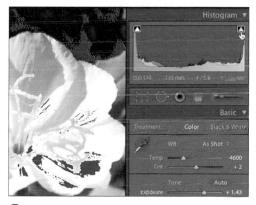

(B Turn on the clipping indicators in the top corners of the Histogram. Areas without highlight details are red; blacks without detail are blue.

() You can adjust the tones by click-and-dragging left or right within the Histogram.

looking results, see "Creating Blackand-White Photos" on page 166.)

4 WB (White Balance): Temperature, Tint: With many of today's digital cameras, you can leave the WB drop-down menu set to the default of As Shot. If the camera's auto white balance was turned off, however, use the drop-down menu to choose a more appropriate setting (Shade, Fluorescent, Flash, etc.). If your photo contains several light sources of different colors (flash being bluer than daylight, for example), you may need to create a custom setting. To do so, click the White Balance Selector (eyedropper) and move it over your photo to a color-neutral white or gray. indicated when the floating panel's RGB values are roughly equal (). (It doesn't matter if all three read 30 or 90 percent as long as the values are about the same.) When you find the point, click the eyedropper and a custom white balance is applied. (For another approach, see "Syncing White Balance" on page 156.)

5 Tone: (Auto), Exposure, Recovery, Fill Light, Blacks: Begin by turning on the clipping indicators in the top corners of the Histogram (B. Areas in the photo where details are being lost in the highlights turn red, while blacks without detail turn blue. Clipping also appears in the Histogram when the graph line is cut off (clipped) on the right or left sides. While you can click the Auto button to apply an automatic combination of Exposure, Recovery, Fill Light, and Blacks, you'll have more control applying each individually, using the sliders or click-and-dragging left or right within the Histogram **(B**).

continues on next page

Syncing White Balance

Rather than adjust a photo's white balance using the method explained on page 153, some photographers use a neutral gray card. By snapping a photo of the card in the *same light* striking the subject, you can create an absolute reference point to use in Lightroom.

- In the Develop module's Filmstrip, select two photos: *first* the one containing the gray card, and *then* the other of the subject shot in the same light

 This sequence makes the photo of the card the *active* photo of the two selected 1. The active photo appears in Lightroom's main window 2.
- Click the White Balance Selector in the top-left corner of the White Balance section of the Basic panel 3. Your cursor becomes an eyedropper. Move the eyedropper into the photo and click to sample the card's neutral gray area 4.
- **3.** Click the Sync button at the bottom of the Right Panel Group **1**.
- 4. White Balance should be the only item selected in the Synchronize Settings dialog (C). Click Synchronize to close the dialog and apply the setting to the other photo selected in step 1. You can double-check if the setting was applied by selecting that photo and expanding the History panel. The same process can be used to apply adjustments in one photo to other photos.

White Balance	Treatment (Color)	Spot Removal
Basic Tone	Color	Crop
Exposure	Saturation	Straighten Angle
Highlight Recovery	Vibrance	Aspect Ratio
Fill Light	Color Adjustments	
Black Clipping		
Brightness	Split Toning	
Contrast		
	Vignettes	
Tone Curve	Lens Vignetting	
	Post-Crop Vignetti	ng
Clarity	-	
	Local Adjustments	
Sharpening	Brush	
Noise Reduction	Graduated Filters	
	Process Version	
Color	Calibration	
	Canbration	
Grain	Chromatic Aberration	
	Transform	
	Lens Profile Correction	5

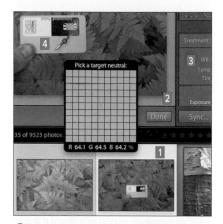

Make the photo with the gray card your active photo in the Filmstrip 1, and it also appears in the main window 2. Click the top-left circle in the White Balance panel 3 to activate the eyedropper tool and sample the card's neutral gray 4.

• After sampling the card, click the Sync button.

White Balance should be he only item selected in the Synchronize Settings dialog.

Adjusting Tone Curves

Use the Tone Curve panel as a follow-up to the changes you make in the Basics panel. Focus on fine-tuning the tonal areas that may still need a bit of tweaking. Usually, only one or two of the four settings, such as the highlights or shadows, need adjusting. Very occasionally, you might need to adjust three settings. If you find yourself tempted to adjust all four, first roll your cursor up to the Histogram panel and readjust your overall exposure. While adjusting the curve helps many photos, it performs near miracles on raw camera files, which contain far more image information.

Controlling the Tone Curve Panel

Take a moment to study the controls packed into the powerful Tone Curve panel A. Many of them are found nowhere else in Lightroom. Compared with Photoshop's somewhat cryptic curve controls, Lightroom's make it much easier to puzzle out how to best adjust the curve. The Targeted Adjustment tool is particularly helpful, since it lets you click directly in the photo and adjust the curves for a particular area—without having to mess with the Tone Curve panel's sliders. Targeted Adjustment Tool: Easy and fast to use, this tool also gives you fairly precise control over an image's tones. Unlike the Edit Point Curve button, it also protects you from posterizing tones by accidentally dragging them too far from their original positions.

Region Sliders: Click any of the four region sliders and Lightroom immediately highlights the affected area of the tone curve. Drag a slider left or right to adjust that portion of the curve. To return any slider to zero, double-click its label. The sliders

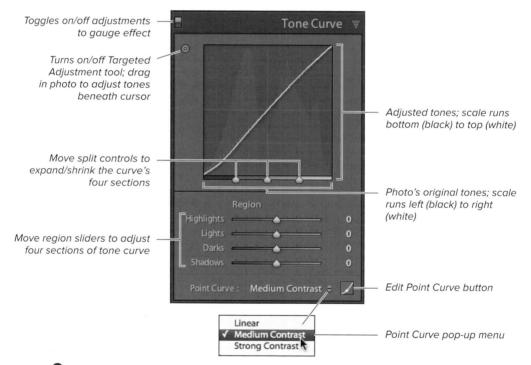

A Take a moment to study the controls packed into Lightroom's powerful Tone Curve panel.

(B) In the Tone Curve panel, click a Region slider or roll the cursor over the curve to highlight the part of the curve affected.

include a nice feedback feature for adjusting the curve: Roll the cursor over a slider and the graph spotlights which section of the curve will be affected **B**. Better still, it even shows you the maximum and minimum changes you can apply to that section.

Split Controls: By default, the split controls divide the tone curve into even fourths. Drag the controls to narrow or widen any of the four sections of the curve: Shadows, Darks, Lights, or Highlights. Then adjust that curve portion using the Targeted Adjustment tool or region sliders. Doubleclick each Split point to return it to its default position.

Point Curve pop-up menu: Clicking the menu reveals three choices. Most of the time, you'll leave it set to the default Medium Contrast setting and use the sliders to adjust your tones. Medium Contrast slightly lightens the highlights and slightly darkens shadows, represented by the slightly curved line running diagonally across the tone curve graphic. Strong Contrast boosts the milder effects of Medium Contrast. Linear, as the name implies, applies a straight line, indicating no tones have been lightened or darkened.

Edit Point Curve button: Clicking the button lets you add or change individual points on the tone curve. Unless you're a veteran Photoshop user, however, leave it alone. In fact, even Photoshop pros should try using the region sliders, which protect the image by keeping you from distorting the curve.

To adjust the tone curve:

- Select the photo you want to adjust and switch to the Develop module. Make sure the clipping indicators are turned on in the Histogram. Switch the main window to Before/After using the split screen button or by pressing the Y key.
- 2. Set the Navigator panel in the Left Panel Group to Fit and 1:1 or 2:1 (C). This way you can toggle your view of the photo as you adjust the tone curve.
- **3.** Leave the Point Curve setting at the bottom of the Tone Curve panel on the default of Medium Contrast.
- Adjust the tone curve by one of three methods: dragging the panel's curve, moving the region sliders, or, as in this example, using the Targeted Adjustment tool.
- 5. Select the Targeted Adjustment tool by clicking the small circle in the Tone Curve panel's top left. Roll the cursor over an area of tones in the photo you'd like to change. The cursor changes to a crosshair pointer, and a circle with a double-headed arrow appears nearby D.
- Press Z to zoom in for a closer view. A light background appears behind the affected portion of the curve in the Tone Curve panel (). Adjust your cursor position if needed.

(Set the Navigator panel in the Left Panel Group to Fit and 1:1 or 2:1.

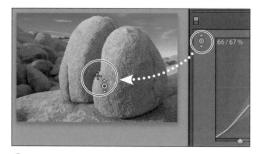

Click the small circle in the Tone Curve panel's top left, then roll the cursor over an area in the photo whose tones you'd like to change.

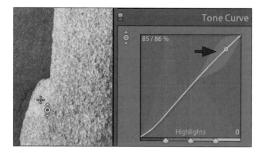

 Press Z for a closer view as you fine-tune your cursor position. The affected portion of the curve is highlighted and labeled in the Tone Curve panel.

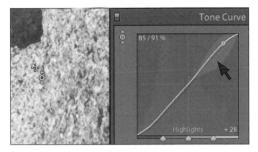

Dragging the cursor up lightens the tone, as reflected in the thumbnail and the curve's shifting upward from its previous position, marked by the dotted line.

G Narrow or widen a section of the curve by shifting the lone curve's split controls at the bottom of the graph.

- Click and drag your cursor up or down to adjust the tone in that area—and all similar tones in the photo. Dragging up lightens the tone; dragging down darkens it. The photo changes to reflect the adjustment, as does the panel's curve ①.
- To fine-tune the adjustment, use your keyboard's up and down arrows to jump either way in increments of 5.
 Press Z to toggle between the zoomed and full view of the photo to gauge your progress.
- 9. Once you're satisfied, click the Targeted Adjustment tool to turn it off. Take a snapshot of your work to make easier to jump back to this point if needed later. If you want to adjust another photo area—or another portion of the curve such as the shadows—repcat steps 5–8.

You can narrow or widen any of the curve's four sections by shifting the tone curve's split controls at the bollom of the graph **(G)**. Then readjust that section of the curve using the Targeted Adjustment tool or the region sliders.

(IIP) You don't have to turn off the Targeted Adjustment tool in step 9 if you want to go straight from adjusting, for example, the highlights to the shadows.

Lightroom now lets you click and drag a single *point* on the curve. While long a staple of Photoshop, many photographers say they find adjusting the curve by *sections* easier and more intuitive.

Using the HSL and Color Panels

The HSL, Color, and B&W panels all nest together about midway down the Right Panel Group. The HSL (Hue, Saturation, and Luminance) and Color panels come at the same essential tasks from different directions. The HSL panel organizes the tasks into three separate views, or tabs (). You use one to adjust all your hues, another for all the saturations, and a third for all the luminance values. In the Color panel, each color appears with its own group of HSL sliders, making it a natural way to focus on a single color at a time ().

Whichever approach you use, both panels control a selected color's hue or range (such as how blues range from aqua to near purple), saturation (the intensity from faded to deep), and luminance (darkness to lightness). The Color panel does this with just sliders, while the Hue panel also includes a Targeted Adjustment tool like the one found in the Tone Curve panel. (The B&W [Black & White] panel is covered separately, beginning on page 167.)

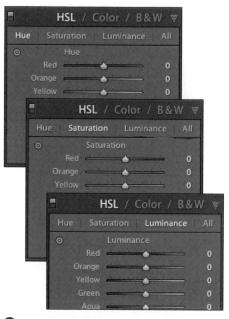

A The HSL panel offers three views, or tabs: Hue, Saturation, and Luminance.

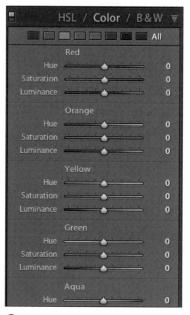

B In the Color panel, each color has its own group of HSL sliders.

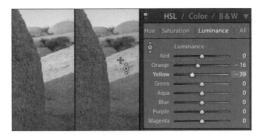

(By enabling you to click and drag directly in the photo, the Targeted Adjustment tool makes it easier to change the intended hue, saturation, or luminance.

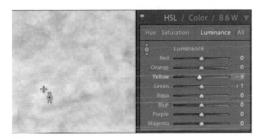

O Zoom in for more precision when using the Targeted Adjustment tool. Only the Yellow slider has been affected here, compared with Yellow and Orange in O.

To adjust the HSL controls:

- Switch the main window to a Before/ After view by pressing the Y key. Set the Navigator panel in the Left Panel Group to Fit and 1:1 or 2:1 so that you can toggle your view as you adjust the hue, saturation, or luminance.
- 2. When the HSL panel is set to All, it makes for a deep, unwieldy panel. So click one of the other three labels—Hue, Saturation, or Luminance—and begin adjusting that aspect of the photo ().
- Click the Targeted Adjustment tool within the active section (Hue, Saturation, or Luminance) to turn it on. Then click directly in the photo on the color range you want to adjust. Drag the tool up or down to respectively increase or decrease the selected aspect. Lightroom automatically selects the correct slider or sliders in the panel and applies the adjustment C.
- 4. If the adjustment changes too broad an area, undo the action (Ctrl-Z/Cmd-Z). Then click and drag in the Navigator panel, along with the Z key, to zoom in on an area. You can then apply the Targeted Adjustment tool again with better control **●**. (Compare **●** and **●** to see how the zoomed-in adjustment changed the luminance for only the Yellow slider and not the Orange.)

continues on next page

5. If you need to adjust another area of the photo, click there and Lightroom automatically activates the correct sliders. When you are done making adjustments, click the Targeted Adjustment tool again (or the Done button in the main window) to turn it off.

It's tempting when trying to give colors a bit more punch to head to the Saturation panel. But boosting a color's saturation even a tad can quickly look artificial. As in step 3, try using the tool to change the *Luminance* for a color instead. It's more subtle—and often more effective.

(III) The Targeted Adjustment tool can be used in four panels, but you don't have to close the tool in one panel to use it in another. Instead, click the Target Group pop-up menu beneath the photo you're adjusting and choose another panel **(3)**. It's a nice timesaver since it's common after making an HSL adjustment to re-tweak the Tone Curve panel.

(IIP) The arrangement of the Hues in the HSL panel offers a visual clue to how each slider depicts a *range* of colors **()**. At the top, the Red slider ranges from very red on the far left to nearly orange on the far right. Drop down to the Orange slider and you'll see that the far *left* color nearly matches the Red's far *right* color. This holds true for all eight sliders, with Magenta's far-right color nearly matching Red's far-left color. It's quite helpful for understanding how your hue adjustments may affect colors.

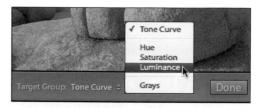

The Targeted Adjustment tool can be used in four panels; jump to each using the pop-up menu in the main window.

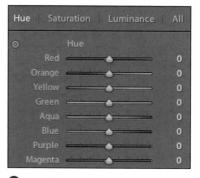

Get a hue clue: The far-*right* color of each slider continues at the far-*left* of the slider below it.

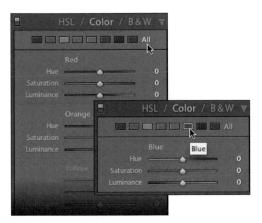

() To see all 24 sliders in the Color panel, click All (top). Or click a single color range, and the panel collapses to show only the HSL sliders for that color (bottom).

To adjust the Color controls:

- Switch the main window to a Before/ After view. Set the Navigator panel in the Left Panel Group to Fit and 1:1 or 2:1. This way you can toggle your view of the photo as you adjust the colors.
- In the Color panel, select All to see every color range or click a single color range label if you want to focus on tweaking only one at a time (top, G).
- Choose which aspect you want to adjust (Hue, Saturation, or Luminance) by clicking and dragging its respective slider (bottom, ^(C)). When done, you can choose another color range label and make adjustments to it.

The sliders-only Color panel lacks the HSL panel's Targeted Adjustment tool. If you can't get the effect you need in the Color panel, try finessing it with the tool in HSL.

Creating Black-and-White Photos

When you shoot with black-and-white film, or use a digital camera's black-and-white effect setting, all the colors in the scene are mapped to various tones of gray. Once you take the photo, you can't convert it back to color. You also cannot precisely adjust which colors mapped to which tones of gray. With Lightroom, however, you can shoot in color, convert the scene to black and white, and adjust that sky so that it's a light, airy gray or a dark, dramatic gray. Then, if you don't like the results, you can convert that photo *back* to color just by clicking the HSL or Color labels in the HSL/Color/B&W panel.

You have a lot of options when working with black-and-white photos in Lightroom. You can adjust which colors are mapped to which black-and-white tones. This is done in the Black & White Mix section of the HSL/Color/B&W panel. Another approach is to keep the photo in color but create a black-and-white effect by playing with its saturation and luminance (see page 168). Finally, you can use the Split Toning panel to tone the photo with a single color, or assign one color to a photo's highlights and another to its shadows. Warm sepia and bluish cyanotype photos are the most common digital examples of this old darkroom chemical technique. The Presets panel includes several such toning effects that you can apply with a single click (see page 148). To apply your own split tones to a black-and-white photo, see page 170.

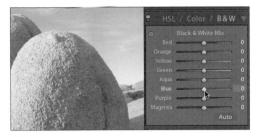

After you click the B&W label, the photo's colors become black-and-white tones, with all sliders set to 0.

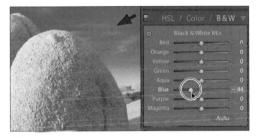

B Drag any slider left (to darken) or right (to lighten) a particular gray, in this case Blue to darken the sky.

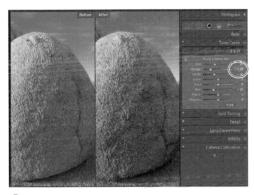

G Roll the Targeted Adjustment tool over the *Before* view to pick a color whose gray you want changed in the *After* view.

To adjust the black-and-white mix:

- Adjust the photo's exposure in the Basic panel beforehand. Expand the HSL/Color/B&W panel and click the B&W label. The photo's colors immediately switch to black-and-white tones, and all eight sliders are set to 0 ().
- In the Black & White Mix section of the panel, drag any slider left (to darken) or right (to lighten) a particular shade of gray .
- **3.** For more control, press Y to see Before and After views of the photo. Click the panel's Targeted Adjustment tool and roll it over the *Before* view to pick a color whose gray you want to darken or lighten in the *After* view **(**.
- 4. Adjust how the photo's various colors map to different black-and-white tones until you're happy with the results. Once you are done, click the Targeted Adjustment tool again (or the Done button) to turn it off. If you're planning to create a split tone version of this photo (see page 170), create a snapshot now so you can easily return to this version later on.

(IIP) You also can convert a photo from color by pressing Y or by expanding the Basic panel and clicking Black & White in the Treatment area.

To use saturation/luminance for black-and-white effect:

- Adjust the photo's exposure in the Basic panel and switch the main window to either of the Before/After split screen choices. Set the Navigator panel in the Left Panel Group to Fit and 1:1 or 2:1 so that you can toggle your view as you apply adjustments.
- 2. Expand the HSL panel and click the Saturation label. Drag all the sliders to the far left (−100), and the desaturated photo loses its color **①**.
- **3.** Click the Luminance label in the HSL panel, and click the Targeted Adjustment tool to turn it on. Click in the *Before* (color) view of the photo on an area where you want to adjust the luminance.

Watch the After (desaturated) view of the photo as you drag the cursor (E). Move it down to darken the area or up to lighten it, and the luminance sliders move to reflect the changes.

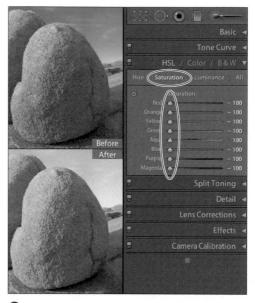

D Under the Saturation label, drag all the sliders to the far left, and the photo appears to lose its color.

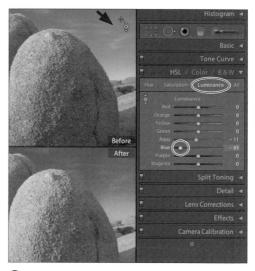

(c) After clicking the Luminance label in the HSL panel, turn on the Targeted Adjustment tool and click in the *Before* (color) view on an area you want to adjust. Here, I've darkened the sky by reducing its luminance.

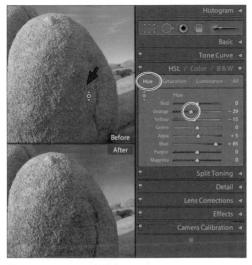

Click the Hue label in the HSL panel and try fine-tuning a hue or two with the Targeted Adjustment tool.

- 4. After adjusting the luminance as needed for various areas, you may want to click the Hue label in the HSL panel. Unless you already turned off the Targeted Adjustment tool, it remains active. Again, click and drag in the *color* (Before) view of the photo on any areas where you want to adjust the hue ①. (You may need or want to re-tweak some of the luminance sliders afterward.)
- When you're satisfied, click the Targeted Adjustment tool again (or the Done button in the main window) to turn it off. The tones using this method (are often better separated compared to the Black & White Mix method (1).

This saturation and luminance approach might seem like a lot of trouble compared to adjusting the black-and-white mix. But it enables you to still adjust the luminance, or even the hue, giving you more control over the final image.

(The saturation and luminance approach sometimes gives you more control over gray tones...

(1) ...than using the Black & White Mix controls, especially in midtones like those in the foreground rocks.

To use the Split Toning panel:

- Select a photo that you've already converted to black and white, fixed its basic exposure, and adjusted its mix of tones. Expand the Split Toning panel and click the box just right of the Highlights label to open the Highlights panel 1.
- To select a color to apply to the photo's highlights, roll the cursor (which becomes an eyedropper), over one of the colored boxes or anywhere in the color spectrum box. Click to sample the color, which is applied immediately to the photo's highlights ①.
- Click and drag the Highlight panel's S slider to change the chosen color's saturation, or click another color you like better (). When you're done, click the top-left X to close the Highlights panel. If you are happy with the results, you can stop after applying the single tone.
- **4.** To apply a second tone to the photo's shadows, click the box to the right of the Shadows label in the Split Toning panel.

To apply split toning, start with a photo you have already converted to black and white and expand the Split Toning panel.

Olick the box just right of the Highlights label to open the Highlights panel.

Click to sample a color, which is applied immediately to the photo's highlights.

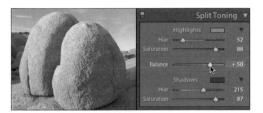

• After applying both tones, use the Balance slider to adjust the point where the shadow tone gives way to the highlight tone.

- Roll the cursor, which becomes an eyedropper, over one of the colored boxes or anywhere in the color spectrum box. Click to sample the color and it is applied immediately to the photo's shadows.
- 6. Click and drag the S slider to change the chosen color's saturation, or click another color you like better. When you're done, click the top-left X to close the Shadows panel.
- 7. Once you apply both tones, use the Split Toning panel's Balance slider to adjust the dark-to-light point where one tone gives way to the other **①**.

(IIP) After creating a particular highlight or shadow tone, you can save it in the Highlights or Shadows panel. Select the color in one of the panels, then click and hold your cursor on one of the five color boxes to replace that old color.

(IIP) To get a better feel for how various color choices and saturations affect a photo's appearance, apply some of the Precets panel's effects and look at the settings generated in the Split Toning panel.

Using the Detail Panel

The Detail panel does exactly what its name suggests: lets you see a photo's individual pixels *without* blocking your overall view of a photo. The panel contains tools for two tasks that especially benefit from this view: sharpenIng and noise reduction **(A)**. Thanks to Lightroom 3's new process version, both controls do a much better job (see page 145). (The controls for adjusting chromatic aberration are now in the Lens Corrections panel).

Around since the earliest days of Photoshop as the Unsharp Mask filter, sharpening tools find the edges in a photo and boost the contrast along them. Done right, you don't know it's being used. Done wrong and you wind up with halos and edges craggier than a cliff. How much you sharpen depends on the photo obviously, but there are general rules as well. JPEG photos are automatically sharpened some by the camera. Raw files are untouched by the camera and, so, usually need some sharpening. In addition to the sharpening applied here in the Develop module's Detail panel, Lightroom's Slideshow, Print, and Web modules can apply sharpening tailored to each of the three media.

"Noise" in digital photography is the equivalent of grain in film photography. It's often caused by shooting a scene with the camera set with an ISO of 200 or more. Generally, the more expensive the camera, the better it is at suppressing noise. (Though many times a tripod or flash will do the job for fewer bucks.) Sometimes you may like the noise effect; many times you want to reduce its visibility as much as possible. The Noise Reduction section has two tools to do this. Luminance suppresses the differences between dark and light areas

A The Detail panel contains tools for sharpening and noise reduction.

Right-click (Control-click on single-button Macs) the Detail panel window to make sure you are zoomed to at least 1:1.

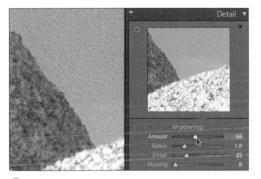

G Press Alt/Option while dragging the Sharpening panel's Amount slider, and you will see a blackand-white version of the photo, which can make it easier to judge the effect.

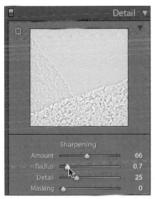

D To fine-tune the Radius adjustment, press Alt/Option while dragging its slider.

within the noise. Color suppresses the differences between tiny color splotches in the noise. Both tools include options for setting how much detail you want to preserve. Take some time to experiment with both tools to discover which works best for individual photos.

To adjust sharpening:

- After selecting the photo to adjust, click the crosshair in the Detail panel's topleft corner and then click in the photo on the problem area. The panel's closeup window zooms to that area. Rightclick (Control-click on single-button Macs) the window to make sure you are zoomed to at least 1:1 before starting ^(B).
- 2. The Detail panel's Sharpening section has four sliders (). By default, the Amount slider is set to 25. To adjust the effect, which is often likened to a volume control, press Alt/Option while dragging the slider. The zoom window shows a black-and-white version of the photo, which can make it easier to see the effect.
- By default, the Radius slider is set to 1 with a maximum of 3 (pixels). To flnetune the effect's pixel width, press Alt/ Option while dragging the slider. The zoom window shows a black-and-white version of the photo, which can make it easier to see the effect ①. The effect is smoother if the Radius is set no higher than 1.

continues on next page

- By default, the Detail slider is set to 25. To adjust the effect, which controls the photo's apparent texture, press Alt/ Option while dragging the slider. The zoom window shows a black-and-white version of the photo, which can make it easier to see the effect ¹/₂.
- 5. By default, the Masking slider is set to 0 (zero). Masking works like an overlay that controls the collective effect of the other three sliders. At 0, the mask is off and solid white, which means it's not blocking the other three sliders **()**. At 100, the masking is fully on and solid black, completely blocking the effects of the other three sliders. To adjust the masking between those extremes, press Alt/Option while dragging the slider. The zoom window shows the mix of white, which lets the effects of the other sliders show through: and black. where those effects are blocked. Like a smoky window, the gray areas let some of the other three effects show through **G**. **B**.

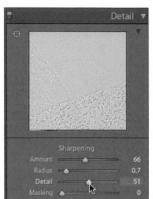

• The Detail slider controls the photo's apparent texture.

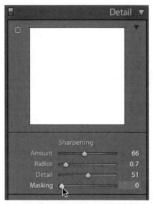

Masking works like an overlay that controls the collective effect of the Amount, Radius, and Detail sliders. At 0, the mask is off and solid white, so it's not blocking the other three sliders.

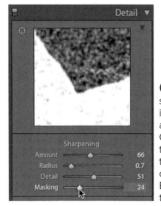

G With the slider set low, masking is applied broadly across the image. Gray areas let through *some* of the effects of the other three sliders. Black lets none through.

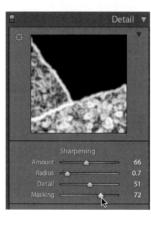

With the slider set high, masking is applied to only the strongest edges seen in the original, unadjusted image.

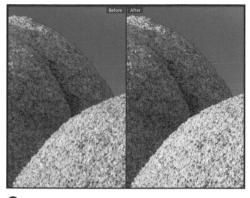

If you use the Before and After views to assess your sharpening adjustments, make sure you zoom in to at least 1:1.

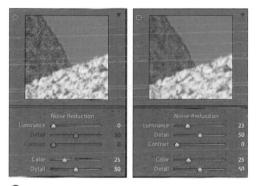

Left: Before any noise reduction. Right: The Luminance slider does most of the work in this example. Having set all four sliders, you may need to readjust some of them to get the overall sharpening effect you want.

(III) Before Lightroom 3, using the sharpening preview at anything less than a 1:1 view didn't give you an accurate sense of its effects. With the new process version, the Fit view provides a ballpark sense of the sharpening effects. If you need speed, use Fit view; if you need to be dead certain how the sharpening will look, stick with a 1:1 view in either the Detail panel window or the main window **(1)**.

(IIP) Use the on/off toggle switch at the Detail panel's top-left corner to help you better gauge the results of your sharpening.

You can now apply *negative* sharpening. Anything between –50 and –100 blurs the edges.

To adjust noise reduction:

- Be sure the Detail window is set to at least 1:1. After selecting the photo to adjust, click the crosshair in the Detail panel's top-left corner, and then click on the problem area in the photo. The panel's close-up window zooms to that area (left, 1).
- Click and drag the Luminance and/or Color sliders while watching the panel's close-up window. More often than not, only one of the tools needs to be used (right, ①). Pushing either slider to the far right reduces the photo's crispness; use their adjacent Detall sliders to suppress noise along narrow edges.

Using the Lens Corrections Panel

Nearly every lens has flaws that affect the quality of your photos. Most of the problems boil down to geometric distortion, uneven light capture, or color shifts. The Lens Corrections panel handles them all. The panel's Profile section offers the ability to automatically correct problems using a lens-by-lens database **(A)**. For now, the available profiles cover only a handful of Canon, Nikon, and Sigma lenses. But over time, Adobe and third-party vendors are expected to generate hundreds more profiles. Until then, the panel's Manual section enables you to fix many lens problems by hand. (You also can download Adobe's Adobe Lens Profile Creator for generating custom profiles for your lens at http://labs. adobe.com.)

There are two kinds of photographic vignetting—uncontrolled and deliberate. The panel's Lens Vignetting section covers the kind you want to minimize: uncontrolled lens vignetting, which causes an image to darken in the corners. You may see it in photos with large areas of uniform color, such as a clear sky. What's called post-crop vignetting is sometimes added to portraits to direct a viewer's attention to the center of the photo. That's explained under "Using the Effects Panel" on page 180.

The final problem handled by the panel is chromatic aberration, or color fringing. An artifact of how your lens bends different colors of light, it's most noticeable in photos where a section of sky meets a darker object. (In Lightroom 2, its controls were in the Detail panel.)

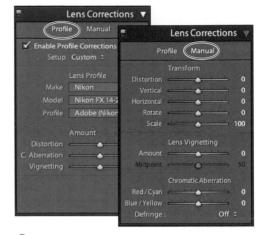

A The Lens Corrections panel fixes problems with geometric distortion, light capture, and color shifts. Until more profiles are available, you'll do most of your work in the Manual section (right).

B It's easy to fix problems created by shooting close with a wide-angle lens.

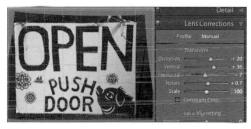

() Start with the Vertical or Horizontal sliders and use the grid over the photo for live feedback about your adjustments.

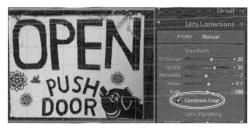

D Select Constrain Crop to trim off the bent edges of the photo.

To correct lens geometry problems:

- Select a photo needing correction (B). Open the Lens Corrections panel and click the panel's Manual label (see first Tip).
- 2. Start with the Vertical or Horizontal slider to better align the subject with the camera lens. When you roll the cursor over any of the sliders, a light grid appears over the photo, which you can use to gauge the direction and amount to move the sliders **(**.
- Once you're satisfied with the Vertical and Horizontal adjustments, experiment with the other sliders to square up the photo as needed.
- 4. When you're finished making the corrections, select Constrain Crop D.
 Lightroom trims away the curved edges of the photo (see second Tip).

If you're lucky enough that a profile is available for your lens, click the Profile label, select Enable Profile Corrections, and use the drop-down menus to select the profile. Lightroom then will automatically apply adjustments tailored for that lens.

When shooting, if you know the lens is distorting things a bit, try to leave plenty of room around the main subject. It will help you avoid cropping problems later when you use Lightroom to correct the lens's geometry.

To fix lens vignetting:

- Select a photo needing correction, zoom in slightly on a problem corner if necessary, and open the Lens Corrections panel 3.
- 2. Move the Lens Vignetting Amount slider to the right to lighten the corner (the more typical problem) or to the left to darken it.
- Move the Midpoint slider to control how much area is affected by the Amount adjustment. Moving the slider to the right shrinks the area affected, to the left expands it.
- **4.** Adjust both until you're happy with the results **()**.

To adjust chromatic aberration:

 Photos most likely to have chromatic aberrations contain dark objects against bright backgrounds, often the sky G. Use the Navigator panel to quickly move around and zoom in to check for problems, such as the yellow fringe in the example 1. (By default, Defringe is turned off in the Chromatic Aberration section of the Lens Corrections panel.)

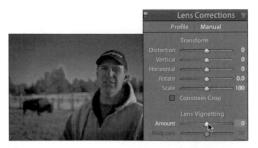

Before any adjustment is made, the vignetting in the photo's upper-left corner is obvious.

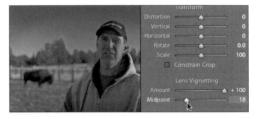

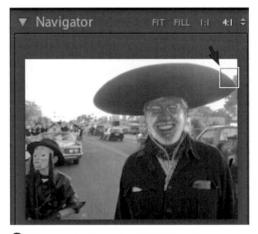

(6) Where dark objects (and UFO-sized hats) meet bright backgrounds, you'll likely find chromatic aberration.

Before any adjustments are made, a yellow fringe marks where hat meets sky.

Setting Defringe to Highlight Edges helps darken the fringe...

...but selecting All Edges, plus moving the Blue/Yellow slider to the right, eliminates it entirely.

- Once you've located the problem, select Highlight Edges in the Defringe pop-up menu (1) (best for where extreme highlights meet darker objects) or All Edges. If that fixes the problem, you are done. But in our example, Highlight Edges does not knock back the yellow edge (bottom, (1)).
- Select All Edges in the Defringe pop-up menu and then use one of the two sliders, based on which color you're trying to control **①**. Press Alt/Option while dragging the slider to better see the adjustment as it's applied to the fringe. (In the example, the Blue/Yellow slider is shifted to the right to reduce the yellow fringe.)
- Use the Navigator panel to zoom back out for an overall view. If necessary, zoom back in to tweak the settings until you're satisfied.

Think of the Red/Cyan and Blue/Yellow sliders as seesaws. For example, shifting loward the yellow end glves more "weight" to the blue **1**. To reduce red, shift that slider to the left, which applies more cyan.

Using the Effects Panel

Use the Effects panel to apply post-crop vignetting or grain to a photo. While it's a bit of a mouthful, post-crop vignetting simply means that the vignette you create readjusts its position as you crop (or recrop) a photo. It also means you can create a particular vignette effect and save it as a preset for applying to other photos since it's not dependent on their dimensions. The grain effect, new in Lightroom 3, lets you imitate the look of grain of different film types. Kodachrome may be gone, but thanks to Lightroom, such slide film looks can live on.

To apply post-crop vignetting:

- 1. Expand the Effects panel after selecting the photo you want to adjust (A).
- With a pop-up menu and five sliders in the panel, you can adjust any of the following settings B:
 - Style: Use the pop-up menu to choose one of three post-crop vignetting effects. Highlight Priority works well when you want to preserve a photo's highlights as much as possible. Color Priority works better when you want to preserve the photo's original hue. Paint Overlay works just like Lightroom 2's postcrop vignetting by applying a blend of black and white.
 - **Amount:** Negative values create a dark vignette; positive values create a light vignette.
 - Midpoint: This slider controls how much area is affected by the Amount adjustment. Moving the slider to the right shrinks the area affected, to the left expands it.

Apply vignetting to Portrait shots as a way to focus the viewer's attention.

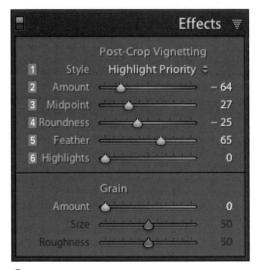

(b) Use the many options in the Post-Crop Vignetting section to experiment with various vignette effects.

() The final vignette darkens the background, using an oval shape and a soft feather (fade), to put the focus on the person's face.

D Some subjects may lend themselves better to the grain effect than others.

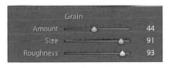

Horo the Amount has been left moderate, but the Size and Roughness have been boosted to better show the grain effect.

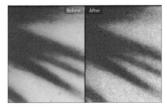

Exaggerated here to make it more visible, the added grain can create almost painterly effects.

- According to the solution of the second s
- **5** Feather: Shifting the slider to the right creates a gradual fade between the main area and the background. Moving it all the way to the left separates the two areas with a hard line.
- **6 Highlights:** Shifting the slider to the right helps darken highlight areas.
- Once you're satisfied with the results (), consider creating a preset for later use (see page 149).

To add grain:

- Select a photo to which you want to apply a grain effect **①**. Switch the main window to a Before/After view, using the Before/After button or pressing the Y key. Set the Navigator panel in the Left Panel Group to Fit and 1:1 or 2:1 so that you can toggle your view as you adjust the grain.
- 2. Use the three Grain sliders—Amount, Size, and Roughness—to create the effect you want ①. Moving Amount to the right increases the overall strength of the effect. Use Size to control the particle size of the grain. Use the Roughness slider to control the irregularity or uniformness of the grain; farther right increases the irregularity.
- Once you're satisfied with the results
 consider creating a preset for later use (see page 149).

Putting It All Together

- 1. Use the Quick Develop panel to automatically adjust the photo's tones.
- **2.** Create a virtual copy of the photo for applying the rest of the adjustments listed below.
- **3.** Apply one of Lightroom's develop presets to the virtual copy, change it slightly, and make a snapshot of the result.
- **4.** Use the Histogram, along with the Basic panel, to fix the photo's overall exposure problems.
- 5. Practice using the Targeted Adjustment tool to zoom in and adjust specific aspects of the tone curve and HSL values.
- **6.** Create a black-and-white photo, and then apply split toning to it.
- **7.** Use the Detail panel to adjust the photo's sharpening and noise.
- **8.** Use the Lens Corrections panel's manual section to correct (or distort) the geometry of the photo.
- **9.** Use the Effects panel to apply a vignette to a photo and then adjust its grain.

Just below the Histogram panel resides the Tool Strip **(a)**. With the exception of the Crop Overlay tool, the Tool Strip is used to apply *local adjustments*. These adjustments affect only certain parts of a photo, which you select. Clicking each of the five tools reveals a set of adjustments related to the particular tool.

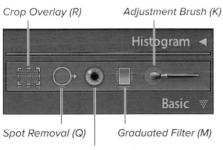

Red Eye Correction (none)

(A) The Tool Strip houses five tools, shown here with their keyboard shortcuts.

In This Chapter

Using the Crop Overlay Tool	184
Using the Spot Removal Tool	187
Using the Red Eye Correction Tool	189
Using the Graduated Filter	190
Using the Adjustment Brush	193
Putting It All Together	196

Using the Crop Overlay Tool

The Crop Overlay tool isn't really a local adjustment. After all, what's more global than a crop? Still, its placement in the Tool Strip makes it easy to find and use. Like everything else in Lightroom, the adjustments are stored as metadata. That means you can redo or undo the crop at any time.

To crop a photo:

- Select the photo you want to crop or straighten, and click the Crop Overlay tool (R) to reveal its related adjustments panel (a). A set of eight adjustment handles appears along the perimeter of the photo.
- 2. Do any of the following:

To crop to a specific ratio, use the dropdown menu to choose a common printsize proportion. An overlay appears based on your choice, which you can move to frame the crop **(B)**.

or

To preserve the photo's original proportions, click the Lock button and then use the photo's handles or drag your cursor over the photo to frame the crop **G**.

or

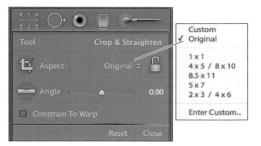

A Click the Crop Overlay tool to reveal its related adjustments panel for cropping and straightening photos.

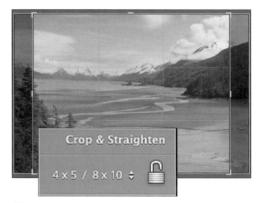

After choosing a common print-size proportion, an overlay appears, which you can move to frame the crop.

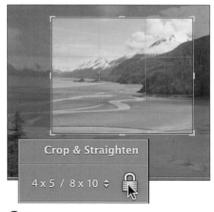

(To preserve the photo's original proportions, click the Lock button. Then use the photo's handles or drag your cursor to frame the crop.

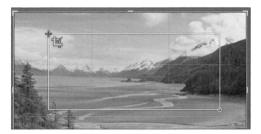

D To crop freehand, click and drag in the photo. To frame the crop properly, use the handles or reposition the overlay. To crop freehand, click and drag in the photo. To frame the crop properly, use the photo's handles or reposition the overlay **D**.

3. To apply the crop, press Enter/Return, click the panel's Close button, or click the Done button in the main window.

(III) Click the panel's Reset button whenever you want to start over applying a crop.

(IIP) A new Crop Overlay check box, Constrain To Warp, works in tandem with the Lens Corrections panel's Transform sliders. Keep both panels open when using it to apply a crop that preserves as much of the original image as possible. For now, it's a bit of a work in progress that you might want to steer clear of.

ID In step 2, press the X key if you want to switch the orientation (landscape or portrait) of a pending crop.

To straighten a photo:

- Select the photo you want to straighten and click the Crop Overlay tool (R) to reveal its related adjustments panel.
- 2. Do any of the following:

Click the panel's Angle slider and drag in either direction to level the photo. A more detailed grid overlay appears to guide you.

or

Click one of the photo's corners and rotate the handle that appears to level the photo. A more detailed grid overlay appears to guide you ().

or

Click inside the photo on a level surface or the horizon. The cursor becomes a level, which you can use to draw a line to another point on the surface or horizon **()**. After the second click, the photo is straightened **()**.

3. To apply the straightening crop, press Enter/Return, click the panel's Close button, or click the Done button in the main window **()**.

(IIP) Press Alt/Option while using the Straighten tool, and a grid appears to help you.

E Click one of the photo's corners and rotate the handle to level the photo.

Click in the photo on a level surface or the horizon. The cursor becomes a level, which you can use to draw a line to another point on the surface or horizon.

G After you draw the level line, the photo is straightened.

Press Enter/Return to apply the straightening crop. Or click the Done button below the photo.

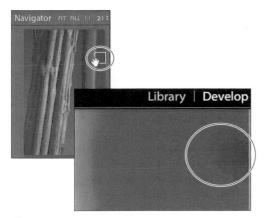

Select a photo and use the Navigator panel, along with the main window zoom, to zero in on the spot you want to remove or repair.

Click the Spot Removal tool (Q) to reveal its related adjustments panel.

(Set the Tool Overlay to Always so that you can see the circles.

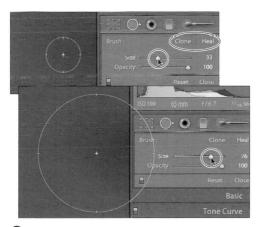

O Click to select the Clone or Heal tool, and adjust the circle (brush) if needed using the Size and Opacity sliders.

Using the Spot Removal Tool

The Spot Removal tool offers two powerful ways to fix blemishes and dust spots in your photos. The Clone tool samples the pixels from another area of the photo and replaces those in the target area. The Heal tool matches the texture and light of the area surrounding the spot, which makes for a seamless blend. Learning to manipulate the sampling of your source and target areas can seem a bit awkward initially. Take the time to learn, however, and you'll never look back.

To remove spots:

- Select a photo and use the Navigator panel, along with the main window zoom (press Z on your keyboard), to zero in on the spot you want to remove or repair ().
- Click the Spot Removal tool (Q) to reveal its related adjustments panel (B). (The old keyboard shortcut, N, is now reserved for the Library module's Survey view.) In the main window toolbar, make sure the Tool Overlay is set to Always (C).
- Click to select the Clone or Heal tool, and adjust the circle if needed using the Size and Opacity sliders D.

continues on next page

- Click in the photo on the spot you want to remove. A second circle appears immediately, marking the *source* for the repair sample ().
- Roll the cursor over either circle and when it becomes a hand; click and drag to reposition as needed (3). The fix is applied "live," so as you move the source spot, the targeted spot is updated. When you're satisfied with the results, click the panel's Close button or the Done button in the main window (3).

To move the source or target circle, roll the cursor over it until it becomes a hand. Click and drag the circle to its new position ().

(IIP) To resize the target or source circle, roll the cursor over it until it becomes a doubleheaded arrow. Click and drag to make the circle larger or smaller **(9**.

(IIP) To remove a selected circle, press Backspace/Delete. On the Mac, an animated puff of smoke signals its deletion.

(IIP) If necessary, you can repeat steps 3–5 to apply multiple circles and change the size and opacity of each independently.

(IIP) Click the panel's Reset button if you want to start over.

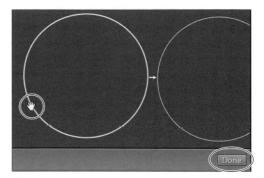

Click on the spot you want to remove. A second circle appears immediately, marking the *source* for the repair sample. Reposition as needed, and click Done to complete the job.

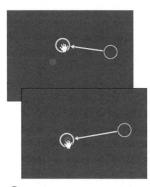

• To move a circle, roll the cursor over it until it becomes a hand, then click and drag it to a new position.

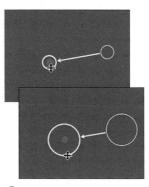

G To resize a circle, roll the cursor over it until it becomes a double-headed arrow, then click and drag to change it.

Click the Red Eye Correction tool to reveal its related adjustments panel.

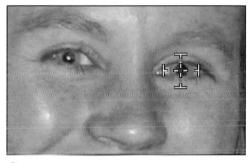

(B) Click on the center of the eye's pupil, and the cursor becomes a crosshair.

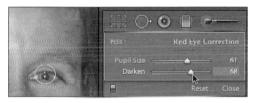

G Drag the cursor toward the pupil's edge, using the Pupil Size and Darken sliders to adjust as needed.

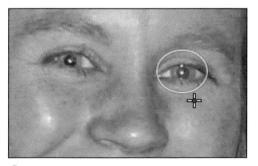

D When you finish one pupil, repeat the process for the other pupil.

Using the Red Eye Correction Tool

The Red Eye Correction tool is essential for removing the ghoulish eyes created in flash photos. Its adjustment sliders allow you to precisely apply the correction.

To remove red eye:

- Select the photo from which you want to remove red eye, and click the Red Eye Correction tool to reveal its related adjustments panel (). (There is no keyboard shortcut for this tool.)
- Click on the center of one eye, and the cursor becomes a crosshair ⁽¹⁾. Drag the cursor toward the edge of the pupil, using the Pupil Size and Darken sliders to adjust as needed ⁽¹⁾.
- When you finish one pupil D, you can repeat the process for the other pupil. Then click the panel's Close button or click the Done button in the main window.

(IIP) Click the panel's Reset button whenever you want to start over.

Using the Graduated Filter

Landscape photographers will love Lightroom's Graduated Filter tool, which is perfect for shots where the difference between the sky and foreground shadows is often too great to expose properly incamera. But this feature has plenty of studio and portrait uses as well—for example, to apply a negative sharpening effect (the equivalent of blurring) to areas surrounding your subject. No matter what combination of the seven effects you use, the filter lets you do it as subtly as necessary (), ().

A Before applying the Graduated Filter tool to bridge the differences between the sky and shadows.

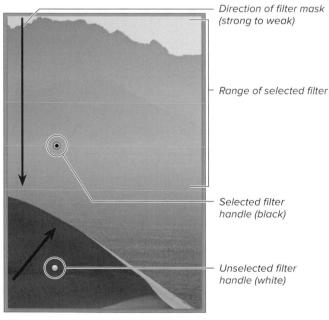

B After applying the Graduated Filter tool, the exposure extremes are reduced.

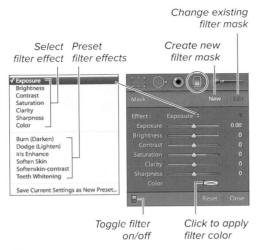

C Click the Tool Strip's Graduated Filter (M) to reveal its related adjustments panel.

D In the main window toolbar, set Show Edit Pins to Always.

To apply a graduated filter:

- Select a photo and click the Tool Strip's Graduated Filter (M) to reveal its related adjustments panel C.
- You can apply a single adjustment by choosing it in the Effect drop-down menu. Or apply multiple adjustments by moving each of the panel's six sliders.
- In the main window toolbar, make sure Show Edit Pins is set to Always ①. Click and drag in the photo, and three parallel lines show the extent of the graduated filter ③. Drag farther to apply the filter over a larger area, or reverse direction with your cursor to narrow the area affected by the filter.
- Click and drag any of the three lines to adjust the distance between the filter's high, center, and low ranges (). This compresses or expands the shift from one range to another.

continues on next page

• Three parallel lines show the extent of the graduated filter.

Click and drag any of the three lines to adjust the distance between the filter's high, center, and low ranges.

- To adjust the angle of a filter, click anywhere along the center line. The cursor becomes a double-headed arrow, which you can then pivot in either direction (G).
- 6. If needed—and it usually is—readjust the panel's sliders to fine-tune the filter's effects. To gauge the filter's effects, click the bottom-left switch to turn the filter off and on.
- You also can apply a color to the adjustments by clicking the Color patch and using the eyedropper in the Select a Color panel that appears (1). Click the X to close the panel.
- **8.** To add a second filter, click the New button and begin the process again for another area of the photo.
- 9. To remove a filter, click its "adjustment pin," and the center of the pin turns black. Press Enter/Return and the adjustment is deleted. On the Mac, an animated puff of smoke marks the deletion ①.
- **10.** To go back and adjust another filter, click its adjustment pin to select it before moving the sliders. The panel's Edit button becomes active. When you're done, click the panel's Close button or click the Done button in the main window.

(IP) In step 2, you can apply one of six preset filter effects. The Soften Skin effect, for example, applies a combination of Clarity and Sharpness adjustments.

(IIP) Click the panel's Reset button if you want to remove all the filters and start over.

G To adjust the angle of a filter, click the center line, and then pivot your cursor in either direction.

To remove a filter, select its adjustment pin and press Enter/Return. On the Mac, an animated puff of smoke signals its deletion.

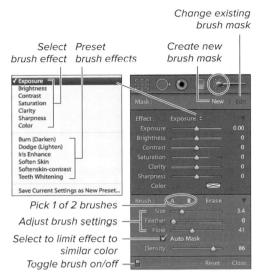

Click the Tool Strip's Adjustment Brush tool to reveal its related adjustments panel.

Show Edit Pins : Always 🗧 🗹 Show Selected Mask Overlay

In the main window toolbar, set Show Edit Pins to Always. Whether you select Show Selected Mask Overlay depends on the situation.

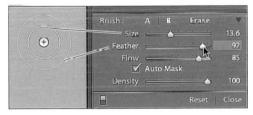

(Based on the brush mark made by your first click, you may want to fine-tune the Size and Feather.

Using the Adjustment Brush

Like the Graduated Filter, the Adjustment Brush tool gives you the ability to apply a variety of adjustments to precise areas of your photo. One obvious use is as a digital equivalent of the chemical darkroom's old dodge and burn tools. But as you learn to use the brush—and it does take some practice—you will discover that its many possible effects will take you far beyond that starting point.

To apply the Adjustment Brush:

- Select a photo and click the Adjustment Brush tool to reveal its related adjustments panel (A). The Mask section automatically selects the New setting.
- Using the Effect drop-down menu, you can choose one of seven adjustments. You can apply multiple adjustments by moving any of the section's six sliders. Or choose one of the six preset effects.
- 3. In the main window toolbar, make sure Show Edit Pins is set to Always (3). In the Brush section, where the A brush is selected by default, set its Size, Feather, and Flow. Use the slider to set the brush's Density, which is the brush stroke's transparency. If you want to limit the effect to similar colors, select Auto Mask. (For an example, see the third Tip on page 195.)
- 4. Once you've set the brush, click in the photo where you want to apply the effect and an "adjustment pin" is inserted to mark this set of brush strokes. Based on the brush mark made with your first click, you may want to fine-tune the Size and Feather before continuing ().

continues on next page

- **5.** Begin "painting" with your cursor to apply the effect. You can adjust the effect for *all* the strokes associated with this first adjustment pin just by changing the panel's settings.
- If you need to erase some strokes, click the panel's Erase button or press Alt/ Option. When the cursor becomes a – (minus) sign, paint over your mistakes.
- 7. To remove an entire set of brush marks, click that set's adjustment pin. The pin's center turns black to signal that it is selected. Press Enter/Return and the pin is deleted. On the Mac, an animated puff of smoke appears.
- 8. If you prefer to work without the mask overlay always on, but you need to quickly check where it's being applied, roll your cursor over the adjustment pin ①. If you cannot find the pin, press H and it appears. (Press H again and the pin disappears.)
- 9. When applying the effect, you can create a different size brush by clicking the B in the Brush section. Use the Brush section's Size, Feather, Flow, Auto Mask, and Density settings to adjust the B version of your brush ⁽³⁾. Press the / (slash) key to toggle between applying the A and B versions of the brush.
- **10.** To apply *another* effect, click New to create a whole new brush, which again can have a B variation if you like. As you work, you can adjust each set of

D If the mask is hidden, roll your cursor over the adjustment pin to quickly see its extent.

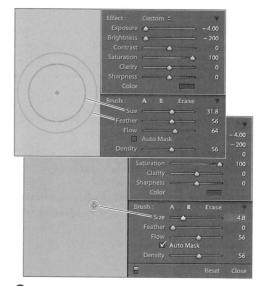

Use the Brush section's settings to adjust the B version of your A brush.

Three different Adjustment Brush settings, using a mix of Exposure, Clarity, and Sharpness effects, were applied to different areas of the photo.

G Before using the Adjustment Brush tool, the photo had some problem highlight and shadow areas.

already-applied brush marks by selecting its controlling adjustment pin and changing the panel settings (), (). When you're done, click the panel's Close button or click the Done button in the main window.

If you create a brush that you may want to use again, choose Save Current Settings as New Preset in the drop-down menu and give it a name.

In step 3, it can be useful to set one brush to the Burn (Darken) preset effect and the other to the Dodge (Lighten) preset. That lets you quickly touch up problem exposure areas without fiddling with the brushes.

If you set the brush Flow and Density between 50 and 80, you can build an effect using light, multiple passes. Select Auto Mask if you want the brush's effect limited to areas of similar color.

(IIP) Selecting Auto Mask makes it much easier to apply an adjustment along an edge without it bleeding into adjacent areas **()**.

(IIP) Sometimes the mask overlay makes it hard to see what effect your brush is having. Toggle it on/off by pressing the letter O on your keyboard or deselecting Show Selected Mask Overlay in the main window's toolbar **()**.

The Auto Mask makes it easier to apply an adjustment along an edge without it bleeding into adjacent areas.

If the mask overlay keeps you from seeing the effect being applied, toggle it off by pressing the letter O on your keyboard or deselecting Show Selected Mask Overlay.

Putting It All Together

- 1. Open a photo and use the Crop panel's drop-down menu to apply a common print-size proportion.
- Open another photo and apply a treehand crop using the click-and-drag method.
- **3.** Undo the freehand crop and click the Lock button to apply a crop that preserves the photo's original proportions.
- Click one of the photo's corners and use the handle that appears to rotate and level the photo.
- Use the Tool Strip's Spot Removal tool to fix a photo with a blemish or dust spot.
- **6.** Use the Tool Strip's Red Eye Correction tool to fix a person's red pupils.
- **7.** Using a single effect from the Tool Strip, apply a graduated filter to a photo.
- **8.** Use the Tool Strip's Adjustment Brush tool to fix the exposure for a small part of a photo.
- **9.** Retouch a portrait photo using the Adjustment Brush tool's Iris Enhance and Soften Skin presets.
- 10. Create your own custom effect with the Adjustment Brush tool, using any combination of slider settings. When you're done, save it as a new custom preset.

Creating Slideshows and Web Galleries

The Slideshow and Web modules are good examples of why Lightroom is far more than a photo organizing and retouching tool. Both modules give you lots of ways to customize how your photos are presented, but with a streamlined interface that makes them easy to use. In producing Web galleries for your Web site, Lightroom automatically generates all the necessary, behind-the-scenes coding. You do not need to know HTML or Adobe Flash to create galleries of clickable thumbnail images arranged on Web pages. Lightroom handles all that and guides you through uploading them to your Web site.

In This Chapter

Selecting and Ordering Photos	198
Using the Slideshow Module	199
Choosing Slideshow Settings	201
Setting Slideshow Playback	207
Creating Web Galleries	210
Choosing Web Gallery Settings	212
Previewing and Uploading a Web Gallery	214
Putting It All Together	216

Selecting and Ordering Photos

Whether you are creating a slideshow or a Web gallery, you begin in the Library module. That's where you select the photos you want to use and arrange them in the order you want them to appear.

To select and arrange the order of photos:

- In the Library module, use the Grid view or Filmstrip to select the photos you want to include in the slideshow or Web gallery.
- 2. Turn the selection into a collection, then select that new collection in the Collections panel. (For more information on creating collections, see page 122.)
- To rearrange the order of the photos, you can use the Grid view or the Filmstrip. Click to select a photo and drag it to a new place in the photo order (top, (1)). Release the cursor and the order is rearranged (bottom, (1)).
- **4.** Repeat until you have rearranged the photos in the order you want for the slideshow or gallery. You can fine-tune that order at any point later.

(A) To rearrange the photos, click to select a photo and drag it to a new place in the photo order.

Using the Slideshow Module

The Slideshow module is packed with options for presenting your photos onscreen, but you use it by following a series of simple-to-use panels. Select a pre-built template as a starting point and customize it using a variety of settings available in the Right Panel Group (A).

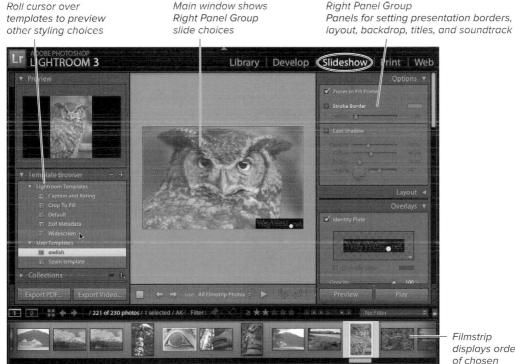

displays order of chosen slides

A The Slideshow module lets you control the onscreen appearance, titling, and playback of your photos.

To choose a slideshow template:

- Select a collection of photos you have already arranged in order and switch to the Slideshow module B.
- If the Filmstrip is not already visible, expand it by clicking the triangle at the bottom of Lightroom's main window. Also, turn on the toolbar (press T on your keyboard), which will display slideshow-specific buttons C.
- In the Left Panel Group, expand the Template Browser panel **①**. Roll your cursor over any of the slideshow templates to see it in the Preview panel. Click one of the five templates to apply it to your slideshow.
- **4.** If you want to customize the template you have chosen, see "Choosing Slideshow Settings" on the next page.

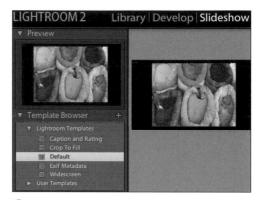

B The Slideshow module includes pre-built templates for presenting your photos.

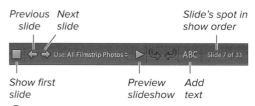

G In the Slideshow module, the toolbar displays slideshow-specific buttons. (Press T on your keyboard to show/hide it.)

• Roll your cursor over any of the slideshow templates to see it in the Preview panel.

Use the Options panel settings to fill the frame with the photo, add a border, and/or create a shadow effect.

(B) The Option panel's stroke and shadow settings in **(A)** as they appear in Lightroom's main window.

and the second		Layout 🔻
🗹 Show Gu		
Left 💷	- 	⇒ 82 px
Right 🗉		= 82 px
Top 🖽	·	а. 🔒 ри 🛛
Bouturis (m)	-	- 82 рх
	Link All	
interest and submitted		

G Use the Layout panel settings to display guides that will help you position items.

D With Show Guides selected in the Layout panel in C, all four guidelines appear in Lightroom's main window.

Choosing Slideshow Settings

The five basic slideshow templates included with Lightroom serve as starting points, although they do offer all you need for a basic slideshow. All the settings for creating your own customized templates can be found in the Right Panel Group's Options, Layout, Overlays, Backdrop, and Titles panels. (The Playback panel is covered on page 207.) As you select settings and adjust sliders in each panel, your choices appear immediately in Lightroom's main window, giving you a rough sense of the slideshow's appearance. At any point along the way, you can see how your choices look on the full screen by clicking the toolbar's Preview button. You can go back to any panel and change your choices at any time.

To choose slideshow settings:

- To customize the basic slideshow template you chose on the previous page, start with the Options panel and work your way down through the Titles panel.
- Options: Use the panel settings to fill the frame with the photo, add a border, or create a shadow effect (A), (B).
- Layout: You can use the panel's guide settings to help you align any items you might apply in the Overlays panel, which is covered below , . Once you have positioned those items, if you like, you can turn off the guidelines for a less cluttered view.

continues on next page

6. Titles: Use the panel settings to display an Intro Screen and/or Ending Screen for your slideshow, including identity plates if you like. (For more information, see "Creating Custom Identity Plates" on page 206.)

Now you are ready to set the slideshow's playback, as explained in the next section.

If you turn on a text option, such as caption, and a particular photo does not have a caption, the Slideshow module's main window displays <empty>. However, that placeholder does not appear when actually running the slideshow, so don't feel compelled to fill in every text option you've turned on.

While you are free in step 5 to apply a color wash, a background image, *and* a background color, the results may well be a visual mess. The simpler the slideshow, the more likely viewers will focus on the photos.

() To create a *new* identity plate, select Add Identity Plate in the Titles panel and choose Edit in the drop-down menu.

• Use a styled text identity plate O Use a grap	hical identity plate
Andalucía Jour	
Tahoma Regular	36
	Cancel OK
Custom	current land

• Use the Identity Plate Editor to create new text or choose a graphic. Then choose Save As in the drop-down menu, and name the plate in the dialog that appears.

Back in the Titles panel, select the new plate in the drop-down menu to use for an Intro or Ending screen.

To create a new identity plate:

- 2. Use the Identity Plate Editor to create new text or choose a graphic, then click Save As in the drop-down menu.
- **3.** Give it a name in the dialog that appears, close that dialog, and then click OK to close the Identity Plate Editor dialog **0**.
- Back in the Titles panel, select the new plate in the drop-down menu to use for an Intro or Ending screen P.
- To see the Intro or Ending screens without running the slideshow, uncheck and then recheck the Add Identity Plate option O. The screens appear briefly, enabling you to inspect them.

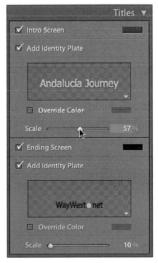

• The Titles panel can be set to show different identity plates for the Intro and Ending screens.

Creating Custom Identity Plates

By default, Lightroom displays its own identity plate in the top-left corner of every module. However, you can create your own identity plate using text or a graphic. Such plates can be especially handy in slideshows or printouts for highlighting your company's brand. To create an identity plate:

- 1. Choose Edit > Identity Plate Setup (Windows) or Lightroom > Identity Plate Setup (Mac).
- 2. In the Identity Plate Editor dialog, select 11 to create a text-based plate or 22 to use a prepared graphic (1). For a text-based plate, type directly in the text window and style it using the Font, Style, and Size drop-down menus. For a graphic plate, you can drag the graphic file directly into the text box. Or select "Use a graphical identity plate," and when the Locate File button appears, click it to navigate to the graphic.
- **3.** When you have finished, click the drop-down menu at the top of the dialog and choose Save As. Name your identity plate in the dialog that appears and click Save.
- To switch to your new identity plate, check Enable Identity Plate in the top-left corner (top, S). Your new identity plate immediately replaces Lightroom's default identity plate (bottom, S).
- 5. You can create multiple plates, saving each under a different name. When you are done, select the one you want to use in the top drop-down menu and click OK to close the Identity Plate Editor dialog.

Enable Identity Plate Custo				
	m			
Personalize the Lightroom environme	-	vn branding eleme	ents.	
Use a styled text identity plate	e 🔾 Use a gra	aphical identity pla	ate	and choose a co
WayWestor	iet			Li
Myriad Web Pro	ondensed	144		Myriad Web Pro

In the Identity Plate Editor dialog, select 1 to create a text-based plate or 2 to use a prepared graphic.

S To switch to your new plate, check Enable Identity Plate in the lower-left corner (top). The new plate replaces Lightroom's default plate (bottom).

	Playback 🔻
Soundtrack	
01 A Night In Tunisia.m4	4a
Duration: 0:11:16	
Select Music	Fit to Music
Playback Screen	
THESE BUILDES BUILDER	
Blank other screer	15
Slide Duration	
Slides 👝 🔺	
Fades Arrow Color	2.5 sec
Random Order	
🗹 Repeat	
Prepare Previews in A	dvance
Preview	Play

▲ Use the Playback panel to choose background music (if any), set how long the slides play, and set what happens once all the slides are shown. If a second monitor is connected, you also can set which screen displays the slideshow.

Setting Slideshow Playback

Once you have sifted through all the slideshow settings, all that remains are the final steps of setting how the slideshow plays. The Playback panel is where you choose background music (if any), set how long the slides play, and set what should happen once all the slides are shown . When you're done, you can export the whole show as a music-free PDF file, or as a video complete with a soundtrack, for playback on a variety of devices.

To choose playback settings:

- If you want to choose a music file, select Soundtrack and click the Select Music button to navigate to the file to use as your soundtrack (see the first Tip on the next page). If you click Fit to Music, Lightroom will pace your slides to end when the music does.
- If you are connected to a second monitor, use the Playback Screen section to select which screen displays the show. (See the second Tip on the next page for more on screen choices.)
- 3. Use the panel's remaining sections to set how long each slide appears, how long it takes to fade to the next slide, and whether the photos play in random order and/or repeat at the end of the slideshow. To avoid any stutter, select Prepare Previews in Advance.
- Press Preview to see how the slideshow looks in Lightroom's main window. You can go back and readjust any of your settings if necessary.
- **5.** Once you are happy with the setup, press Play to run the full slideshow.

continues on next page

- 6. If you want to save all your slideshow settings as a single template, click the + (plus) in the Template Browser panel.
- 7. When the New Template dialog appears, type in a name for your template, make sure the Folder is set to User Templates, and click Create. The dialog closes, and the new template is added to the Template Browser panel.

Lightroom can play a variety of music files: .mp3, .m4a, or .m4b. It cannot play .m4p files, which have digital rights management (DRM) protection. That includes music from the iTunes Store—unless you bought or upgraded the file to what Apple calls iTunes Plus, which is formatted as an .m4a file. How do you know which kind you have? Here's one way: In step 1, Lightroom won't let you select any .m4p tracks when you navigate to them. Here's another: Use Windows Explorer or the Mac Finder to locate a track on your hard drive and look at the file extension **()**.

(IIP) You can use the main window and second window buttons in the Filmstrip to set how the slideshow is displayed. Options include running the slideshow full screen with the menu bar turned off or running it on both screens with the controls visible on only one machine.

Name	Kind
🖪 01 A Night In Tunisia.m4a	MPEG-4 Audio File
01 A Night In Tunisia.m4p	MPEG-4 Audio File (Protected)

B Lightroom slideshows can play .m4a files (top) but not .m4p files (bottom). The top file is an iTunes Plus version of the bottom iTunes track, bought before the iTunes Store offered the unrestricteduse version.

() To export a slideshow, click Export PDF **(**) or Export Video **(**) at the bottom of the Left Panel Group.

Save As:	SpainSlideshow_PDF	•
Where:	PDFexports	
Quality:	<u>1.1.1.1.1.1.1.1.1.1.1.1.1.1.1.1.1.1.1.</u>	1680
	Automatically show full screen Height:	1050
	Common sizes: Other	
Notes:	Adobe Acrobat transitions use a fixed speed. Music is not saved in PDF Slideshows.	×

D Name the export, select where you want it saved, and choose a quality and size for the PDF file generated.

	Export Slideshow to Video	
Save As:	Spain_SlideVideo	
Where:	audio/videos	
		√ 320 x 240
Video Preset:	320 x 240	480 x 320
		720 x 480
	Optimized for personal media players and email.	960 x 540
	Compatible with Adobe Player, Apple Quicktime,	720p
	and Windows Media Player 12.	1080p

(B) Name the export, select where you want it saved, and choose a quality and size for the video file generated.

To export a slideshow:

- In the Slideshow module, click the Export PDF 1 or Export Video 2 button at the bottom of the Left Panel Group
 C.
- In the dialog that appears (D or D), name the export and select where you want it saved. Set the quality using the slider and use the drop-down menu to choose among the common image sizes.
- **3.** Click Export to start the export and close the dialog. Lightroom displays several progress bars as it converts and saves the images.
- 4. The PDF is saved as a single file. If opened with Adobe Acrobat or Adobe Reader, the PDF will play as a slideshow (see first Tip below). The video export creates an .mp4 file that you can send to others or upload to the Web (see second Tip below).

When you export a slideshow as a PDF, the soundtrack is not exported, and your transition speeds are replaced by a fixed interval.

When you export a slideshow as a video, the soundtrack and transitions also are exported.

Creating Web Galleries

Lightroom makes it easy to display your work on the Web in well-designed galleries that use either HTML or Adobe Flash (a). Building a gallery is very much like creating a slideshow, particularly since Lightroom automatically generates all the necessary coding behind the scenes. For example, each gallery automatically creates thumbnails of your photos that appear quickly when Web visitors surf around your site. If a visitor clicks a thumbnail, however, a larger, better-quality image will be downloaded.

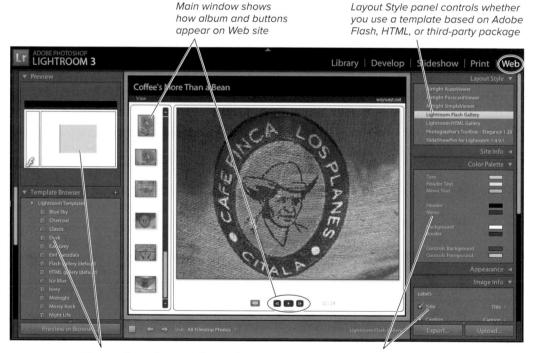

Choices depend on your Layout Style selection in the Right Panel Group

Other choices control album's appearance, colors, titles or caption, and upload settings

A Pre-built Web gallery templates are listed in the Left Panel Group, which you can customize by choosing options in the Right Panel Group.

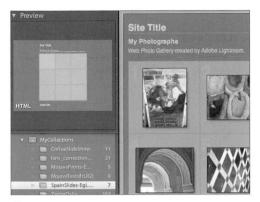

Begin by selecting a collection of photos that you have already arranged in order, then switch to the Web module.

© Roll your cursor over any of the Web gallery templates to see its overall design in the Preview panel.

To choose a Web gallery template:

- If the Filmstrip is not already visible, expand it by clicking the triangle at the bottom of Lightroom's main window. Also turn on the toolbar (press T on your keyboard), which will display Webgallery-specific buttons.
- Select a collection of photos that you have already arranged in order and switch to the Web module B.
- In the Left Panel Group, expand the Template Browser panel. Roll your cursor over any of the templates to see its overall design in the Preview panel **(**. In the Right Panel Group, the Layout Style panel tells you whether your template choice is based on Adobe Flash, HTML, or a third-party package such as Elegance from the Photographer's Toolbox.
- Click a template choice to apply it to your photos. A progress bar appears briefly while the appropriate code is generated.
- If you want to customize the template you have chosen, see "Choosing Web Gallery Settings" on the next page.

(IIP) Adobe's Lightroom Exchange includes links to various third-party slideshow plug-ins. (For more information, see page 239.)

Choosing Web Gallery Settings

The Web gallery template you chose on the previous page serves as a starting point for creating your own customized template. All the settings for customizing the template reside in the Right Panel Group's Site Info, Color Palette, Appearance, Image Info, and Output Settings panels. (The Upload Settings panel is covered on page 215.)

To choose Web gallery settings:

- To customize the basic Web gallery template you chose on the previous page, start with the Site Info panel and work your way down through the Output Settings panel. As you select settings, your choices appear immediately in Lightroom's main window. At any point along the way, you can see how your choices look by clicking the Preview in Browser button at the bottom of the Left Panel Group. You can go back to any panel and change your choices at any time. Your options vary based on which layout style you choose.
- Site Info: Expand the Site Info panel and fill in the text boxes whose information you want to use in your Web gallery, such as the Site Title or Collection Title (a) (see first Tip). Select Identity Plate if you want to activate that option as well.
- Color Palette: Expand the panel and change the default color for any of the text, backgrounds, cells, grids, or numbers by clicking the adjacent color patch ⁽¹⁾. When the Select a Color panel appears, you can choose another color using that panel's eyedropper.

Ouse the Site Info panel to fill in the text boxes used in building Web galleries.

B Use the Color Palette panel to change the default color for any of the listed items.

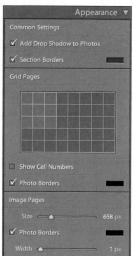

© Use the Appearance panel to select which items you want to appear, such as drop shadows, borders, and cell numbers.

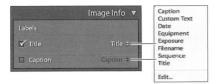

• Use the Image Info panel to set whether you want any labels to be displayed; the two pop-up menus determine which two labels are used.

() Use the Output Settings panel to control the quality of the gallery's large images, and set whether any metadata or sharpening is used.

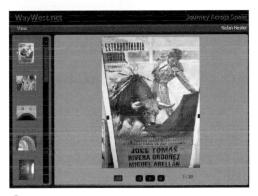

• After choosing your gallery settings, you can see the overall look in Lightroom's main window.

- Appearance: Expand the panel and select which items you want to appear, such as drop shadows, borders, and cell numbers. Use the Image Pages slider to set the image width displayed by the viewer's Web browser .
- 5. Image Info: Expand the panel and set whether you want any labels to be displayed; the two pop-up menus determine which two labels are used **①**. For more on setting the many choices, see "To customize a file-naming template" on page 31.
- 6. Output Settings: Expand the panel and use the slider to control the quality of the gallery's large images. (Thumbnail images are not affected by this setting.) The Metadata pop-up menu offers just two display choices: only the copyright or *all* of the photo's metadata. You can now display a separate watermark of your choice. This somewhat reduces the likelihood of other people downloading your images and using them as their own. The Sharpening setting should be left at Standard since Lightroom does a good job of fine-tuning sharpening to the given output **C**.
- After making all your choices in the gallery panels, take a good look at how your Web gallery looks in Lightroom's main window . Make any necessary adjustments. Now you are ready to set how the Web gallery is uploaded to your Web site, as explained in the next section.

If you click any of the small triangles on the right of each option, any previously entered text lines are available for selection, saving you time.

(IIP) Adobe's Lightroom Exchange includes links to various third-party Web gallery pluglns. (For more Information, see page 239.)

Previewing and Uploading a Web Gallery

Once you choose all your Web gallery settings, you are ready to preview the gallery, save its settings, and upload it to your Web site.

To preview and save a Web gallery:

- In the Web module, click the Preview in Browser button at the bottom of the Left Panel Group (A). Or from the Menu bar, choose Web > Preview in Browser.
- The Web gallery appears in your default browser, enabling you to test the various controls and views B.
- If you want to save your Web settings as a template, click the + (plus) in the Template Browser panel (left,).
- Type in a name for your template, make sure the Folder is set to User Templates, and click Create. The new template is added to the Template Browser panel (right, ^(G)).

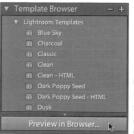

Click the Preview in Browser button to see how the gallery appears in your default Web browser.

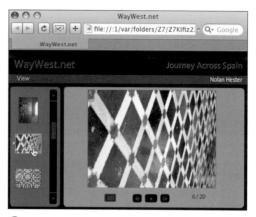

(B) When the Web gallery appears in your default browser, you can test the various controls and views.

G To save your Web settings as a template, click the + (plus) in the Template Browser panel (left). After you name and save the template, it is added to the list of User Templates (right).

D To upload a Web gallery, click the FTP Server pop-up menu, and choose Edit.

	Configure	FTP File Trans	ifer	
Preset: Cus	tom			0
Server:	ftp.use_your_own_	settings.net		
Username:	your_user_name	Password		
			Store password	in preset
Server Path:	/images/LR3vgs/			Browse
Protocol: FT	P Port: 21 Passi	ve mode for a	data transfers:	Passive 🗘
			Cancel (OK

Benter the URL for your Web site's server, your username and password, and the Server Path, and then...

	Configure FTP File Transfer
Prese	✓ Custom
	Save Current Settings as New Preset
	Conver En longe not

I...click the Preset drop-down menu and choose Save Current Settings as New Preset.

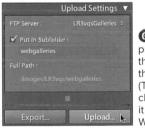

G With your new preset selected as the FTP Server, click the Upload button. (The Put in Subfolder choice is optional, but it makes for a tidier Web site.)

	Enter Password
Password:	
	Cancel Upload
	Cancer Oprodu

H Enter your site's password and click Upload.

To upload a Web gallery:

- Expand the Upload Settings panel, click the FTP Server pop-up menu, and choose Edit D.
- 2. In the dialog that appears, enter the URL for your Web site's server, the username you've been assigned, and the password (). If you like, you can select "Store password in preset" and you will not need to enter it during future uploads. Type in the Server Path or, more likely, click Browse to navigate your way to the correct folder on the Web site. Leave the remaining settings as they are, unless your site administrator tells you otherwise.
- Click the Preset drop-down menu at the top and choose Save Current Settings as New Preset ().
- Type in a name for your preset and click Create. Select your new preset in the Preset pop-up menu and click OK.
- In the Upload Settings panel, your new preset is selected as the FTP Server. Select Put in Subfolder and click the Upload button G.
- Enter your password in the dialog that appears and click Upload (1). A progress bar tracks the upload (1).
- 7. When the upload finishes, use your Web browser to check that the files uploaded properly in the folder you specified.

• A progress bar tracks the upload. The time required varies depending on the number of photos and their quality.

Putting It All Together

- 1. Select and arrange the order of photos to use in a slideshow and Web gallery.
- **2.** Use the Slideshow module to choose a slideshow template.
- **3.** Choose the settings for the slideshow and include a custom identity plate.
- Set the playback options for the slideshow and pick an audio file for use as a soundtrack.
- **5.** Save the slideshow as a custom template.
- **6.** Export the slideshow once as a PDF file and again as a video.
- **7.** Using the same photos selected in step 1, choose a Web gallery template.
- **8.** Choose the settings for the Web gallery.
- **9.** Preview the Web gallery in your own local Web browser and make any necessary adjustments.
- **10.** Save the Web gallery and upload it to your Web site.

Despite Lightroom's slideshow and Web gallery options, many photographers still find that there's nothing quite like seeing photos as prints. The program now gives you more control over creating and customizing picture packages. Thanks to new point-and-click options, you can quickly change a print layout at any point.

In This Chapter

Setting Up to Print	218
Choosing a Basic Print Template	220
Customizing a Print Template	222
Saving a Custom Template	226
Choosing Print Settings	227
Printing Photos	228
Putting It All Together	230

Setting Up to Print

Lightroom offers a rich array of printing choices within its Print module **(a)**. But you also can start printing immediately using the module's pre-built templates. Begin by selecting which photos you want to print, arrange their order if appropriate, and choose what paper size to use.

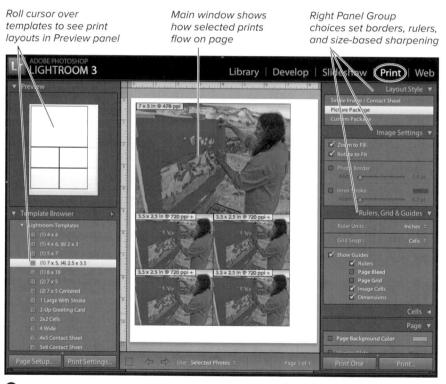

A The Print module lets you set how photos lay out on a page. Pre-built templates run down the Left Panel Group, while the Right Panel Group offers ways to customize them.

A To set the paper size, click the Page Setup button at the bottom of the Print module's Left Panel Group.

Name:	\\ELFPAD\Canon i350	•	Properties
Status:	Ready		
Турит	Canon (350		
Where:	USB002		
Comment	:		
Paper		Orientati	yn -
			Ø Postrait
Size.	Letter		
	Letter • Auto Sheet Feeder •	À	Candecape

B In the Windows Print Setup dialog, make a choice from the Paper Size drop-down menu.

	Page Setup	
Settings.	Page Attributes	
Format for:	Any Printer	
Paper Size:	US Letter	101
	8.50 by 11.00 inches	
Orientation:	Tê Te	
Scale:	100 %	
Scale:	100 %	
0	Ca	ncel OK

(In the Mac Page Setup dialog, make a choice from the Paper Size drop-down menu.

Press I on your keyboard to display the layout's page number, the paper size, and the selected printer

To select photos to print:

- In the Library module, use the Grid view or Filmstrip to select the photos you want to print.
- 2. Turn the selection into a collection, then select that new collection in the Collections panel. (For more information on creating collections, see page 122.)
- 3. Switch to the Print module.

If you plan to print several different images as part of a contact sheet or package, you can rearrange the order of the photos in the Filmstrip. Click to select a photo and drag it to a new place in the sequence.

To set the paper size:

- In the Print module, click the Page Setup button at the bottom of the Left Panel Group ().
- In the Print Setup/Page Setup dialog, make a choice from the Paper Size drop-down menu (B), (C). Click OK to close the dialog.

(IP) It you forget what size paper you are using, press I on your keyboard. An information overlay appears in the main window, listing the page number in the print layout, the paper size, and the selected printer **()**. Press I again to hide the information.

Choosing a Basic Print Template

Lightroom's pre-built print templates can handle many of your basic print needs. They include examples of Lightroom's three layout styles: the Single Image/Contact Sheet, the Picture Package, and the Custom Package. The Single Image/Contact Sheet-based layouts arrange multiple same-size photos across one or more pages. The Picture Package-based layouts arrange multiple different-size photos across one or more pages. The Custom Package-based layouts arrange multiple photos in a wide variety of combinations. All of these templates provide great starting points for creating your own custom layouts, as explained on page 226.

To choose a print template:

- Select a collection of photos that you want to print. Switch to the Print module and turn on the toolbar (press T on your keyboard). The toolbar displays printrelated buttons (A).
- In the Left Panel Group, expand the Template Browser panel. Roll your cursor over any of the pre-built templates to see its overall design in the Preview panel B. Depending on your choice, Single Image/Contact Sheet, Picture Package, or Custom Package is highlighted in the Layout Style panel C.

Go to first print page

4	Use: Selected Photos ÷	Page 1 of 1
Previous	Next print	Page in
print page	page	sequence

(A) Turn on the toolbar (press T on your keyboard) to display print-related buttons.

Slideshow	Print Web
	Layout Style 🔻
Single Image / Cont	act Sheet
Picture Package	and the second second
Custom Package	A STREET OF STREET, ST

G After you choose a template, one of the three underlying styles is highlighted in the Layout Style panel.

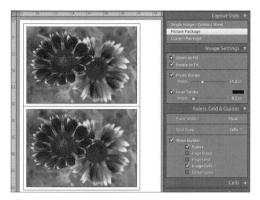

Once you pick a pre-built template, the main window shows the template applied to your photos.

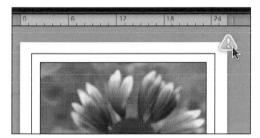

() Lightroom displays an alert if you pick an incompatible layout/paper size.

- **3.** Click a template choice to apply it to your photos **D**.
- If you are happy using one of the prebuilt templates and are ready to print the photos, skip ahead to "Choosing Print Settings" on page 227. If you want to customize your chosen pre-built template, see "Customizing a Print Template" on the next page.

(IIP) By default, the main window displays horizontal and vertical rulers along the sides of the printer page. To turn them off or on, choose View > Show Rulers (Ctrl-R/Cmd-R).

Depending on your needs, you may want to display guides that indicate the page bleed, margins and gutters, or individual image dimensions. To turn the guides on or off, choose View > Guides and make your choices in the drop-down menu.

IIP Lightroom alerts you if you pick an incompatible layout/paper size **(f)**.

Customizing a Print Template

Once you pick a pre-built template as a starting point, you can customize it using the various settings in the Right Panel Group. The individual panels available vary depending on whether you start with a template using a Single Image/Contact Sheet, Picture Package, or Custom Package. (The last panel, Print Job, is covered on page 227.) You can go back and change your choices at any time.

To customize a print template:

- To customize the pre-built template that you have chosen, work your way down through the Right Panel Group panels you want to adjust. The availability of the Rulers, Grid & Guides panel or the Layout panel depends on the template you start with ().
- 2. Image Settings: Select the default settings you want to change ^(B). If you select Zoom to Fill, be aware that it crops the image to fit the layout. Select Rotate to Fit if you need to turn the photo from horizontal to vertical (or vice versa) for a better layout. Deselecting Repeat One Photo per Page enables you to change a Single Image/Contact Sheet layout to show *multiple* photos instead of just one photo on each page ^(C).

A The availability of the Rulers, Grid & Guides panel or the Layout panel depends on which template you choose.

B Select Rotate to Fit whenever turning the photo makes for the better layout.

C Deselecting Repeat One Photo per Page enables you to show *multiple* photos instead of just one photo on each page.

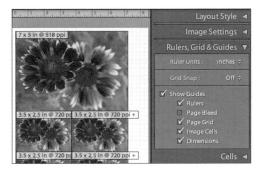

D The Rulers, Grid & Guides panel is available only when you use a Picture Package-based or Custom Package-based template. It controls the display of rulers, grids, guides, bleed/paper trim edges, and dimensions for package photos.

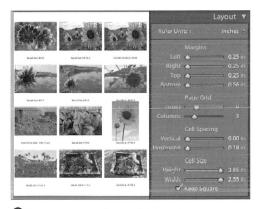

 The Layout panel is available only when you use a Single Image/Contact Sheet-based template. It controls the margins, page grid, cell spacing, and cell size of the overall layout. 3. Rulers, Grid & Guides: This panel is available only when you use a Picture Package or Custom Package. It simply lets you display rulers, grids, guides, bleed/paper trim edges, and dimensions for the package photos **D**.

or

Layout: This panel is available only when you use a Single Image/Contact Sheet-based template (). It controls the margins, page grid, cell spacing, and cell size of the overall layout. You can adjust the settings by using the sliders or by clicking and dragging their lines within the main window.

continues on next page

 Cells: This panel is available only when you use a Picture Package or Custom Package. For a Custom Package, the Cells panel has an extra button for rotating a selected cell and preserving its height-to-width ratio (). For either package style, use the panel to add photos and new pages to an existing package, rearrange the package layout, or clear the layout and start anew (). Click any of the six sizes to add a photo of that size to the layout. As you add more photos, new pages are automatically added.

With a Picture Package, the Auto Layout button creates the most compact arrangement to save paper. With either package, you can click and drag photos to rearrange or resize them. The Custom Package offers you the ability to overlap photos and control which photo appears on top of the stack ().

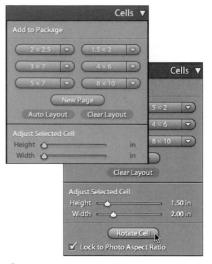

Use the Cells panel to change the contents and layout of a Picture Package or Custom Package. The panel includes extra controls for Custom Packages (lower right).

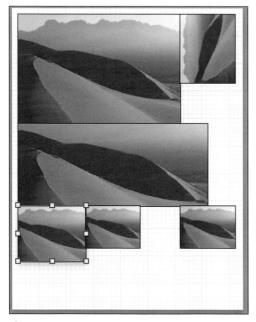

G Use any of the six size buttons to add a photo to the layout. Click and drag a photo to rearrange the layout.

(1) The Custom Package lets you overlap photos and control which photo appears on top of the stack.

The Page panel lets you add an identity plate to a Picture Package or Custom Package. It also includes page background and watermarking options.

• A Picture Package customized in the Page panel to include an identity plate, color page background, and watermark on every photo.

- 5. Page: This panel, which replaces Lightroom 2's Overlays panel, lets you add an identity plate to a Picture Package or Custom Package ①. Options include turning it 90 degrees, adjusting its opacity and size, and placing it partially behind the photos. Other new options include picking a page background color and printing a watermark ①. If you use a Single Image/Contact Sheetbased template, the panel includes options to add page numbers, crop marks, or such metadata as captions.
- 6. Double-check your choices and take a close look at the photos as they appear in Lightroom's main window. Once you are satisfied, choose your print settings as explained on the next page.

III In step 4, you can press Alt/Option to duplicate a selected cell.

Saving a Custom Template

After customizing one of the pre-built templates and choosing your printer settings, you can save all of it as a custom template. After doing so, you can apply your custom template to any other photos with just a few clicks.

To save a custom template:

- Take a moment to recheck the settings in the print-related panels. Also, make sure that Lightroom's main window shows the photos as you want them to be printed (A).
- Click the + (plus) in the Template Browser panel and when the New Template dialog appears, type in a name for your template ^(B). Make sure the Folder is set to "User Templates" and click Create. The new template is added to the Template Browser panel ^(C). You are ready to print. See "Printing Photos" on the next page.

(IIP) The real beauty of creating a custom print template is that you can use it again and again, but with different photos **(D)**.

A Before saving your settings as a custom template, make sure the main window shows the photos as you want them to be printed.

B In the New Template dialog, type in a name for your custom template.

C The new template is added to the Template Browser panel.

Creating a custom print template enables you to use it again, but with different photos.

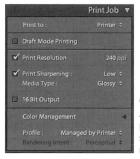

A Use the Print Job panel to set print resolution, sharpening, and color management.

Choosing Print Settings

Before actually making prints, you need to set how Lightroom handles the job. Within the Print Job panel, you choose the print's resolution, how color management is handled, and how much (if any) sharpening is applied to the print.

To choose print settings:

- Once you select your photos and choose either a pre-built or custom print template, expand the Print Job panel (A).
- 2. Select Draft Mode Printing if you want to print out something quickly, such as a contact sheet. Draft mode uses the image previews Lightroom has already generated, so it's faster—even if the quality is less than perfect. For the best results, leave draft mode off.
- **3.** By default, Print Resolution is set to 240 ppi (pixels per inch), which is good for most photo printers. Lightroom 3 lets you boost it as high as 720 ppi. Leave Print Sharpening set to Standard, adjusting to Low or High only if necessary.
- **4.** Use the Media Type pop-up menu to choose Glossy or Matte, depending on the paper you are using.
- In general, leave Profile in the Color Management section set to Managed by Printer. If you have installed a separate printer color profile, it appears in the Profile pop-up menu. (For color settings, see "To print photos" on page 228.)

(IIP) You also can select 16 Bit Output in the Print Job panel if you are running Mac OS X 10.5 or higher and have a 16-bit printer.

Printing Photos

If, as recommended in step 5 on page 227, you elected to let your printer manage your color, then now's the time to set that up. Printer dialogs run the gamut as far as where the color management settings are placed. The steps below offer typical examples. But be prepared to poke around your own printer's dialogs to find where these choices reside.

To print photos:

- In the Print module, click the Print button at the bottom of the Right Panel Group A.
- When the printer dialog appears, do one of the following based on whether you are running Windows or a Mac:

In Windows, click the Properties button and look for a color management or adjustment section **B**. Inside the color management/adjustment section, look for an option to turn on ICM (Image Color Management) as your color management option **C**. Click OK or Save to apply the setting.

On the Mac, look for a Color Matching section, choose ColorSync, and click OK or Save to apply the settings **D**.

	Print	
Printer:	Canon iP4200	
Presets:	Standard	
Copies: Pages:	Line and the second second	
	Color Matching	
6	ColorSync OVendor Matching	,
?) (PDF •)	Preview Supplies) Ca	

D On the Mac, look for a Color Matching section, choose ColorSync, and click Save.

(A) In the Print module, click the Print button at the bottom of the Right Panel Group.

Printer	
Name: \\ELFPAD\Canon i350	Properties
Status: Ready	43
Type: Canon i350	
Where: USB002	
Comment:	Print to file
Print range	Copies
Al	Number of copies: 1
Pages from: 1 to: 17	
	11 22 33 Collate
Selection	
Help	OK Cancel

(b) In Windows, the printer dialogs vary greatly, but use the Properties button to find a color management or adjustment section.

	Color Balance		
- APPEN	Cyan:) <	-
	Magenta:) <	•
18	Yellow:) (•
	Black:		
ABC123	Intensity:	, 🛛 . — . (—	
	Enable ICM		
	Print Type:	Auto	v
	Brightness:	Normal	-
	OK Car	cel Defaults Help	

C In Windows, look for an option to turn on
ICM (Image Color Management) as your color
management option.

 After choosing the printer's settings, you can use those same settings to print a single photo by simply clicking the Print One button. **3.** Navigate back to the printer's main dialog. Click OK or Print to begin printing a photo.

(III) Once you set the printer's color management, you can print future photos using those same settings by simply clicking the Print One button **()**. For multiple copies, however, you need to click the Print button.

IF you want to dive deep into the details of color management, take a look at Martin Evening's *The Adobe Photoshop Lightroom 3 Book: The Complete Guide for Photographers*, from Adobe Press.

(IP) If you have not calibrated your monitor, as explained on page 139, you will have problems creating prints with anywhere near the colors you see on your screen.

Putting It All Together

- 1. Select a group of photos to print and create a new collection for them.
- **2.** Set the paper size for the printer you'll be using.
- **3.** Choose a basic print template from those found in Lightroom's Template Browser panel.
- Using the same photo collection created in step 1, create a customized template based on one of Lightroom's Single Image/Contact Sheet templates.
- Using the same photo collection created in step 1, create a customized template based on one of Lightroom's Picture Package or Custom Package templates.
- 6. Use the identity plate you created in Chapter 11 to further customize the template you chose in step 5.
- 7. Now save your customized Picture Package or Custom Package template.
- **8.** Use the Print Job panel to set the ppi and media type for your prints.
- **9.** Finally, use the Print module to print the photos selected for your customized Picture Package or Custom Package.

B Exporting Images

As long as you work within Lightroom, all your changes are saved as metadata. At some point, however, you may need to export those files to post them on the Web, edit them in a non-metadata based program like Photoshop, or burn them onto a disc. When exporting Lightroom files, you create *copies* of your original images in four formats: JPEG for e-mail or the Web, PSD for working in Photoshop, TIFF for print projects, or DNG (digital negative).

You need not leave behind all the advantages of Lightroom when you click the Export button. You can track the exported images, even when they are edited in Photoshop, by adding them to Lightroom's catalog (see step 5 on page 233). And you can use a new feature—Publish Services to update photos you export to your hard drive or Flickr. (See "Setting Up Publish Connections" on page 244.)

In This Chapter

Basic Exporting	232
Export Setting Options	235
Creating Export Presets	238
Adding Export Plug-ins	239
Meshing Lightroom and Photoshop	241
Setting Up Publish Connections	244
Collecting Photos to Publish	249
Publishing a Collection	253
Putting It All Together	256

Basic Exporting

At its most basic, exporting photos boils down to selecting one or more photos, setting the details of how to convert them to another format or using a preset to do so, picking a destination for the saved files, and perhaps applying some extra actions after they're saved. Along the way, of course, you face dozens of choices. Fortunately, Lightroom's Export dialog breaks it down into manageable chunks using three groups of panels: Presets, Post-Process Actions, and Settings (a). You won't need to set all these options for every group of exported images. Even better, many of them you don't have to mess with or only need to set once. To get started, see "To export images" on the next page. For details on the other Settings panels, see pages 235–237.

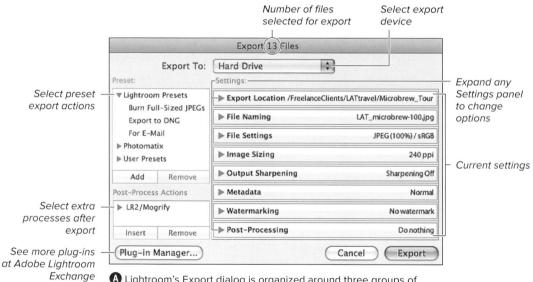

A Lightroom's Export dialog is organized around three groups of panels: Presets, Post-Process Actions, and Settings.

To export your selected images, choose File > Export (Ctrl-Shift-E/Cmd-Shift-E) or click the Export button at the bottom of the Left Panel Group.

Preset	Settings		
▼ Lightroom Presets Burn Full-Sized JPEGs	Export Location		
Export to DNG	▶ File Naming		
For E-Mail	▼ File Settings		
 Photomatix User Presets 	Format: DNG		
	Compatibility: Camera Raw 5.4 and later		
	JPEG Preview: Medium Size		
	Embed Original Raw File		

(If you select a preset, Lightroom automatically applies the appropriate settings.

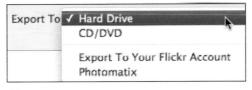

Use the Export To menu to choose a hard drive or CD/DVD, or to trigger a plug-in that you've installed.

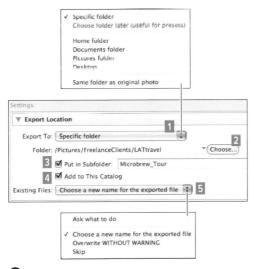

Use the Export Location panel to choose a destination for the exported files.

To export images:

- In the Library module, use the Grid view or Filmstrip to select the photos you want to export.
- From the Menu bar, choose File > Export (Ctrl-Shift-E/Cmd-Shift-E) or click the Export button at the bottom of the Left Panel Group B.
- When the Export dialog appears, the top line notes how many files you are exporting. If you want to use an export action, select it in the Preset panel G. If, for example, you select Export to DNG, Lightroom automatically sets that format and fills in the relevant settings. All you need to do then is click the dialog's Export button.
- Use the Export To menu to choose whether to export the files to a hard drive, burn to CD/DVD, or trigger a plug-in that you've installed [●].
- 5. Expand the Export Location panel and use the Export To drop-down menu 🕒 🚺 to pick a destination for the exported tiles. It you choose "Specific folder," use the Choose button 2 to navigate to the folder or click the adjacent triangle to select a recently used folder. Select Put in Subfolder 3 to place the files in a new subfolder, which you name in the adjacent text box. You have the option of letting Lightroom keep track of the exported files by selecting Add to This Catalog 4. (As an added bonus, if the original files are part of a stack, Lightroom will add the exports to that same stack, which makes file tracking that much tidier.) Finally, the Existing Files drop-down menu 5 lets you control what happens if the names of the exported files conflict with filenames already in the Lightroom catalog.

continues on next page

- Expand the File Naming panel to set how the exported files are named (). The various combinations are identical to those available when you import images into Lightroom.
- 7. Check the current settings for the remaining six Settings panels. Expand any of the panels as needed to choose other export options. (For details on the panels, see "Export Setting Options" on page 235.)
- Before you click the Export button, consider whether you want to save this group of settings as a preset that you can use later. (For details, see "Creating Export Presets" on page 238.) When you're ready, click Export ⁽⁶⁾. Lightroom exports the files and a task bar tracks the progress ⁽¹⁾.

Custom Text:	
Example: 20080318-untitled_shoot-0001.jpg	Start Number: 1 Extensions: Lowercase
,	Custom Name (x of y) Custom Name - Original File Number Custom Name - Sequence Custom Name - Sequence Custom Name - Sequence-ext date=shoot=sequence=ext date=shoot=sequence Filename - Sequence Filename - Greater

When you name exported files, the choices in the Rename To drop-down menu are identical to those used when naming imported images.

G Once you have set how the exported files should be handled, click Export at the bottom of the Export dialog.

B As the selected photos are exported, Lightroom's task bar tracks the progress.

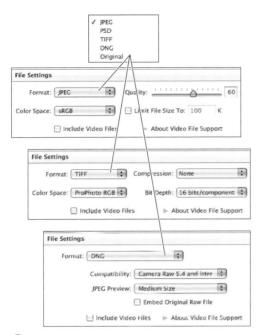

A Depending on your choice in the Format dropdown menu, the File Settings panel offers choices appropriate for that format.

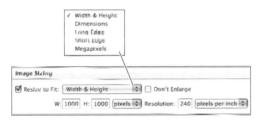

B The Image Sizing panel lets you specify the exported file's maximum width and height.

Export Setting Options

Because they are used so frequently, the Export Location and File Naming panels are explained in "To export images" on page 233. Expand and use the remaining Settings panels, explained below, as needed.

Choosing File Format Settings

Expand the File Settings panel to set which file format you want to use **(A**). Depending on your format choice, the related options vary. A nice touch is that Lightroom automatically lists the appropriate Color Space based on your chosen format. While they remain in their original format, video files can now be exported in the same batch as selected still images.

Image Sizing

If you choose TIFF or Original as your file format, the Image Sizing panel is dimmed, since you would not want to resize the images. For all other formats, you can specify the experted life's maximum width and height **B**. The Long Edge and Short Edge options are convenient when you have a mix of landscape and portrait images. By setting the Long Edge at 750 pixels, for example, you can control the longest edge-no matter what the orientation of a photo may be. Select Don't Enlarge if you want to preserve the original resolution (and avoid a pixelated image). While they are not resized, video files can now be exported in the same batch as selected still images.

Output Sharpening

The Output Sharpening panel lets you apply sharpening based on the output destination **①**. For example, select Screen in the Sharpen For drop-down menu if the exported photos are bound for a Web page. Select one of the two paper types if the final output will be a print. If you are exporting photos for eventual printing in *Photoshop*, this panel lets you apply *Lightroom's* sharpening beforehand. While they are not sharpened, video files can now be exported in the same batch as selected still images.

Metadata

The Metadata panel lets you control what Lightroom metadata will remain embedded in the photo once it is exported \mathbf{D} . Choosing Minimize Embedded Metadata strips out all the metadata except the copyright information. The Write Keywords as Lightroom Hierarchy choice preserves some sense of the parent/child relationship of keywords even in applications that can handle only ASCII-based characters. For example, "Places > West US > Utah > Capitol Reef N.P." will be stored as "Places/West US/Utah/Capitol Reef N.P." where the | (the ASCII pipe character) is used as the delimiter between parent/ child keywords. The last choice embeds a watermark in the photos to reduce the risk of others claiming them as their own. While no metadata is changed, video files can now be exported in the same batch as selected still images.

Output Sharpen	ng			
Sharpen For:	Screen	Amount:	Standard	ļ
	✓ Screen Matte Paper Glossy Paper		Low ✓ Standard High	

G This panel lets you apply sharpening based on whether the exported files will be viewed on a screen or on paper.

Metadata	
	Minimize Embedded Metadata
	Write Keywords as Lightroom Hierarchy

D The Metadata panel lets you control what Lightroom metadata remains embedded in the photo once it is exported.

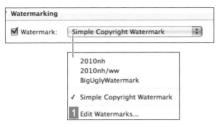

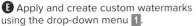

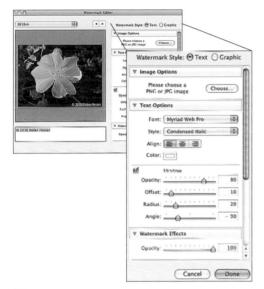

The Watermark Editor makes it easy to create custom text or a graphic to apply to photos.

Post-Processing	
After Export:	Do nothing
Application:	Choose an application * Choose)
	 ✓ Do nothing 1 Show in Finder Open in Adobe Photoshop CSS Open in Adobe Photoshop CS3
	Open in Other Application gradient_map smart_object vignette(selection) G to Export Actions Folder Now

G The Post-Processing panel tells Lightroom what to do *after* the files are exported.

Watermarking

The new Watermarking panel makes it casy to add a simple copyright watermark to your exported photos (2). With Photoshop CS5's new content-aware fill feature, it's become incredibly easy for would-be thieves to remove your copyright. Still, Lightroom watermarks provide a discreet way to sign your work or highlight your brand, especially with the new Watermark Editor, reached by selecting Edit Watermarks at the bottom of the drop-down menu (1). Much like the Identity Plate Editor, the Watermark Editor enables you to create custom text or a graphic to apply to photos (5)

Post-Processing

Use the Post-Processing panel to tell Lightroom what to do after the export is finished. In the expanded panel, make a selection in the After Export drop-down menu **G**. By default, the menu is set to "Do nothing," which is listed in the top section of the drop-down menu. Choices in the second section 11 include opening the Explorer/Finder folder in which the exported files are saved, opening the files in Photoshop, or opening them in another application. (For details on meshing Lightroom and Photoshop, see page 241.) The third section 2 is visible only if you have created droplets using Photoshop and then saved them to Lightroom's Export Actions folder. You can look inside that folder by using the drop-down menu to choose Go to Export Actions Folder Now 3. If you have Photoshop, you can create and save any droplet to that Lightroom folder. (Explaining how to create Photoshop droplets, however, falls outside this book's coverage.)

Creating Export Presets

Most of the time, you export photos in the same formats for clients. Or, you regularly create slideshows or photos for the Web using the same settings over and over. Take the time to create export presets for these commonly used settings, and you can get work done more swiftly and consistently.

To create an export preset:

- Set up the Export dialog's various panels exactly as you need them for a particular client or format. At the bottom of the left panel, click Add ().
- When the New Preset dialog appears, type in a name for your export preset set

 Make sure the Folder is set to User Presets and click Create. The new export preset is added to the Preset panel of the Export dialog

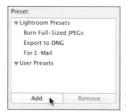

Click Add in the Preset panel to create an export preset based on your custom settings.

	No. of Conception, Name
BlogPosts400	
esets	
	esets Cancel

(b) When the New Preset dialog appears, name your export preset, set the Folder to User Presets, and click Create.

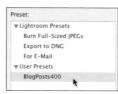

C The new export preset is added to the Preset panel of the Export dialog.

To add third-party export plug-ins, click the Plug-in Manager button in the bottom-left corner of the Export dialog.

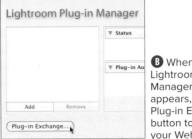

When the Lightroom Plug-in Manager dialog appears, click the Plug-in Exchange button to launch your Web browser.

When your Web browser takes you to the Adobe Lightroom Exchange, look at the page's right column under Browse by Category, and click the Export Plug-In link.

Staff Picks	Most Recent	Most Popular	Nest Aaren
License type	e All	- Filter	1-10 of 133
	-Flickr Plug	in r plugin fur Lightroom.	Download
f • x • b	ne sekcied photo t ickr nur Flickr Account sport Location ke framing 7-May-08 48,437 2 2		
	D-Facebook	book plugin for Lightraa	Download m Win Mai
Export	one selected photo		

• You can sort the list of export plug-ins several ways until you find one you'd like to download.

Adding Export Plug-ins

Lightroom makes it easy to add third-party export plug-ins, which give you even more choices for exporting photos. There are plug-ins, for example, to upload your photos directly to your SmugMug or Facebook account. These are available through Adobe's online Lightroom Exchange, so you need to be connected to the Web before beginning.

To add an export plug-in:

- From the Menu bar, choose File > Export (Ctrl-Shift-E/Cmd-Shift-E).
- 2. When the Export dialog appears, click the Plug-in Manager button in the bottom-left corner (A).
- When the Lightroom Plug-in Manager dialog appears, click the Plug-In Exchange button, which also sits at the bottom left ^(B).
- If it's not already running, Lightroom launches your default Web browser and takes you to the Adobe Lightroom Exchange. In the page's right column, under Browse by Category, click the Export Plug-In link C.
- A Lightroom Export Plug-in list appears, which you can sort in several ways D.
 When you find something useful, download it.
- **6.** After your browser downloads the file, double-click the file to unzip it and note what it is named.

continues on next page

- In the Lightroom Plug-in Manager dialog, which remains open, click the left panel's Add button ¹.
- 8. Use the dialog that appears to navigate to your browser's default downloads folder. Open the downloads folder and look for a file or folder with the name you noted in step 6. Once you find the actual plug-in file, select it, and click Add Plug-in .
- The plug-in is added to the left list in the Lightroom Plug-in Manager dialog G. Click Done to close the dialog.
- You are returned to Lightroom's Export panel. Click the upper-right drop-down menu to find and launch your new export plug-in .

Add	Remove	
Plug-in Exchan	qe)	

G After you decompress the downloaded plug-in, click the Add bullon at the bottom of the Lightroom Plug-in Manager dialog.

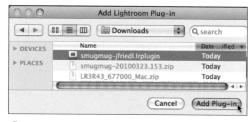

• Once you find the plug-in file, select it, and click Add Plug-in.

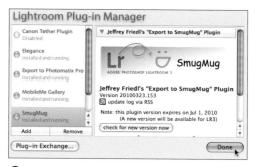

G Once the plug-in is added and activated in the Lightroom Plug-in Manager dialog, click Done.

Ex Preset:	port To Hard Drive CD/DVD
 Lightroom Presets Photomatix 	Flickr MobileMe Gallery
▶ User Presets	Photomatix
	SmugMug

When you return to Lightroom's Export panel, use the upper-right drop-down menu to launch your new export plug-in.

references			
File Handling 1		•	
File Saving Option	s		
Ima	Image Previews:		-
E	le Extension:	Use Lower Cas	e 🕶
General	File Sa	ving Options -	
Interface		1	mage Previews:
File Handling 2			6
Performance			
Cursors			

♦ Set Photoshop's Preferences dialog to work best with Lightroom by selecting File Handling in the drop-down menu 1 (in CS2) or in the left panel 2 (in CS3–CS5).

Juni	Compatibility			
Ca	mera Raw Prefere	nces)		
🗹 Pr	efer Adobe Came	ra Raw for Sup	ported	Raw Files
🗌 Igi	nore EXIF Profile	Tag		
As	k Before Saving I	ayered TIFF Fi	les	
Maxi	mize PSD and PSI	File Compatib	oility:	Always 💲

B Make sure the Maximize PSD and PSB File Compatibility preference is set to Always 1.

Meshing Lightroom and Photoshop

With Lightroom local adjustment tools, you may find yourself doing less photo work in Photoshop. Inevitably, however, you will want to switch to Photoshop to work in layers or to use other tools not available in Lightroom. Thankfully, what's called roundtrip editing between Lightroom and Photoshop has grown simpler—and tidier. By setting Photoshop's preferences and using particular Lightroom commands, you can edit your photos in either program and still have Lightroom's catalog track all the images you generate.

To set Photoshop preferences for Lightroom:

- Begin by opening Photoshop's Preferences (Ctrl-K/Cmd-K). When the Preferences dialog appears, select File Handling in the drop-down menu (A) 1 (CS2) or in the left panel (CS3–CS5).
- Look for Maximize PSD and PSB File Compatibility and set it to Always

 Click OK to close the dialog. For now, you are done with Photoshop. See the next section on editing Lightroom images in Photoshop.

To edit Lightroom images in Photoshop:

- In Lightroom's Library module, use the Grid view or Filmstrip to select the photos you want to edit within Photoshop.
- Right-click (Control-click on single-button Macs) the selected photos. In the drop-down menu (), choose "Edit In" and then one of the following:

Edit in Adobe Photoshop: This option simply opens the photo in any installed version of Photoshop, where you can then make edits using any of that program's tools.

Open as Smart Object in Photoshop:

This option opens the photo as a special type of Photoshop layer called a Smart Object. In Photoshop, when you double-click a Smart Object layer, a Photoshop plug-in, Camera Raw, appears. Its controls work identically to those in Lightroom—and it saves your changes as metadata. It's like using Lightroom from *within* Photoshop. (For more on the wonders of the Camera Raw plug-in, see *Photoshop CS5 for Windows and Macintosh: Visual QuickStart Guide*, by Elaine Weinmann and Peter Lourekas, also from Peachpit Press.)

G Right-click (Control-click on single-button Macs) the selected photos and make a choice in the drop-down menu.

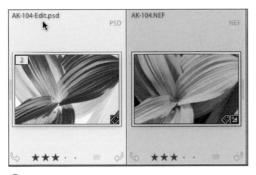

• After you save your changes in Photoshop, a copy with -Edit.psd added to the original name appears in the Lightroom catalog next to the original photo.

Merge to Panorama in Photoshop: This choice opens each image as a layer in Photoshop, which then seamlessly merges the layers into a composite panorama. (This option is available only if you have selected more than one photo.)

Merge to HDR Pro in Photoshop: This choice works much like the panorama option by merging each image as a layer. (It's available only if you have selected more than one photo.)

Open as Layers in Photoshop: This option opens each photo as a separate layer within Photoshop, but it does not merge them. (This option is available only if you have selected more than one photo.)

- Photoshop launches and, based on your choice in step 2, either waits for you to make your edits or begins generating and merging layers.
- Once you finish editing the photo in Photoshop, save the changes (Ctrl S/ Cmd-S). A copy is saved, with -Edlt.psd added to the original name. This new file automatically appears in the Lightroom catalog next to the originally selected photos D.

Setting Up Publish Connections

Using Lightroom's new Publish Services involves three (sometimes four) steps: setting up a publish connection, collecting photos for that connection, publishing or exporting those photos, and, if necessary, republishing photos as you edit them within Lightroom. Though surrounded by an entourage of confusing terms, a publish connection is simply a specific set of export settings tied to a specific destination. In setting up a publish connection, you have two options: publishing to a hard-drive folder location or to your Flickr account on the Web. Setting up a hard-drive connection lets you designate a folder to receive photos that you later export using the Publish Services panel. Such photo folders can be synced with screensavers, your iPhone or iPod, or folders you're creating for clients, or they can be stashed on the Internet using a cloud-based service such as Dropbox. (For details on setting up a Flickr connection, see page 246.)

To set up a hard-drive folder connection:

- Click the + (plus) button in the Publish Services panel and choose Go to Publishing Manager in the pop-up menu (A).
- In the Lightroom Publishing Manager, click Add

 Or, click the Hard Drive or Flickr icons marked "(not configured)"

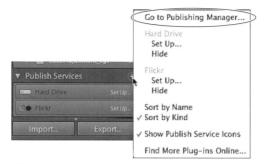

(A) To create a publish connection, click the + (plus) button and choose Go to Publishing Manager.

Hard Drive	Publish Service
(not configured)	Export Location
 Flickr (not configured) 	▶ File Naming
	File Settings
	▶ Image Sizing
_	Output Sharpeni
Add Remove	▶ Metadata

In the Lightroom Publishing Manager, click
 Add 1. Or, click the Hard Drive or Flickr icons marked "(not configured)"

	Create New Pu	blish Connection
Via Service:	Hard Drive	•
Name:	LAT-travel	
	(optional)	
		Cancel Create

Choose Hard Drive or Flickr in the Via Service menu, name the connection, and click Create.

V Publish Service	
Description: LAT-travel 1	
▼ Export Location	
Export To. Specific folder	
Folder: /Pictures/exportsom/Free	elanceClients/LATtravel * (Choose)
Put in Subfolder: 2010	0417_portlandbeertour 2
NOTE: This can not be changed o	once this publish connection is created.
▼ File Naming	
▼ File Naming ✓ Rename To: Filename	(*)
	Start Number:

D After the name appears in the Lightroom Publishing Manager's top-right panel **1**, choose a folder and subfolder to store the exports **2**.

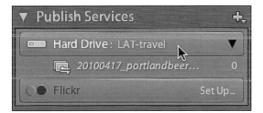

 After you save it, the new (still empty) export folder is listed in the Publish Services panel.

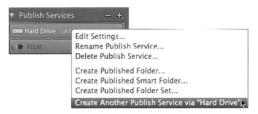

To create more hard-drive services, right-click (Control-click on single-button Macs) a listing in the Publish Services panel. Choose Create Another Publish Service via "Hard Drive."

- In the Create New Publish Connection dialog, use the Via Service pop-up menu to choose Hard Drive or Flickr, type a name for the connection, and click Create ^(C). The name appears in the Lightroom Publishing Manager's top-right panel ^(D) ⁽¹⁾.
- Use the Export Location panel to choose a folder and make a subfolder within it for the new Publish Service's exports 2 (For more on using folders and subfolders, see the third Tip below.)
- Fill in the Lightroom Publishing Manager's remaining panels, which work similarly to those in Lightroom's regular Export dialog, as needed. When you finish, click Save to close the dialog. Your new connection is added to the list in the Publish Services panel ⁽¹⁾.

The first time you use the Publish Services panel, you can simply click the Set Up button for the hard drive or Flickr to reach the Lightroom Publishing Manager.

(IP) The first time you set up a hard drive, Hard Drive is selected by default in the top-left panel. In that case, you do not need to click Add but can instead begin making connection settings in the right-hand panels.

IP In step 4, you can organize your exports by creating a folder for each client and a subfolder within that for each shooting assignment ①.

(IIP) To create more hard-drive services, rightclick (Control-click on single-button Macs) a listing in the Publish Services panel. Choose Create Another Publish Service via "Hard Drive" **()** and repeat steps 3–5.

To set up a Flickr connection:

- In the expanded Publish Services panel, if this is your first time creating a Flickr connection, click Set Up in the Flickr title bar G.
- Type a name for the connection in the Description text box in the Lightroom Publishing Manager's Publish Service panel (1) 1, and click Log In in the Flickr Account panel 2.
- **3.** Click Authorize when Lightroom asks if it's OK to upload images to Flickr **1**.
- When your default Web browser takes you to your existing Flickr landing page, click the Next button on the right (the one asking if you arrived here through Lightroom) ①. When a second page appears, click OK, I'll Authorize It ③.

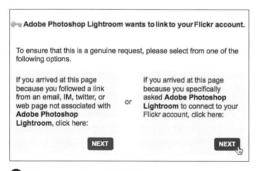

When your default Web browser takes you to your existing Flickr landing page, click the Next button on the right.

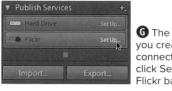

G The first time you create a publish connection to Flickr, click Set Up in the Flickr bar.

Publish Service				
Description:	Public Lightroom Collection 1			
Flickr Account	Flickr Account			
	Not logged in Log In			

(1) Use the Description text box to name the Flickr connection 1, then click Log In 2.

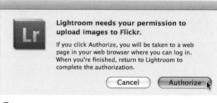

Click Authorize when Lightroom asks if it's OK to upload images to Flickr.

📾 Ado	be Photoshop Lightroom wants to link to your Flickr account.
	a third-party service. If you don't trust it with access to your account, ou should not authorize it.
By aut	thorizing this link, you'll allow Adobe Photoshop Lightroom to:
£ F	Access your Flickr account (including private content)
. ∉ L	Jpload, Edit, and Replace photos and videos in your account
	nteract with other members' photos and videos (comment, add lotes, favorite)
£ 0	Delete photos and videos from your account
OK, I	
₫ 0	Delete photos and videos from your account

When a second page appears, click OK, I'll Authorize It.

Once Flickr allows the connection, return to Lightroom and click Done.

Publish Service							
Description: Public Lightroom Collection							
Flickr Account							
	Logged in a	s waywest 1 Log In					
Flickr Title 2							
Set Flickr Title Usin	g: IPTC Title	pty, Use: Filename					
When Updating Photo	Replace Existing Title						
Filename ✓ IPTC Title Leave Blank	√ Filename Leave Blank						

The Flickr Account panel now shows that you're connected 1. Use the Flickr Title panel to control the name of the Flickr set in your photostream 2.

♥ File Settings	
Format: JPEG 1	Quality:60
	Limit File Size To: 100 K
Include Video Files	2

Solution Flickr photos are automatically formatted as JPEG flies 1, but you can set the quality and/or maximum file size 2.

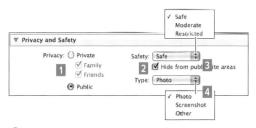

• The Privacy and Safety panel lets you control who can see the photos you publish to Flickr.

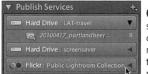

After you save the Flickr connection, its name is added to the Publish Services panel's llst.

- Once Flickr allows the connection, return to Lightroom and click Done ①.
- When the Publishing Manager reappears, the Flickr Account panel shows that you're now connected 1. Use the Flickr Title panel to set how the set is named in your Flickr photostream 2.
- 7. By default, Flickr photos are formatted as JPEG files, so the Format drop-down menu is dimmed in the File Setting panel 1. However, you can set the quality and/or maximum file size 2. The next four panels work just like their counterparts in Lightroom's Export dialog.
- At the bottom of the Lightroom Publishing Manager, there's one more Flickr-specific panel: Privacy and Safety ①. Make your choices for setting the uploaded photos' Safety and Type. Your Privacy choices 1 reflect Flickr's usual settings of Private (photos that only you can see), Family or Friends, or Public. If you select Public, you still can block photos from showing up in Flickr searches or groups by selecting "Hide from public site areas" 2. The Safety choices use Flickr's definitions 3, as do the Type choices 4.
- 9. When you finish, click Save to close the dialog. The connection is added to the list in the Publish Services panel **D**.

(IIP) It's easy to assign different privacy settings to each Flickr connection—for example, one for public photos and another available only to friends and family.

(IIP) To create more Flickr services, right-click (Control-click on single-button Macs) a listing in the Publish Services panel. Choose Create Another Publish Service via Flickr and repeat steps 6–9.

To change a publish connection:

- In the Publish Services panel, right-click (Control-click on single-button Macs) the hard-drive or Flickr connection you want to change and, in the drop-down menu, choose: Edit Settings, Rename Publish Service, or Delete Publish Service ①.
- In the Lightroom Publishing Manager, change any of the settings and click Save. The changes are applied to the connection. If you have already published photos with this connection, Lightroom asks if you want to republish them (). Depending on whether the changes are significant, click Leave As-Is or Republish All, and Lightroom does just that.

or

In the dialog that appears, type in a new name for the connection and click Rename to apply and save the change.

or

In the Confirm dialog, click Delete and the connection is removed.

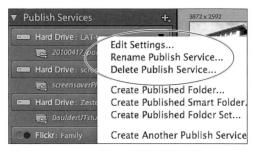

① To change a hard-drive or Flickr connection, right-click (Control-click on single-button Macs) its title bar and choose one of the drop-down menu's first three listings.

You have changed the settings for this publish connection.				
Do you want to mark all 12 photos in this connection to be re-published, or leave them as they are now?				

(When you change a connection, Lightroom asks whether to republish its photos.

Collecting Photos to Publish

Lightroom gives you several ways to gather photos for publishing to a harddrive or Flickr connection. You begin by creating what Lightroom calls a "published folder," which you can populate by making it a target collection or by dragging photos to it from the Grid view or Filmstrip. Or, you can generate a queue of to-publish photos using a "published smart folder." Just like a smart collection, this smart folder automatically collects photos that meet rules you construct for it. This makes it easy to generate to-publish photos without interrupting your regular editing workflow. Finally, you can use a "published folder set," similar to a collection set, to organize multiple to-publish folders.

To create a Flickr collection:

- Right-click (Control-click on singlebutton Macs) a Flickr connection and choose one of the following in the dropdown menu 1:
 - Create Photoset: Name the photoset in the dialog that appears, decide whether to include any selected photos or use virtual copies of them, and click Create. The empty photoset is added to the selected Flickr list 1.
 - Create Smart Photoset: Name the smart photoset in the dialog that appears, add rules controlling its content, and click Create. The smart photoset is added to the selected hard-drive list and is immediately populated by photos meeting your rules ①.
- 2. If you created a smart photoset, photos are added to it automatically. To add photos to a regular photoset, select them in the Grid view or Filmstrip and drag them to the listing in the Publish Services panel. Or, you can mark a folder as a Target Collection and add photos to it by marking them in the Grid view. (For more information on using Target Collections, see page 130.) You're ready to publish the photos, so see "Publishing a Collection" on page 253.

(1) To create a Flickr collection, right-click (Controlclick on single-button Macs) a publish connection and select Create Photoset or Create Smart Photoset.

The empty photoset is added to the selected Flickr list.

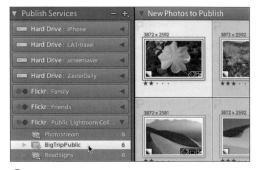

• Once the smart photoset is created, it's automatically populated by photos meeting your rules.

(A) To publish your photos, you can click the Publish button at the top-right of the main window...

B ... or click the Publish button at the bottom of the Publish Services panel.

G Lightroom's progress bar tracks the export to your hard-drive folder.

Publishing a Collection

Once you gather a collection of images, you publish them to a hard-drive folder or your online Flickr account. After the photos have been uploaded, Lightroom keeps watch for whenever you change any of the original versions. You then can choose to "re-publish" updated versions using the same export settings you used the first time.

To publish photos to a hard-drive folder:

- Expand the Publish Services panel and select the hard-drive folder you want to publish. The to-be published photos appear in the main window.
- 2. Click the Publish button at the top-right of the main window **(A**).

or

Click the Publish button at the bottom of the Publish Services panel **B**.

Lightroom's progress bar tracks the export to your hard-drive folder **(C)**, while the main window displays photos shifting from a New Photos to Publish queue (top) to a Published Photos queue (bottom) **(D**.

continues on next page

D The main window displays photos shifting from a New Photos to Publish queue (top) to a Published Photos queue (bottom). Whenever photos are added to a folder in the Publish Services panel—whether manually or by a smart folder—the New Photos to Publish queue appears (3). At that point, just click Publish once more.

(IIP) If you later edit the original version of a published image, Lightroom displays a Modified Photos to Re-Publish queue **()**. Cllck the Publish button to post an updated version.

Whenever photos are added to a folder in the Publish Services panel—whether manually or by a smart folder the New Photos to Publish queue appears.

If you edit the original version of a published image, the Modified Photos to Re-Publish queue appears.

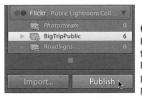

G Click the Publish button at the bottom of the Publish Services panel to upload photos to Flickr.

X

(I) Lightroom's progress bar tracks the upload to your Flickr account.

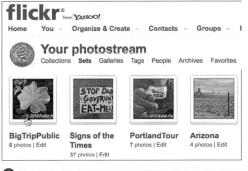

Use your Web browser to review the uploaded photos or photoset on your Flickr page.

Scene Gran Start		35	5	C One Comment 🐄	
Secossion Black IPA	15		6.		
Act of Spades				choirboi Shours ago	
ORDANIC GIGABIT IPA	14	75	5.	Looks like you've got your work cut out f you.	
IPA	15	75	5	Favorite Count: 0	

U Lightroom checks for and downloads any visitor comments about your Flickr photos.

To upload photos to Flickr:

- Expand the Publish Services panel and select the Flickr folder you want to publish. The to-be published photos appear in the main window.
- Click the Publish button at the top-right of the main window or the Publish button at the bottom of the Publish Services panel G.

Lightroom's progress bar tracks the upload to Flickr (1), while the main window displays photos shifting from a New Photos to Publish queue to a Published Photos queue.

 Use your Web browser to log on to your Flickr account. The newest photos or photoset appears on your Flickr page 1.

Whenever you republish to your Flickr account, Lightroom checks for and downloads any visitor comments about your photos. The comments appear in a panel at the bottom of the Right Panel Group **①**.

Putting It All Together

- Select a group of photos to export, and use the Export dialog to choose an export device and destination.
- **2.** Use the Export dialog's File Naming panel to generate new names for those files.
- **3.** Create a custom watermark for the photos using the Export dialog's Watermarking panel.
- Create a customized export preset based on your settings in steps 1–3 and save it.
- **5.** Now export the group of photos using your new export settings.
- **6.** Use Lightroom's Plug-in Exchange to select and install an export plug-in.
- **7.** Set up two publish connections: one for a folder on your hard drive, the other for your Flickr account (if you have one).
- **8.** Collect photos for the hard-drive folder and publish them to that folder.
- **9.** Create a smart folder, and then publish the photos collected by the folder to your Flickr account.

Index

1:1 previews, 23, 29

Α

ABC button, 202, 203 action triangles, 11–12 Add Identity Plate command, 205 Add option, Import dialog, 21 Adjustment Brush tool, xii, 183, 193–195 Adobe Acrobat, 209 DNG files, 20 Flash, 10, 210, 211 Lens Profile Creator, 176 Lightroom Exchange, 211, 213, 239 Photoshop. See Photoshop Photoshop Lightroom See Lightroom Reader, 209 Adobe Photoshop Lightroom 3 Book: The Complete Guide for Photographers, The, 229 After Export menu, 237 After view. See Before/After views Amount slider, 180 Anale slider, 186 Appearance panel, 212, 213 Apple FireWire, 40 iTunes, 208 Macintosh. See Macintosh Apply During Import section, 25, 26 ASCII characters, 236 As Shot setting, 153 Attribute button, 108, 112, 113 Attribute toolbar, 112

audio tracks. See soundtracks Auto button, 153 auto-complete feature, keywords, 92 Auto Hide & Show option, 11, 12 Auto Import settings, 21 Auto Mask, 193, 194, 195 auto-stack feature, 71–72

B

Backblaze, 47 Backdrop panel, 201, 203 background colors, slideshow, 203, 204 background images, slideshow, 203, 204 background music, slideshow, 207 Back Up Catalog dialog, 47 backups for catalogs, xi, 36, 46-47 for imported images, 21, 24, 29 new features in Lightroom 3, xi Badges, 124 Balance slider, 171 Basic panel, 7, 143, 152, 155 Before/After views and basic adjustments, 152 and black-and-white adjustments, 167 and color adjustments, 165 and grain effect, 181 and HSL adjustments, 163 and process version updates, 146 and sharpening adjustments, 175 black-and-white effect, 166, 168 black-and-white photos, 166–171 black flags, 74 Blacks control, 140, 153, 154

Black & White button, 152 Black & White Mix controls, 167, 169 Blue/Yellow slider, 179 blur effect, xii, 190 Brightness control, 140, 154 Burn preset, 195 B&W panel, 162, 166

С

Camera Raw plug-in, 242 cameras and Auto Import settings, 21 automatic rotating of photos by, 63 and black-and-white photos, 166 and embedded previews, 23 importing photos from, 18, 19 and lens-geometry problems, 177 and noise reduction, 172 numbering of files by, 29 and raw files, 20, 155, 172 renaming files from, 24 and tethered shooting, xii, 21 and white balance, 153 Candidate photo, 83, 85 Canon cameras, xii lenses, 176 raw-file formats, 20 captions, 8, 57, 202, 204, 225 Carbon Copy Cloner, 47 Catalog panel, 4, 28, 51 catalogs, 35-48 adding photos to, 20-22, 35, 43 backing up, 36, 46-47 benefits of using, 35 defined, 17 deleting keywords from, 104 exporting, 36, 37 "home" vs. "field," 40 importing, 36, 38-40 importing videos into, xii and Lightroom versions, 35, 44

meraina, 36, 41-44 naming, 37 opening, 45 removing photos from, 88-89 storage location for, 19, 36 storing on the Internet, 47 switching among, 35-36, 45 Catalog Settings dialog, 98 CD backups, 47 Cell Icons options, 55 Cells panel, 224 chromatic aberration, 172, 176, 178–179 Clarity control, 140, 154 clipping indicators, 153, 155 Clone tool, 187 Collapse All Stacks command, 72 collections, 121-136 adding photos to, 123-125, 129 benefits of using, 121 creating, 128, 134 deleting, 129 gathering photos for, 128 grouping, 132-133 organizing, 122 publishing, 253–255. See also Publish Services feature rearranging photos in, 59 removing photos from, 126 rules-based, 134 saving, 127 and stacking feature, 68 tying to Lightroom modules, 122 viewing list of, 51, 128 collection sets, 122, 132-133, 249 Collections panel. See also collections adding to collections in, 129 and collection sets, 132 deleting collections in, 129 and photo searches, 110, 112, 113 purpose of, 4 and Quick Collections, 127 rearranging photos in, 198 and Smart Collections, 134, 135

and Target Collections, 130 viewing list of collections in, 51, 128 color accuracy, 23 color fringing, 176. See also chromatic aberration color labels, 77, 79-82, 112 color management, 227, 228, 229 color mapping, 166, 167 Color Matching section, 228 Color Palette panel, 212 Color panel, 162, 165 Color Priority effect, 180 color profiles, printer, 227 color saturation. See saturation color shifts, 176 Color slider, 175 Color Space options, 235 ColorSync option, 228 color wash, 203, 204 Compact Cell Extras options, 55 Compact Cells option, 99 Compact Cell view option, 55 companion Web site, this book's, xiii Compare view purpose of 52,83 switching to, 52 and two-monitor systems, 87 using, 83-86 vs. Filmstrip/Grid views, 83 computer. See also laptops; Macintosh; Windows systems calibrating monitor for, 139, 229 importing photos from, 19 internal vs. external drive for, 40 using Lightroom on Windows vs. Mac, xiii working with two-monitor, 13-15 connections, 244-248 changing, 248 setting up Flickr, 246–247, 248 setting up hard-drive folder, 244–245 Constrain Crop option, 177 Constrain To Warp check box, 185 contact sheets, 219, 220, 222

Contrast control, 140, 154 controlled vocabulary, 97 Copy as DNG option, Import dialog, 20 Copy option, Import dialog, 20 copyright notice, 26, 236, 237 .CR2 files, 20 Create Collection dialog, 128 Create Collection Set dialog, 132 Create Keyword Tag dialog, 95, 96 Create New Publish Connection dialog, 245 Create Smart Collection dialog, 134–135 Create Virtual Copy command, 144 Crop Overlay tool, 183, 184-186 cropping photos, 184-185 Cropping tool, 143 Crop Ratio setting, 140 .CRW files, 20 curve controls, 158. See also tone curves Custom Filter button, 108, 117 Custom Filter menu, 116-117, 118 Custom Filter presets, 117-118 custom filters, 116–118. See also Library Filter Custom Package layout style, 220, 222, 224 Custom Text field, 25 cyanotype photos, 166

D

Datacolor, 139 Date Format menu, 27 Default Columns option, 116 Default label set, 80 Defringe option, 178, 179 Delete from Disk button, 88 deleting photos, 88–89 Density slider, 194, 195 desktop systems, external drives for, 40 Detail panel, 6, 143, 172–175 Detail slider, 174 developing images, 137–182 adjusting tone curves, 157–161 creating black-and-white photos, 162–171 defined, 137

developing images (continued) making basic adjustments, 152–156 making quick fixes, 138-142 making virtual copies, 144 updating process version, 145–147 using Detail panel, 172–175 using Effects panel, 180–181 using History panel, 150 using HSL/Color panels, 162–165 using Lens Corrections panel, 176–179 using Presets panel, 148–149 using Snapshots panel, 150, 151 visual feedback for, 137 working in Develop module, 143 Develop module lens correction feature, xii. See also Lens Corrections panel making basic adjustments in, 152 new features in Lightroom 3, xii panel groups, 6-7, 143 purpose of, 6 saving work created in, 144 working in, 143 Develop presets, 148-149 Develop Settings menu, 25 diffused effect, 154 digital cameras and Auto Import settings, 21 automatic rotating of photos by, 63 and black-and-white photos, 166 and embedded previews, 23 importing photos from, 18, 19 and lens-geometry problems, 177 and noise reduction, 172 numbering of files by, 29 and raw files, 20, 155, 172 renaming files from, 24 and tethered shooting, xii, 21 and white balance, 153 digital photography, xi. See also digital cameras digital raw capture, 20

digital rights management, 208 Dim Level menu, 67 Display Calibrator Assistant, 139 DNG files, 20, 231, 233 dodge and burn tools, 193 Dodge preset, 195 Draft Mode Printing option, 227 DRM protection, 208 Dropbox, xiii, 47, 244 droplets, 237 DVD backups, 47

E

Edit Color Label Set dialog, 82 Edit in Adobe Photoshop option, 242 editing. See also image adjustments keywords, 103-105 nondestructive, 17 in Photoshop, 242-243 roundtrip, 241 Edit Keyword Set dialog, 101 Edit Keyword Tag dialog, 104 Editor Color Label Set dialog, 81 Edit Point Curve button, 158, 159 -Edit.psd files, 243 Edit Smart Collection dialog, 135 Edit Watermarks command, 237 Effects panel, 180-181 Elegance, 211 embedded previews, 23 Embedded & Sidecar option, 23 Evening, Martin, 229 Expand All Stacks command, 72 Expanded Cell Extras options, 55 Expanded Cells option, 99 Expanded Cell view option, 55 Export Actions folder, 237 Export As Catalog command, 37, 42 Export button, 234 Export Containing Keywords option, 98 Export dialog, 232, 233, 238

exporting catalogs, 36, 37 images, 231–238 slideshows, 207, 209 Smart Collections, 135 Export Location panel, 233, 235, 245 Export PDF button, 209 export plug-ins, 239–240 Export Synonyms option, 98 Export To menu, 233 Export Video button, 209 Exposure control, 140, 153, 154 external drives, 36, 39, 40, 47 eyedropper, 153, 156, 170

F

Facebook, 239 Feather slider, 181, 193, 194 File Handling menu, 23, 38, 40, 43 Filename Template Editor, 31–33 File Naming panel, 24, 234, 235 File Renaming panel, 31 File Settings panel, 235 Fill Light control, 140, 153, 154 Filmsulp controlling appearance of, 11-12, 54 finding photos by flag with, 112 location in main window, 2 using Compare view with, 86 filters, custom, 116–118. See also Library Filter Filters Off option, 116 finding images by attribute, 112 with custom filters, 116-117 by flag, 112 by keyword, 93 with Library Filter, 93, 110-113 by metadata, 113, 119 by rating, 89 by text, 110-111 FireWire, 40 Fit to Music option, 207

flag, finding photos by, 112 Flagged option, 116 flagging photos, 73-76 with Painter tool, 75-76 as picks, 74 as rejects, 73 Flagging tool set, 50 Flash, 10, 210, 211 Flickr changing publish connection for, 248 creating collection for, 249, 252 filename considerations, 24 privacy settings, 247 republishing photos to, 255 setting up publish connection for, 246-247 uploading photos to, 255 Flickr Account panel, 246, 247 Flow slider, 193, 195 folders naming/renaming, 27 navigating to specific, 51 organizing images into, 27 published, 249 Folders panel, 4, 51 f-stops 140 FTP Server menu, 215

G

General options, Loupe view, 57 geometric distortion, 176, 177 global adjustments, 143, 184 glossy prints, 227 Go to Publishing Manager command, 244 Graduated Filter tool, 183, 190–192 grain effect, 172, 180, 181 grayscale photos, 166 grids, 212, 222 Grid view adding photo to stack in, 69 expanding/collapsing stack in, 69 moving from screen to screen in, 61 moving through photos in, 60 Grid view (continued) moving to top/bottom thumbnail in, 61 purpose of, 3, 52 rearranging photos in, 59 removing photo from stack in, 70 reversing sort order in, 29 selecting photos in, 62 setting options for, 53–55 switching to, 52 Grid View tab, 54 grouped keywords, 92 Group into Stack command, 68 group panels, hiding/showing, 12 quides, 201, 221, 222, 223

Η

halos, 154, 172 hard drive changing publish connection for, 248 cloning, 47 creating collection for, 250-251 deleting photos from, 88 failures, 47 importing photos from, 19 internal vs. external, 40 publishing photos to, 253-254 setting up publish connection for, 244-245 Heal tool, 187 Hide Toolbar command, 50 Highlight Edges option, 179 Highlight Priority effect, 180 highlights, 154, 157, 159, 166, 170-171 Highlights panel, 170 Highlights slider, 181 Histogram panel adjusting tones in, 153 expanding, 152 purpose of, 4 turning on clipping indicators in, 153 histograms, 155 History panel, 7, 142, 143, 150 HSL panel, 162-164, 165, 166, 168-169

HSL sliders, 162 HTML, 10, 210, 211 Hue panel, 162

I

ICM, 228 Identity Plate Editor, xii, 205-206 identity plates, 202, 204, 205-206, 225 IEEE 1394 connections, 40 i.Link, 40 image adjustments. See also local adjustments adjusting noise reduction, 175 adjusting sharpening, 173–175 adjusting tone curves, 157-161 applying long series of, 150 copying, 155 creating black-and-white photos, 166-171 local vs. global, 143 making basic, 152–156 preserving set of, 151 rolling back, 150 using Detail panel, 172–175 using HSL/Color panels, 162–165 using Lens Corrections panel, 176–179 using Split Toning panel, 170–171 Image Color Management, 228 Image Info panel, 212, 213 images adding grain to, 180, 181 adding metadata to, 114–115 adding to catalogs, 20-22 adjusting black-and-white mix for, 167 adjusting precise areas of, 193-195 adjusting sharpening for, 172–175 applying color labels to, 77, 79–82 applying graduated filter to, 190–192 applying keywords to, 26, 91, 99. See also keywords applying metadata to imported, 20, 26 applying post-crop vignetting to, 180–181 applying ratings to, 77-78 blurring parts of, xii, 190

color/black-and-white conversions, 152-153. 166.167 comparing, 83-87, 144 copying to new location, 20-21, 36 creating black-and-white, 166-171 cropping, 184–185 developing. See developing images displaving keywords for, 93 exporting, 231-238 flagging, 73-76 how Lightroom stores, 17 laving out on page, 9 locking, 15 making adjustments to. See image adjustments making virtual copies of, 144 moving/copying, 2/ moving through, in Library module, 60–61 moving to new location, 21, 36 organizing, 27, 65 preserving original proportions of, 184 printing, 228–229. See also printing publishing, 253-255. See also Publish Services feature rearranging, 59 removing/deleting, 88-89 removing keywords from, 103 removing red eve from, 189 removing spots from, 187-188 renaming imported, 24 reviewing, 65, 83 rotating, xii, 63 searching for, 107, 110-113 selecting, 62 sorting view of, 58 stacking/unstacking, 68-72 straightening, 186 viewing on two monitors, 13 watermarking, xii, 202, 236, 237 zooming in/out on, 58, 84 Image Sizing panel, 235 Import button, 19 Import dialog, 17, 29

Import from Catalog command, 38 Import from Catalog dialog, 38, 39 importing catalogs, 36, 38–40 images, 17, 19–33 new features in Lightroom 3, xii videos, xii import presets, 30 Include on Export option, 98 internal drives, 40. *See also* hard drive iPhone, 244 iPod, 244 ISO, 172 iTunes, 208 iTunes Plus, 208

J

JPEG files correcting exposure of, 155 and Detail panel, 172 exporting Lightroom files as, 231 and Flickr, 247 and Import dialog, 20 and merged catalogs, 44 sharpening, 172 and Tone controls, 155

K

keyboard shortcuts, xiii keyword groups, 105 keywording. *See also* keywords removing/deleting photos prior to, 88 speeding up, 93 Keywording panel creating keywords in, 92, 93, 94 displaying photo's keywords in, 93 purpose of, 5 removing keyword from photo in, 103 Keyword List panel creating keywords in, 92, 93 deleting keyword from catalog in, 104 displaying photo's keywords in, 93

Keyword List panel (continued) finding photos by keyword in, 119 purpose of, 5 rearranging keyword groups in, 105 synonyms feature, 92, 95 Keyword Name text box, 95, 96 keywords, 91-106 applying existing, 99 applying to imported photos, 26 broad-to-narrow application of, 93 converting to sets, 100-101 creating, 92-97 deleting from catalog, 104 downloading from Web, 97 editina. 103-105 naming/renaming, 104 nested, 92, 96-97, 98 purpose of, 91 rearranging, 105 removing from photos, 103 setting catalog to suggest, 98 and stock image agencies, 91 synonyms for, 92, 95 updating, 103 Keyword Set menu, 100-102 keyword sets, 100-102 keyword synonyms, 92 Keyword Tag Options, 95, 96, 98 Keyword Tags text box, 93

L

labels, color. See color labels landscape orientation, 185, 235 laptops and catalog backups, 47 external drives for, 40, 47 installing Lightroom on, 36 moving/copying photos to, 36, 40 Layout panel, 201, 223 Layout Style panel, 211 layout templates, 9 Left Panel Group controlling appearance of, 11-12 Develop module, 6-7, 143 Library module, 4 Print module, 218 Lens Corrections panel, 172, 176-179, 182, 185 Lens Profile Creator, 176 lens profiles, 176, 177 lens vianettina, 176, 178 Library Filter, 107–120 finding photos by attribute with, 112 finding photos by keyword with, 93 finding photos by metadata with, 113 finding photos by text with, 110-111 finding rejected/low-rated photos with, 89 locking/unlocking, 108, 109 main search buttons, 108 predefined searches, 108 purpose of, 107, 108 refining searches with, 110 showing/hiding toolbar for, 108, 111 using custom filters in, 116-118 Library module, 49-64 arranging photos in, 59, 198 moving through photos in, 60-61 panel groups, 4–5 purpose of, 3, 49 rotating images in, 63 selecting photos in, 62, 198 setting Grid/Loupe view options in, 53-57 setting photo source for, 51 setting sort view in, 58 setting thumbnail size in, 58 using toolbar in, 50 views, 3, 52 vs. Photoshop, 65 and Web galleries, 198 Library View Options dialog, 54, 56 Lightroom catalogs. See catalogs collections. See collections creating slideshows in. See slideshows

creating Web galleries in. See Web galleries developing images in, 137–182. See also image adjustments exporting images from, 231–240 finding images in, 107–120 importing images into, 17, 19–33 interface, 2 keyword feature, 91. See also keywords and Mac/Windows systems, xiii, 2 making local adjustments in, 183–196 making prints in, 217-230 meshing Photoshop and, 241–243 modules, 2–10 navigating Library in. See Library module new features in Lightroom 3, xi-xiii organizing/reviewing images in, 65–90 Publish Services feature, xiii, 244–256 purpose of, xi, 1 this book's companion Web site, xiii vs. Photoshop, xi workflow, xi, 2 Lightroom Default label set, 80 Lightroom Exchange, 211, 213, 239 Lightroom Publishing Manager, 244–248 Lights Dim option, 66 Lights Off option, 66 "lights out" feature, 66-67 Lights Out panel, 66, 67 Linear setting, 159 Link Focus button, 84 Live Mesh, 47 Live setting, Loupe view, 14 local adjustments, 183–196 applying adjustments to precise areas, 193-195 applying graduated filter, 190–192 cropping photos, 184-185 defined, 143 removing red eye, 189 removing spots, 187–188 straightening photos, 186 and Tool Strip, 143, 183 using Adjustment Brush tool, 193–195

using Crop Overlay tool, 184–186 using Graduated Filter tool, 190–192 using Red Eye Correction tool, 189 using Spot Removal tool, 187–188 vs. global adjustments, 143 Location Columns option, 116 Lock button, 109, 184 Locked setting, Loupe view, 14 Lock to Second Monitor command, 15 Long Edge option, 235 Loupe Info 1 options, 57 Loupe Info 2 options, 57 Loupe view moving from screen to screen in, 61 moving through photos in, 60 opening second window in, 13–15 purpose of, 3, 52 setting options for, 53, 56-57 switching to, 52 Loupe View tab, 56 Lourekas, Peter, 242 low-light photos, xii .Ircat files, 38, 42 luminance, xii, 162, 164, 166, 168. See also HSL panel Luminance slider, 1/5

М

.m4a files, 208 .m4b files, 208 .m4p files, 208 Macintosh Display Calibrator Assistant, 139 external drives for, 40 hard-drive cloners, 47 keyboard shortcuts, xiii Page Setup dialog, 219 and photo-import process, 19 printer dialog, 228 USB connections, 40 Main Window button, 15 Make a Second Copy To option, 24

Manual option, for triangle actions, 12 marking photos, 73-76 with Painter tool, 75–76 as picks, 74 as rejects, 73 Masking slider, 174 mask overlays, 193, 194, 195 Match menu, 134 matte prints, 227 Maximize PSD and PSB File Compatibility preference, 241 Media Type menu, 227 Medium Contrast setting, 159 memory cards, 20, 40 Merge to HDR in Photoshop option, 243 Merge to Panorama in Photoshop option, 243 merging catalogs, 36, 41-44 metadata adding/syncing, 114-115 applying to imported photos, 20, 26 deleting, 89 for exported images, 236 for photos in merged catalogs, 44 searching for photos by, 113, 119 Metadata button, 108, 113 Metadata menu, 26 Metadata panel, 114, 119, 236 Metadata tab, 98 Metadata toolbar, 113, 119 Microsoft Live Mesh, 47 Midpoint slider, 178, 180 midtone contrast, 154 Minimal option, Render Previews, 23 Minimize Embedded Metadata option, 236 Modified Photos to Re-Publish queue, 254 Module Picker, 2, 6, 11-12, 143 modules, 2-10. See also specific modules Develop, 6-7 Library, 3-5 Print, 9 Slideshow, 8 switching among, 2 Web, 10

monitors calibrating, 139, 229 working with two, 13–15 Move option, Import dialog, 21 Move to Top of Stack command, 70 .mp3 files, 208 music, background, 207 music files, 208 My Pictures folder, 39

Ν

naming/renaming catalogs, 37 imported image files, 24 keywords, 104 keyword sets, 100 presets, 30, 32 snapshots, 151 subfolders, 27 naming schemes, 25 Navigate buttons, 60 Navigator panel Develop module, 6 Library module, 4 .NEF files, 20 negative files, 37, 44 negative sharpening, xii, 175, 190 nested keywords, 92, 96-97, 98 New Develop Preset dialog, 149 New Metadata Preset dialog, 26 New Photos to Publish gueue, 253, 254, 255 New Preset dialog, 100, 238 New Template dialog, 226 Nikon cameras, xii lenses, 176 raw-file format, 20 noise effect, 172 noise reduction, xii, 172, 175 nondestructive editing, 17 Normal setting, Loupe view, 14

0

Opacity slider, 202, 203 Open as Layers in Photoshop option, 243 Open as Smart Object in Photoshop option, 242 Open Catalog command, 45 Open Recent command, 45 Option panel, 201 Organizer menu, 27 Outdoor Photography keyword set, 5, 100, 102 Output Settings panel, 212, 213 Output Sharpening panel, 236 overlays, 174 Overlays panel, 201, 202, 225

Ρ

Page panel, 225 Page Setup button, 219 Painter tool, 73, 74, 75-76 Paint menu, 75 Paint Overlay effect, 180 panels, 11–12. See also specific panels panoramas, 68, 243 Pantone, 139 Paper Size menu, 219 passwords, 215 PCs. See computer PDF files, 207, 209, 216 Peachpit Visual QuickStart Guides, xiii Photographer's Toolbox, 211 photographic vignetting, 176 photos adding grain to, 180, 181 adding metadata to, 114-115 adding to catalogs, 20-22 adjusting black-and-white mix for, 167 adjusting precise areas of, 193–195 adjusting sharpening for, 172–175 applying color labels to, 77, 79–82 applying graduated filter to, 190–192 applying keywords to, 26, 91, 99. See also keywords

photos (continued) applying metadata to imported, 20, 26 applying post-crop vignetting to, 180–181 applying ratings to, 77–78 blurring parts of, xii, 190 color/black-and-white conversions, 152–153, 166.167 comparing, 83-87, 144 copying to new location, 20-21, 36 creating black-and-white, 166-171 cropping, 184–185 developing. See developing images displaying keywords for, 93 exporting, 231–238 flagging, 73-76 how Lightroom stores, 17 laying out on page, 9 locking, 15 making adjustments to. See image adjustments making virtual copies of, 144 moving/copying, 27 moving through, in Library module, 60-61 moving to new location, 21, 36 organizing, 27, 65 preserving original proportions of, 184 printing, 228-229. See also printing publishing, 253–255. See also Publish Services feature rearranging, 59 removing/deleting, 88-89 removing keywords from, 103 removing red eye from, 189 removing spots from, 187-188 renaming imported, 24 reviewing, 65, 83 rotating, xii, 63 searching for, 107, 110-113 selecting, 62 sorting view of, 58 stacking/unstacking, 68–72 straightening, 186 viewing on two monitors, 13

photos (continued) watermarking, xii, 202, 236, 237 zooming in/out on, 58, 84 photosets, 252, 255 Photoshop curve controls, 158, 161 and droplets, 237 editing Lightroom images in, 242-243 meshing Lightroom and, 241-243 unsharp mask, 154, 172 vs. Lightroom, xi, 65 and watermarks, 237 Photoshop CS5 for Windows and Macintosh: Visual QuickStart Guide, 242 Photoshop Lightroom. See Lightroom Picture Package layout style, 220, 222, 224 picture packages, 217, 219, 220, 224. See also printing pixels, xi pixels per inch, xii, 227 Playback panel, 201, 207 Plug-in Manager, 239–240 plug-ins Camera Raw, 242 export, 239-240 slideshow, 211 Web gallery, 213 Point Curve menu/setting, xii, 158, 159, 160 portable photo storage driver/viewer, 40 portrait orientation, 185, 235 Portrait Photography keyword set, 100, 102 post-crop vignetting, 176, 180-181 Post-Process Actions panel, 232 Post-Processing panel, 237 ppi, xii, 227 preferences for importing photos, 18 lights setting, 67 Photoshop, 241 Preferences dialog Lightroom, 18 Photoshop, 241 Presence controls, 154

Preset panel, 238 presets for color label sets, 81-82 for custom filters, 117-118 for export settings, 238 naming, 30, 32 previewing, 6 saving, 30 for toning effects, 166 for Web galleries, 215 Presets panel, 143, 148–149, 232 Preview in Browser button, 214 Preview panel, 9 previews canceling, 29 and import speed, 23 rendering, 23, 29 Previous Process Photos option, 145 Print button, 228, 229 printer color profiles, 227 printing, 217-230 choosing print settings prior to, 227 choosing template for, 220-221 customizing template for, 222-225 aetting set up for, 218-219 new features in Lightroom 3, xii photos, 228-229 saving custom templates created for, 226 selecting photos for, 219 setting paper size for, 219 sharpening photos prior to, 236 showing/hiding guides when, 221 showing/hiding rulers when, 221 Print Job panel, 227 Print module, 9, 218, 228 Print One button, 229 print resolution, xii, 227 Print Setup dialog, 219 Print Sharpening options, 227 print-size proportions, 184 Privacy and Safety panel, 247 process engine, xii, 145–147

process version defined, 145 finding pre-2010, 145 and noise reduction, 172 reverting to previous, 147 and sharpening, 172 updating, 146 Profile menu, 227 progress bar, 28 ProPhoto RGB color space, 23 PSB files, 241 PSD files, 231, 241 Publish button, 253, 254, 255 publish connections, 244-248 changing, 248 for Flickr connection, 246–247, 248 for hard-drive folder connection, 244-245, 248 purpose of, 244 published folders, 249, 250 published folder sets, 249, 250 Published Photos gueue, 253 published smart folders, 249, 250 Publishing Manager, 244–248 Publish Services feature, 244-255 basic steps for using, 244 changing connections for, 248 collecting photos to publish via, 249-252 publishing collections with, 253-255 purpose of, xiii, 231 setting up connections for, 244-247 Publish Services panel, 244-248, 251, 252, 253

Q

Quick Collection, 123–127 adding multiple photos to, 125 adding single photo to, 123–124 emptying, 127 purpose of, 123 removing photos from, 126 saving, 127 vs. Target Collection, 130 Quick Develop panel making quick fixes with, 138–142 purpose of, 4 rolling back adjustments made with, 150 vs. Develop panel, 152

R

Radius slider, 173 Rated option, 116 ratings, 77–78, 112 raw files adjusting tone curves on, 157 and Copy as DNG option, 20 sharpening, 172 vs. DNG files, 20 Recent Keywords command, 100 Recovery control, 140, 153, 154 Recycle Bin, 88, 89 Red/Cyan slider, 179 Red Eye Correction tool, 183, 189 region sliders, 158-159 Rejected flag, 73 Remove button, 88 Remove Flag note, 76 Remove from Stack command, 70 removing photos, 88-89 Rename Files check box, 24, 31 Rename Preset dialog, 32 Render Previews menu, 23 Replace menu, 44 resolution, print, xii, 227 Review Status label set, 80 **Right Panel Group** controlling appearance of, 11–12 Develop module, 7, 143, 148 Library module, 4 Print module, 9, 218 Slideshow module, 8, 199 Web module, 10 widening, 155 Rotate to Fit option, xii, 222 rotating images, xii, 63, 222

Roundness slider, 181 roundtrip editing, 241 rulers, 221, 222 Rulers, Grid & Guides panel, 222, 223

S

saturation, 162, 164, 166, 168. See also HSL panel Saturation control, 154 Saturation panel, 164 Save Current Settings as New Preset option, 117 Saved Preset setting, 140 saving collections, 127 custom templates created for printing, 226 presets, 30 Quick Collections, 127 Web galleries, 214 work created in Develop module, 144 Scale slider, 202 screensavers, xiii, 244 searching for photos by attribute, 112 with custom filters, 116-117 by flag, 112 by keyword, 93 with Library Filter, 93, 110-113 by metadata, 113, 119 by multiple criteria, 113 by rating, 89 by text, 110-111 Secondary Window button, 13, 15 selecting images, 62 in Grid view, 62 in Library module, 62, 198 for printing, 219 for slideshows, 198 for Web galleries, 198, 211 Select Music button, 207 Select photo, 83, 85 sepia photos, 166 Set Color Label command, 79

Set Rating command, 78 Settings panel, 232 shadows, 157, 159, 166, 170-171 Sharpen For menu, 236 sharpening, negative, xii, 175, 190 Sharpening sliders, 173 sharpening tools, 172–175 shoe box icon, 132 Shoot Name field, 25 Short Edge option, 235 Show Badges option, 124 Show Edit Pins option, 193 Show Filter Bar command, 108 Show Grid Extras check box, 54, 55 Show Info Overlay check box, 56, 57 Show Rulers option, 221 Show Toolbar command, 50 sidecar files, 20, 21 Sidecar option, Embedded &, 23 Sigma lenses, 176 Single Image/Contact Sheet layout style, 220.222 Site Info panel, 212 Size slider, 193, 194 skin tones, 154 slides. See also slideshows choosing playback settings for, 207 choosing template for, 200 choosing text option for, 202 Slideshow module, 199-209 choosing playback settings in, 207–208 choosing slideshow settings in, 201–204 choosing slide templates in, 200 creating identity plates in, 205-206 customizing, 199 exporting slideshows from, 209 panels, 199 purpose of, 8, 197 showing/hiding toolbar in, 200 slideshow plug-ins, 211 slideshows, 197–209. See also Web galleries arranging photos for, 198 choosing playback settings for, 207–208

choosing settings for, 201-204 choosing slide template for, 200 creating identity plates for, 205-206 displaying Intro/Ending screens for, 204, 205 embedding soundtracks in, xii exporting, 207, 209 labeling photos in, 203 new features in Lightroom 3, xii previewing, 201, 207 selecting photos for, 198 Smart Collections, 134-135, 249 Smart Collections folder, 51 smart folders, published, 249, 250, 251 Smart Object layer, 242 smart photosets, 252 SmuqMuq, 239 Snapshots panel, 143, 150, 151 Soften Skin effect, 192 Sony i.Link, 40 Sorting tool set, 50 Sort menu, 58 sort order, reversing, 29 soundtracks, xii, 8, 207, 209 split controls, 158, 159 Split Toning panel, 166, 170–171 Spot Removal tool, 183, 187–188 spray can, 75. See also Painter tool stacking photos, 68-72 Standard option, Render Previews, 23 star ratings, 77-78, 202 Start Background Update option, 38 Start Number field, 25 stock image agencies, 91 stops, 140 straightening photos, 186 Straighten tool, 186 Strong Contrast setting, 159 Style setting, 180 subfolders, 27 SuperDuper!, 47 Survey view purpose of, 52, 83 switching to, 52

and two-monitor systems, 87 using, 87 Sync button, 84, 155, 156 Synchronize Metadata dialog, 115 Synchronize Settings dialog, 156 syncing metadata, 114–115 white balance, 156 Sync Metadata option, 115 Sync with Opposite Panel option, 12 synonyms feature, Keyword List panel, 92, 95, 98

Т

Target Collection, 123, 130-131, 251 Targeted Adjustment tool, 158, 160, 161, 162, 163-164 Temperature control, 140, 153 Template Browser panel, 200, 208, 211, 214, 226 templates flle-naming, 31 layout, 9 print, 218, 220-226 slide, 200 slideshow, 201 Web gallery, 211, 212 tethered shooting, xii, 21 Text button, 108, 110, 113 Text toolbar, 111 texture control, 174 third-party plug-ins export, 239-240 slideshow, 211 Web gallery, 213 thumbnails moving to top/bottom, in Grid view, 61 setting size of, in Library module, 58 Web gallery, 210 Thumbnail Size tool set, 50 Thumbnails slider, 58 TIFF files, 231, 235 Tint control, 140, 153

Titles panel, 201, 204, 205 Tone controls, 153-154, 155 Tone Control setting, 140 Tone Curve panel, 143, 157–161 tone curves, 157-161 adding/changing points on, 159 adjusting, 157, 160–161 clicking/dragging single point on, 161 dividing into fourths, 159 narrowing/widening, 161 new features in Lightroom 3, xii for raw files, 157 toning effects, 166 toolbar Attribute, 112 Lightroom, 50 Metadata, 113, 119 Text. 111 Tool Strip, 183–196 Adjustment Brush tool, 193–195 Crop Overlay tool, 184–186 Graduated Filter tool, 190–192 location of, 183 purpose of, 143, 183 Red Eye Correction tool, 189 Spot Removal tool, 187–188 tools available in, 183 Transform sliders, 185 Trash, 88, 89 Treatment control, 140, 152–153 triangle actions, controlling, 11-12

U

undo command, 89 Unrated option, 116 unsharp mask, 154, 172 Unstack command, 68, 70 uploading photos to Flickr, 255 to Web galleries, 215 Upload Settings panel, 215 USB connections, 40

V

Via Service menu, 245 Vibrance control, 140, 154 video features, xii viewers, portable photo storage, 40 View Modes tool set, 50 vignetting, 176, 178, 180–181 virtual copies, 144 Visual QuickStart Guides, xiii

W

Watermark Editor, xii, 237 Watermarking panel, 237 watermarks, xii, 202, 236, 237 waywest.net/lightroom, xiii WB control, 153. See also white balance Web browser previewing Web galleries in, 214 reviewing uploaded photos via, 255 Web galleries, 210-215 arranging photos for, 198 choosing settings for, 212-213 choosing template for, 211 creating, 210-211 previewing, 214 purpose of, 210 saving, 214 selecting photos for, 198, 211 uploading to Web, 215 Web gallery plug-ins, 213 Web module previewing Web galleries in, 214 purpose of, 10, 197 saving Web galleries in, 214 Web site for book, xiii Wedding Photography keyword set, 5, 100, 102 Weinmann, Elaine, 242 white balance auto, 153 custom, 140, 153 syncing, 156 White Balance panel, 153

White Balance Selector, 153, 156 White Balance setting, 140 white flags, 74 wide-angle lenses, 177 Windows systems hard-drive cloning services, 47 keyboard shortcuts, xiii and photo-import process, 19 printer dialog, 228 Print Setup dialog, 219 workflow, xi, 2 work view, setting, 13–15 Write Keywords as Lightroom Hierarchy option, 236

Х

XMP files, 89 X-Rile, 139

Y

YIY button, 152

Z

Zoom slider, 84 Zoom to Fill option, 222

WATCH READ CREATE

Meet Creative Edge.

A new resource of unlimited books, videos and tutorials for creatives from the world's leading experts.

Creative Edge is your one stop for inspiration, answers to technical questions and ways to stay at the top of your game so you can focus on what you do best—being creative.

All for only \$24.99 per month for access—any day any time you need it.

creative

creativeedge.com

.....